The
Luxury
Alchemist

© 2013 Assouline Publishing
601 West 26th Street, 18th floor
New York, NY 10001 USA
Tel: 212-989-6769 Fax: 212-647-0005
www.assouline.com
ISBN: 9781614281504
10 9 8 7 6 5 4 3 2
Printed in the United States.

The
Luxury
Alchemist

Ketty Pucci-Sisti
Maisonrouge

ASSOULINE

To my mother, who taught me that nothing is impossible,
To my father, who taught me about duty and honor,
To my husband, who has always believed in me,
To my sons, who are my *raison d'être*.

Contents

INTRODUCTION

In the last ten years the luxury market has become a true global economic force, and interest in the field has skyrocketed. Any novice can access all there is to know in this ever-evolving landscape from the internet, conferences, in-depth analyses, and books, such as those penned by marketing giants Jean-Noël Kapferer or Pamela Danziger, which are essential reading for anyone interested in the field. So who needs yet another book on luxury? What more is there to say? That is certainly how I felt when asked by my students at Columbia Business School, who thought I should write a book to share my insights.

In the last two years, however, I have felt that something could be added. I have the privilege of addressing groups of approximately one hundred young Chinese students from CFL, the China Future Leadership Project, three times a year. They come to Columbia Business School and other highly regarded campuses around the United States for an intense week of lectures designed to deepen their understanding in various fields of business. During our brief time together, I try to give them

a quick overview of what differentiates the marketing of luxury products from marketing in other industries. During the Q&A period with each group, one question inexorably comes up: "How do you create a luxury brand?"

While I do have a few entrepreneurs in my classes, most of the students are either focused on joining a large luxury group or taking a family company to the next level—growing the business into a real brand. Few people have the temerity to create one themselves, but the only choice these young Chinese students seem to see is starting from scratch.

These young people all have the notion that the most essential pre-requisite to starting a luxury brand is money, and lots of it. They are all very surprised when I say to them, "It is all about *passion*." All flourishing luxury brands today began with a passion for a craft, and that passion permeates into every aspect of the business. When you have true passion, you only want to create perfection; you don't count how many hours it took to get there, dwell on how hard it was or the sacrifices you made. You care only about your creation and sharing it with others. That's how a true luxury brand starts. You can argue that it's the same in every industry, but in the luxury field this passion cannot disappear because you don't sell a product to your clients—you sell a dream. Without passion, it's difficult to share that dream.

Your passion should be infused into every aspect of what you do: perfecting your talent, creating the best-quality products, surrounding yourself with talented and motivated people, never settling for anything but the best, never compromising your values, and sharing your vision. Use your passion to influence one person, then another, and another, all of whom will then share it with even more people. This is the original "word of mouth," the "social hubs" of yesterday. It's about starting small

and growing organically, from the heart. The talented craftsmen who founded today's leading brands (I don't think they saw themselves as entrepreneurs at the time) did not envision creating a company. They wanted to craft beautiful objects and show their love to others. That's how it starts. Small. One atelier, one shop, and a few demanding customers. Then you grow. However, it takes decades to establish your *métier*'s true legitimacy, which is the fundamental pillar of any luxury brand. Passion is the Philosopher's Stone of any successful luxury brand, and its creator is a Luxury Alchemist, playing with the various ingredients to artfully blend each element and turn them into a success story.

A passion's initial creative spark is the Big Bang of a luxury brand—the Magic Ingredient that will transform your idea, craft, or vision into a successful company. You will need the money to grow, but it's not all about the money, especially when you're starting out.

We live in an era of max-speed. Everything needs to go fast, and no one wants to devote the kind of time or patience it took Louis Vuitton, Coco Chanel, Thierry Hermès, or René Lalique to start their companies. Anyone with an idea wants to be the next Bill Gates, which is, of course, understandable—I'd like that too!—but it takes time and persistence to create a lasting and enduring luxury brand, which is the reason why certain brands are sometimes criticized for being too slow to react to change. If you have been around for over a hundred years you know that change also presents itself in passing fads, and only hindsight can really differentiate infatuations from lasting trends. Today's successful entrepreneur will most likely have one goal: selling their creation to a large luxury group. There is nothing wrong with that; it will certainly speed the brand's growth, but the new owner's level of passion might not be

the same as the original Luxury Alchemist who created it. It may also be the opposite; sometimes the new partner brings a renewed energy and enthusiasm. You never know.

Don't get me wrong; there are more and more brands today that are true success stories and were started by determined business people who didn't necessarily have a "craft." What they had was an idea, determination, and drive. In order to be a Luxury Alchemist, they still had to find talented individuals, whether they were fashion designers or jewelry craftsmen. They had to possess the ambition to work so hard that it felt their lives depended on it, to give 1,000 percent of themselves to their new idea. After all, it was the idea of creating flat *malles* (travel trunks) that could be stacked on top of each other and crafted with special waterproof fabric that made Louis Vuitton's company a success when he started out. Today, vintage travel trunks are displayed in every Louis Vuitton store throughout the world to remind customers of the brand's roots.

Of course Louis Vuitton had talent, but he was also an innovator. Without his different, original idea, he would have simply been an excellent *malletier*. His name and company would not be remembered today; they would not be among countless people's top five favorite luxury brands. A Luxury Alchemist must be innovative and ready to risk it all to turn his or her idea into a success story.

My goal for this book is to share what I believe is necessary to start a luxury company—how to transform ideas or talent into a successful brand. Before we delve into our main topic, I'd like to clarify my approach: I am not trying to write a textbook for students or entrepreneurs, including charts, graphs, and a litany of "to-dos" (though they are essential, and I am the queen of "to-do" lists!). In my opinion, you need to "live it to learn it," which

is the reason I consider hands-on experience necessary to any successful business school experience. That's where the power of experience lies—yes, sorry youth, it's true. You cannot enter the business world with only theory, no matter how talented, smart, and hardworking you are. You can—and should—also learn by studying the past, as history does repeat itself in one form or another. While I am not a historian, I will share my ideas through concrete examples, many of them drawn from my own experiences. Most of them relate to people or companies I know well that have shaped my vision and understanding of luxury.

I will share insightful stories with you, which will be divided into two main parts: The first part will focus on what I call the Magic Ingredients required of any Luxury Alchemist when trying to concoct a successful brand. These examples will target more recently established luxury brands whose stories highlight the strengths that made them prosperous. Each anecdote will spotlight one of these Magic Ingredients, but all of them are needed to be a success. That's how you become a flourishing Luxury Alchemist for your own brand!

In the second part of our journey, I will guide you through the various steps taken by two recent luxury start-ups in rather unusual parts of the sector. In their cases, only the future will tell us if they are success stories but I believe (and hope) that they will be!

This book is meant to be fun, but also to teach you a lot about the luxury world. I hope it will make you smile, or even intrigue you, because the best way to learn is by having fun and not taking things too seriously. If you want to be motivated to put in the really long hours, you'd better not feel like you are working. And while this will not be like something out of a fairy tale, it will hopefully spark your imagination and make

you think of the possibilities ahead—to inspire you look at the future a bit differently.

One last thing before we dive in, because my students always tell me I forget: Let me quickly share with you my background so that you'll agree that I have the legitimacy to share the secrets of creating a successful luxury brand with you. Let me start by saying that I have always been an entrepreneur at heart. I first went to business school at Sciences Po[1] in Paris, then law school at the Sorbonne; and finished all the course work for my masters in art history at the NYU Institute of Fine Arts. I was a real nerd, always studying and working hard.

While finishing law school, I was interning at the then-largest French auction house in Paris, Ader Picard Tajan. After deciding to pursue a graduate degree in art history at NYU, they asked me if I could help them in the United States and made me an offer that I gladly accepted. While promoting Ader Picard Tajan, I was given the opportunity to work for the jewelry brand Marina B, which was looking to open a store in New York.

I subsequently aided the French crystal company Daum in establishing itself in New York, even organizing an exhibit for them at the prestigious Didier Aaron Gallery. I guess it was successful because Hervé Aaron, then the Chairman of the United States chapter of the Comité Colbert, recommended me to the Comité and launched my career in this field. (Hervé not only became my mentor, but also one of my dearest friends.) The Comité Colbert, which I'll discuss in greater detail later on, is an organization that was created in 1954 to regroup French luxury brands and address common issues they separately faced—from entering new markets to lobbying to enforce stricter laws against counterfeiting.[2] In 1989, I helped organize their celebrations for the French Revolution's Bicentennial in New York. What was

supposed to be a one-time contract turned into a fifteen-year *représentation* of the Comité Colbert in the United States.

When the Comité Colbert initially hired me, I worked alone. However, I quickly realized that I needed help, so I hired one person to help me, then a second, and then a third. By 1998, my company had grown to twenty people. I didn't have a grand plan to open a marketing agency in 1988 when the Comité Colbert brought me on board. My agency, KM & Co., was an accident that I fully embraced with enthusiasm and zeal. Our clients included some of the most prestigious luxury names, like Hermès and Escada, Parfums Caron, Chaumet, Christofle, and many others.

When I entered the luxury field in the late 1980s, I became an insider at a crucial moment when the industry was undergoing a major metamorphosis. Small and large family-owned companies were morphing into the global economic powerhouses of today. There weren't any luxury programs at major business schools like the ones now available at ESSEC and HEC,[3] two prestigious business schools in France, Columbia Business School, and other major universities. In the 1980s, the sector was not large enough to demand such courses. At the time, most CEOs were family members who had been groomed from childhood to take over the family business. They learned from their parents at the dinner table growing up, working in the ateliers during summer holidays, and from each other—hence the importance and relevance of organizations such as the Comité Colbert, which was unique at that time. (The Walpole Committee was created in 1990 and Altagamma in 1992, these being the British and Italian versions of the Comité Colbert.)

The Comité Colbert was formed in 1954 by Jean-Jacques Guerlain (from the Guerlain family) and a few other friends,

including Christian Dior. Following World War II, France was reviving itself and industries began to flourish again. It was obvious to luxury company heads that the world had changed; new rules were being written every day, and companies had to quickly learn to adapt. These visionaries decided to implement the motto "*L'Union fait la Force*" (union creates strength). As a true economic force, together they represented a power that had to be taken seriously by the French government. They decided to work together instead of against one another.

It's important to remember that from the 1950s to the 1980s the luxury business world was a sort of gentlemen's club in which company presidents could exchange ideas and learn from friendly competitors. There were unspoken rules: For example, you did not steal someone else's manager or other talent because you were among gentlemen. It was their own version of an Executive MBA program, except that the main requirement to pass the entrance exam was to lead a prestigious firm and allow yourself to be co-opted by your peers.

That was the world I entered in 1988, and I have never left. I have been an adjunct professor teaching a course on luxury products at Columbia Business School since January 2005, and have additionally been the president of the Luxury Education Foundation since 2004.[4] The U.S.–based foundation offers programs for MBA and design students with the participation of some of the world's most well-known luxury brands, including Louis Vuitton, Chanel, Hermès, Cartier, Graff, Christian Dior, Lalique, and Loro Piana, just to name a few.

Since 2008 I have worked with two start-ups, one of which is truly in the luxury field and which we'll discuss in the second part of this book. I joined the board of J. Mendel in 2010 and have been working closely with its amazing designer, Gilles Mendel,

and his team to fulfill the brand's full potential. I also embarked on a new adventure in 2012 to support the floral designer Olivier Giugni in the development of his company into a true luxury brand, L'Olivier. Thanks to these experiences, I understand the challenges of creating a luxury brand, as well as the growing pains of a company that wishes to get to the next level.

Over the last twenty-five years, I have witnessed luxury companies expand and change ownership. I saw the first non-family members appointed as leaders of some of the most prestigious firms. I saw the first luxury group created. I saw a surge in interest from young graduates, who rarely thought of entering the luxury field twenty-five years ago but now look at these opportunities as a chance to become a part of this growing power.

In December 2011, the Boston Consulting Group estimated that the global luxury industry represented $1.405 trillion in revenue, 20 percent coming from apparel, leather goods, accessories, watches, jewelry, and cosmetics.[5] The field has been growing in double digits during the last few years, and overall fared well during the financial crisis. Today it is one of the most profitable industries and continues to grow, especially in emerging markets where national luxury brands are just appearing. This is why talented people are thinking of creating luxury companies. I hope that my stories and insights will offer you a better understanding of the Magic Ingredients to create a luxury brand, and help you become a Luxury Alchemist.

PROLOGUE:
WHAT IS LUXURY?

I think we can all agree that the word *luxury* has been so over-used in the last decade that it has lost some of its essence. You now read more about quality, craftsmanship, and timeless elegance. Luxury is something you'll always cherish, whether it comes in the form of an object or an experience. But what does it really mean? We could write a whole book just on that question, but I'll try to do it in a few pages.

Let's start with its etymology: Luxury comes from the Latin word *luxus*, which means indulgence or splendor. It also stems from *luxuria*, which implies decadence and debauchery. Throughout the centuries, luxury has always possessed this split personality. On one hand, it was used to pay respect and show devotion to gods, or by kings or emperors to display their power to enemies or subjects. In this sense, luxury was associated with creating the best tribute to show respect to powerful individuals. On the other hand, it was also associated with excess and depravity because the people using these objects became self-indulgent and decadent. Historically,

luxury was the domain of only a very small number of individuals, and most people could only admire representations of it from a distance or in a house of worship or palace. In Medieval Europe (spanning the fifth to the fifteenth centuries), signs of wealth were highly regimented by the clergy and nobility; a baron could not have more horses pulling his carriage than a marquis, for example, even if he was richer. During that time it was not as much about wealth as it was about power. In the nineteenth century, the Industrial Revolution (approximately the 1760s–1840s) brought upon the loss of landowners' wealth and importance. Instead, those assets went into the hands of a new caste of individuals—the industrialists—who would form the bourgeoisie. The bourgeoisie made a lot of money very quickly, challenged social codes, and broke existing social rules. They had the funds to buy as many horses as they wanted for their carriages and to build the biggest houses; no protocol was going to tell them otherwise. This was the real beginning of the luxury phenomenon as we know it today.

For economists luxury is the opposite of necessity, and it "exists if the income elasticity of demand is positive and greater than one."[6] A luxury item's price should be substantially higher than what its functionality and direct and indirect costs are. There is an intangible quality to a luxury product that goes beyond typical cost structures. We don't need luxury, but we feel it allows us to express ourselves and makes us feel good. Luxury is very personal and changes not just from person to person, but with regard to location and time as well. The same consumer might change his or her attitude depending on these two factors: For example, the air conditioning you take for granted in your home or office might become a luxury if you travel to tropical countries where such things might be harder to find.

The Luxury Alchemist

TIME

Every new term, my students ask me about my personal definition of luxury. Some seem surprised with my answer: time. I realize that it might seem odd to a young person—I remember my stepfather always telling me that "time is money," which of course, as a child, made no sense whatsoever: I had a lot of time, so why didn't I have a lot of money? As the years pass, I'm not sure if I regard time as money precisely, but time is certainly the one commodity I lack the most, and therefore is the greatest luxury for me.

So what does time tell us about luxury? It is something precious that we cherish and wish we could have more of. If you could buy more time—given the laws of supply and demand—it's safe to assume that time would be the most expensive and in-demand commodity possible. As most people view luxury as something rare and expensive, time can therefore be considered as one of most coveted luxury items out there.

It is interesting to see how time directly affects the luxury world. Depending on the customer's sense of time, the selling experience could be different. What do I mean by that? If a potential customer enters a store while on vacation—with time and the desire to linger—the experience should be geared toward educating the client, sharing your knowledge and passion for the brand and product. But if you are faced with a customer in a hurry to shop and get out, you should be as efficient and quick as possible. The most frustrating part for any salesperson is that the same customer could be either one depending on the time and location, so they need to be able to adapt quickly!

Also, when you think about it, time is a factor in the online shopping experience. You might prefer purchasing online

because it's quick or because you can still shop when stores are closed. In this regard, you feel more in control of your time. Or you might just prefer the privacy and the fact that—like walking on a street—you can wander on the Net, explore, and find more information. Whatever the reason, your purchase will have a delayed gratification and you will not leave a boutique carrying your prized item. Delayed gratification is something that might actually make an online luxury purchase more special. You can be excited while anticipating the arrival of your precious item.

EXPERIENCE AND SERVICE

Time is closely linked with experience, which has been a focal point for luxury brands over the last decade. As we discussed, historically luxury was reserved for the aristocracy, and some European firms took a while to adapt to the realities of luxury's democratization. Companies used to know their clients personally and would make them feel at home. If your name didn't figure in their Rolodex, you'd have better been dressed to the nines and look the part, otherwise you might not have received the warmest welcome in some boutiques. (I know this is true because it happened to me!) For many years, patrons would brave the undertaking to be able to return home with their coveted prize, but gradually things changed: Globalization brought new customers from all over the world with different customs and purchasing patterns, but with the same appetite for luxury goods. It became a top priority for brands to assure their customers that their salespeople would be welcoming to all. They beefed up their training programs and incentivized their sales staff to ensure that they

would deliver an experience that matched the quality of the products for sale. For most of us, visiting a luxury boutique is a welcoming and positive experience because of the high-quality service. A positive experience should also come after the purchase, when you have questions, wish to exchange an item, or would like something repaired after twenty years of use.

Luxury brands certainly go beyond service; they create unique opportunities for their clients and devotees and attempt to make them fall even more in love with their company. One of the consequences of the luxury industry's success is the fact that there is a lot more competition out there—and a lot less customer loyalty. There are now so many choices that people rarely shop exclusively at one *maison*. The industry's new It product is creating unforgettable experiences for their clients. For example, in the fall of 2011, Cartier invited some of its VIP clients to their "Sortilège de Cartier" *Haute Joaillerie* collection launch in Rome. During the weekend of festivities, a happy few discovered palaces, visited private collections, and truly felt that Cartier opened doors for them and offered an unparalleled experience. Luxury brands want their VIP clients to feel extra special, which they hope will make them loyal in turn.[7]

If you think about what matters most to you, it's likely a memory of a special moment or an experience that has changed you. This is also why companies like Abercrombie & Kent, which organizes luxury vacations around the globe, have flourished over the last decades; they offer unique travel experiences—from the adventure of a lifetime to memorable family trips. People want to create memories that last forever; that is why the new frontier in luxury is service.

When your core business is a product and not a service, how do you create experiences beyond your store or

online presence? Well, you surprise your clients! When Karl Lagerfeld decided to celebrate the fiftieth anniversary of Chanel's iconic quilted bag, he turned to the architect Zaha Hadid to create the futuristic Mobile Art Pavilion. The spaceship-like structure hosted a contemporary art exhibit featuring both established and emerging artists. It traveled from Hong Kong to Tokyo, and then to New York in 2008. The goal was to share with the public a new vision of modern art in a way that Mademoiselle Chanel would have embraced. Everyone was welcome, there were no fees, and—in order to ensure that everyone would enjoy the unique opportunity—guests registered in advance for a specific time slot to visit. In doing so, Chanel was able to maintain exclusivity while remaining accessible to all. Chanel's Mobile Art Pavilion became a veritable luxury experience, and that's what luxury brands are all trying to do, on a small or large scale, at every point of contact with their client.

QUALITY

Of course, luxury can't exist without quality: It is its essence. Consumers want quality they can enjoy and share with others. I am pretty sure that any young woman would be thrilled to receive a hand-me-down Hermès Kelly or Chanel 2.55 bag from her grandmother because real quality is timeless and its beauty defies the years. Luxury is something that is beautiful inside and out, not just for others to see but for you to cherish in private. That was exactly how Marina Bulgari, the granddaughter of the Bulgari company founder, Sotirio Bulgari, envisioned her creations when she launched the Marina B jewelry line. After working for many years in the family business, she decided to launch her own jewelry brand in the 1980s and it instantly

became recognized for its creative and beautifully crafted pieces. Marina's unique vision was to launch a jewelry brand that was not about ostentatious wealth or pompous ornamentation, but instead about the purity of understated elegance, with pieces that women could feel comfortable wearing at any time of the day—not only at glamorous black-tie events. Marina revolutionized the way women thought of and wore jewelry while preserving the integrity of excellent craftsmanship.

As a young woman, I had the privilege of working closely with Marina and often visited her Parisian atelier as she was prototyping new designs. She showed me necklaces that were being mounted, the same precious metals (gold or platinum) that comprised the artful exterior were being used to create the hidden internal mechanism that would enable the necklaces to embrace the neck's contours. Despite the fact that they weren't visible, the interiors of those necklaces were true works of art. As she saw the puzzlement in my eyes, Marina explained that it was important for her customers to know that the non-visible parts were as much a work of art as the outside—that the same materials and quality were applied at all levels. Luxury is about the personal knowledge that a beautiful object is made with only the most precious metals, the best craftsmanship, and that often there is more to it than meets the eye. In a way, it's your little secret. This concept is hardly new; Fabergé certainly mastered the art with his exquisite eggs that open to reveal even greater treasures, but I couldn't believe it was still being done in the 1980s.

Most luxury brands only use "noble" materials for their creations, which they transform into the coveted objects that entice us. Some objects that may appear the same could have different price points because of the quality of their raw materials, hence the importance of a knowledgeable salesperson

who can explain to the client the differences in quality and how it effects the price.

Of course, quality is not sufficient to create a luxury brand: After all, you can find the most exquisite jewelry in small craftsmens' shops in remote locations, such as small villages in India. What you need to create a luxury brand is a vision and a mission, just as Marina B did: She transformed the high-end jewelry world by having the boldness to strip it of its pomp.

CRAFTSMANSHIP

Quality and craftsmanship go hand-in-hand, and the importance of craftsmanship in the luxury world can never be over-emphasized. This was the main reason why the Comité Colbert spearheaded the "Festival des Artisans" in the 1990s in New York and Los Angeles. The goal was to show children of all ages the passion that lies behind every *métier* of craftsmanship. From Les Métalliers Champenois, who restored the Statue of Liberty's flame in New York from 1984 to 1986, to Saint Louis crystal engravers or the Lenôtre pastry chefs' sculptures made of sugar, thousands of visitors experienced first-hand what it takes to create these treasures.[8]

Craftsmanship requires talent, but also training—many years of training. I remember organizing a weeklong event for Hermès in 1990 in Westport, Connecticut. The goal was to give children and parents the opportunity to witness the craftsmanship that goes into each Hermès creation. The Hermès New York boutique always had its own master craftsman, and at the time the head craftsman was Claude Gandrille.[9] Gandrille, who is still there as of this book's printing in 2013, has spent his entire career at Hermès, having

25

joined the company at the age of seventeen. I remember Claude arriving at the Westport event with a gorgeous taupe leather skin and transforming it over the course of a few days into a sumptuous Birkin bag under the marveled gaze of the guests. Claude, like all other Hermès craftsmen, trained for almost one whole year before being allowed to create his first bag; and it takes eight to ten years to completely master this skill.[10] Each Hermès bag is made from scratch by one craftsperson, and it is said that each leaves a small signature, which enables the artisan to recognize their creation.

The economy was booming in the late 1980s, and Hermès was already the hot brand that it is today. Demand for the Birkin bag was so high that the company allegedly implemented a waiting list to order one (which has been refuted by Hermès executives and also by the author Michael Tonello in his book *Bringing Home the Birkin*). Whatever the case may be, it is a fact that you could not simply walk into a Hermès store at any time and find a Birkin bag. If you were lucky, one might have just arrived, but you'd better like the color and size as there might not be another one for a while. Around the same time, Jean-Louis Dumas, Hermès's former CEO, was pressured to drastically increase the number of Birkin and Kelly bags created every year because they were (and remain) two of the company's bestsellers. Seeing that each craftsman had to be trained for so long to master his or her art, all Hermès could do was follow the trend of increased demand. They couldn't react to what might have been a simple high in the economy. If the economy had gone south, then they would have had a temporarily larger stock of Birkin and Kelly bags. Hermès always had a long-term vision and didn't want to grow just for the sake of growing. The

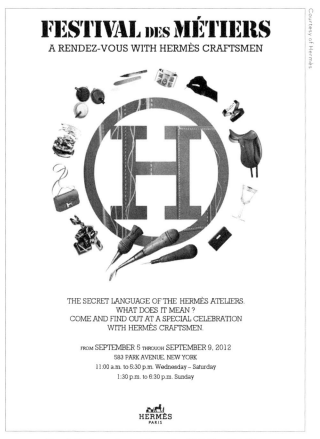

Hermès Craftsmen Festival, September 2012, New York City.

company continued to expand as fast as it could without ever compromising its quality, and that is why it is one of the most enduring luxury brands of our times.

This is a choice successful luxury brands face every day: how to strike the balance between fulfilling their clients' demands and ensuring the quality of their products. The main reason for their success is that quality is not sacrificed in the process.

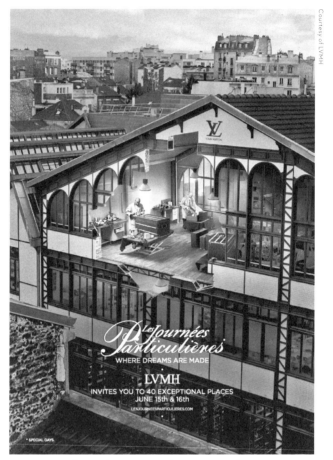

Second LVMH "Journées Particulières," June 15 and 16, 2013.

LEGITIMACY AND HERITAGE

The same way that quality and craftsmanship go hand-in-hand and are integral parts of the luxury experience, the importance of heritage and legitimacy is undeniable.

It's no accident that luxury conglomerate LVMH spent months organizing "Les Journées Particulières," welcoming the

public into what they called in their press release their "heritage sites"—workshops, vineyards, and private mansions. On October 15 and 16, 2011, more than twenty-five sites simultaneiously opened to visitors in France, Italy, Spain, and a few other countries in Europe. The goal was to let visitors experience the heritage of their *maisons* and the deep, historical dedication to excellence and craftsmanship of each of the group's luxury brands.[11] It was such a success that the program was reprised and expanded to forty sites on June 15 and 16, 2013.[12]

The Louis Vuitton Company has been focusing on its heritage since its founding in 1854. Louis Vuitton is undoubtedly one of the most iconic luxury brands today.[13] I have been told that some tourists walk into the New York flagship store asking if they could meet Mr. Louis Vuitton himself! So, while the name is well known, there is a lack of understanding among the general public of the company's history and what the name Louis Vuitton stands for. Everyone knows the Louis Vuitton Speedy bag, but few people know that the company originally started out making trunks. The brand's phenomenal success over the last thirty years resulted from an expert balancing act between creativity, accessibility, and legitimacy. Vuitton's creative team embraced artists and their own interpretations of the brand to surprise devotees with their ingenuity. Yet, despite the promotion of Louis Vuitton's originality, the company continues to emphasize its heritage as a *malletier*.

In April 2011, I was in Hong Kong and went to visit the Louis Vuitton store on Canton Road in Kowloon, one of the city's main shopping destinations. At the time, they were featuring a contemporary art exhibit entitled *Art for Baby* with works by Damien Hirst, Takashi Murakami, and others, and during the entire weekend families flocked to see it.

To come back to legitimacy, I was struck by the fact that—at the end of this contemporary art exhibit—viewers were guided through an equally interesting display of antique Louis Vuitton trunks. While heralding today's creativity, Louis Vuitton wanted visitors to understand their heritage.[14]

As brands expand beyond their original competency, they need to take customers by the hand and explain how a new product category is still part of their firm's DNA. Before entering a new category, a brand must be certain that their clients will feel that they have legitimacy expanding into a new segment. For example, when Baccarat launched a jewelry collection, they focused on crystal, which is what the brand is known for. Heritage and the endurance of certain designs are key elements for a true luxury brand; consumers should be able to remember what the brand represents and link it with a specific item, such as the Chanel quilted jacket or Hermès Kelly bag. The quality and craftsmanship of these iconic objects help them remain desirable throughout the generations, which leads to a sense of timelessness. Luxury is different from fashion fads: An item's design and, of course, quality allow consumers to cherish their purchases for years, even generations. This explains why true luxury has an intrinsic value, sometimes greater than the original purchase price. (If you have ever visited the Portero Web site, an American company specializing in pre-owned luxury, you know that Hermès Birkin bags are often auctioned off for higher prices than in Hermès stores, even though they may have been used for a number of years.)[15]

When you are creating your own luxury brand, you must carefully think about its DNA, core competency, and heritage—these things will give your company legitimacy for decades to come. Heritage should never be perceived as an

anchor weighing you down. It is your point of differentiation, what makes your brand unique. You will always be able to move beyond your initial identity.

CREATIVITY AND TALENT

While craftsmanship and heritage are an integral part of a luxury brand, luxury simply cannot exist without creativity and talent. They are the heart and soul of any luxury brand. Creativity is front and center at any fashion show; just think of haute couture presentations where designers unleash their imagination and inspire us to dream. One such creative genius is Joel Arthur Rosenthal.

When one utters the name "JAR," these two essential qualities instantly come to mind. In 1982, when I met JAR's mastermind, Joel Rosenthal, through one of my closest friends, Genevieve Prillaman, like so many others I was in awe of his creativity and talent. It is precisely those rare qualities that have made JAR an international success. Not marketing. Not promotion. Just creativity and talent. Another characteristic of JAR is that Joel and his partner, Pierre Jeannet, have created a sort of "anti-brand." Joel doesn't follow the normal rules and doesn't care about them. The first time I went to visit his store at the Place Vendôme in Paris, I was—not unlike others before and most likely after me— completely lost. There was no sign or display window. I must have passed in front of it a few times before Joel peeped out of the second-floor window and told me where the entrance was.

In the spring of 2002, a major JAR exhibition took place at Somerset House in London, with almost four hundred unique creations on display.[16] Most of those pieces came from private collections—yet another representation of Joel's unique

31

approach to his art. During the exhibition, François Curiel—the chief jewelry specialist at Christie's and a close friend of Joel and Pierre's for more than thirty years—explained how they "revolutionized jewelry design in the twentieth century and set new standards for future generations" through their "sensational and yet wearable" creations.[17]

When Joel launched his first fragrance, Golconda, it didn't come with the usual fanfare; he didn't even really want it to be widely known. He most certainly didn't want to do public appearances in order to boost sales. No, he just wished to share his inspiration of a fragrance with friends. That it became an overnight sensation goes without saying, and his JAR counter at Bergdorf Goodman (one of the two locations in the world authorized to carry his fragrances) remains one of the most exclusive experiences you can get in the fragrance world.

Many luxury firms' founding designers died long ago. One of the essential exercises great designers do when creating for a brand that doesn't bear their name is to immerse themselves in the company's history: While surprising us with their originality and creativity, they still need to make sure that their creations make sense for their company and could not be mistaken for those of any other brand. There's a little sketch from 1991 that Karl Lagerfeld did of himself that I love, from when he became the creative force behind the house of Chanel in 1983.[18] In it, he portrays himself thinking of the iconic symbols that distinguish Chanel from any other brand, from the camellia form and two-toned shoes to quilted handbags. By embracing and absorbing the heritage of the brand since he became its creative force, Karl Lagerfeld was able to channel his creative genius and craft collections true to the *maison*'s DNA, ensuring its success. That challenge awaits

any designer taking over the direction of a historical fashion house. It was fascinating to learn how Alexander Wang, who became Balenciaga's creative director in November 2012, stressed how he integrated "the codes and the DNA of the house" in his first collection for the company.[19]

Even once you are fully imbued with a brand's essence, a number of challenges lie ahead: For each luxury product you see on a shelf, innumerable designs are discarded. For every It bag, countless purses will be snubbed by consumers. Behind most successful luxury brands there's a little army of talented designers working under the direction of a head designer who is always sketching, drawing, and researching. This is how brands renew themselves—with the energy and dynamism that comes with creativity. And creativity does not necessarily have to imply expense. The path that H&M has been following for years—inviting designers to create capsule collections for their fans—has proved a huge success while offering an innovating example of "fast fashion." (Fast fashion could be considered the fashion equivalent to fast food: affordable clothes that hit the stores at a rapid pace and reflect the latest trends.)

THE ART OF STORYTELLING

According to Forrester Research, Inc., a leading market research firm, brands that deliver emotionally charged stories with their products capture 60 percent greater customer loyalty.[20] Making us dream bigger is an intrinsic part of any successful luxury product's life.

For me, there was no better storyteller than Jean-Louis Dumas of Hermès. He would always explain the company's

creations with stories and images that triggered the imagination. He practically transported people to another universe when he would talk about scarves or any other Hermès product. He would not delve into technical details; instead, he would discuss the stories conveyed in designers' sketches and share artists' anecdotes, making every little element come to life. When the New York–based Hermès team (including myself) was preparing for the exhibit *Scarf Dance* in 1995, held at the National Academy of Design in New York, Jean-Louis came to explain his vision: Guests would first enter the building and go through a small dark box, giving them a feeling of being inside a cocoon (where the scarves' silk comes from). Then, they would walk through various rooms, each representing an aspect of the creative process, ending the journey in a large workshop, where craftsmen were weaving scarves on looms and screens. Visitors were marveled by all the different steps that go into each scarf. Everyone exited with stars in their eyes and a new appreciation for Hermès scarves!

Another example of the art of storytelling is the whimsical 2010 Chanel No. 5 commercial, "Train de Nuit." It features the French actress Audrey Tautou on the Orient Express to Istanbul, transporting viewers to a glamorous past that might have only existed in their fantasies. The video depicts a timeless story of seduction, mystery, and sensuality, with Tautou meeting a handsome stranger on the train. He briefly lingers outside her cabin but they do not speak; their sleepless nights on the train spent musing about the other. By chance, she sees his image on a passing boat and the viewer is left wondering if fate will ever bring them back together again, if a true love story will emerge from their glances. Stories like this

one provoke us to dream, extract us from our daily routines, and make our hearts beat faster. This is exactly what the luxury industry needs: storytelling that renews our fantasies and reminds us of our aspirations.

Whether it's Audrey Tautou for Chanel No. 5 or Charlize Theron for Dior's J'Adore campaign, every woman hopes to be loved and find love, and that is the eternal message these brands are communicating. This is what every luxury brand must do; in addition to having their own history, they need to engage in storytelling. By doing so they rekindle the romance with customers, prolong inspirations, and get people out of their daily worries—like a good book.

That is what makes luxury what it is: It brings a smile to your face, fills your mind with dreams and your heart with happiness. Any successful luxury brand needs to play and master every step of this process, all the while making it seem effortless and natural.

Luxury: The Magic Ingredients

Now that we have defined true luxury, what are the Magic Ingredients needed to create a luxury brand? We are going to discover them one-by-one, through concrete examples and short stories that will help make the theoretical concepts come to life. As I already mentioned, I believe that the best way to learn and understand is through real-life experience, and this is the closest we'll come to that in a book!

The Luxury Alchemist

1

PASSION

As explained earlier, if I had to name the single most important ingredient to create a luxury brand, I would have to say passion. My belief is that no luxury brand can be created without it. Ah, passion! We all have a separate vision or understanding of it, and hopefully each of us has felt it and knows what it means deep down. The passion I refer to when speaking about creating a luxury brand is the same kind that makes you forget how many hours went into crafting a beautiful *objet d'art*—the kind that makes you happy to go to work every day, that frees you from a sense of obligation. All creative types must have it, but it is rarer among business leaders. Some individuals are the complete package, being both creative and adept business leaders. One such individual was Jean-Louis Dumas, the former CEO of Hermès and president of the Comité Colbert from 1988 to 1991.

I will never forget the first time I met Jean-Louis. It was in 1988 and he had come to New York for a press conference at the Cooper Hewitt Museum to announce the future exhibition (it opened in 1989) that the Comité Colbert was sponsoring called *L'Art de Vivre: Decorative Arts and Design in France, 1789–1989*. I had been working with the Comité Colbert for a few months, and specifically with Valérie Hermann, who was then in charge of Special Projects at the Comité Colbert in Paris. Incidentally, Valérie went on to have a brilliant career in the luxury field, and is now the CEO of Reed Krakoff after being at the helm of Yves Saint Laurent. She wanted me to

have the opportunity to spend some one-on-one time with Jean-Louis. We were supposed to have a brief meeting, but his schedule became too tight and it was decided that I would accompany him in the car to his next appointment, which should have given us fifteen minutes. It turned out that we got stuck in traffic and spent one hour together—and that hour changed my life.

You have to understand that Jean-Louis Dumas was (and remained) the icon everyone in the luxury field idolized. I was petrified by the idea of saying the wrong thing, but Jean-Louis had the talent of making everyone around him feel at ease. Within minutes, I had forgotten how nervous I was and felt as if I had known him all my life. While I do not remember all the details of our conversation during the long ride, I remember his sense of passion. Passion emanated from him as he was describing his vision for the Comité Colbert in the United States. One of his goals was developing educational programs for children so that they could one day cultivate an understanding for true craftsmanship—which came to life with "Les Journées des Artisans" previously mentioned. Jean-Louis's passion for his *maison* transcended his work as the firm's CEO, and he did everything with panache, charm, and heart.

Jean-Louis's appreciation for beauty, creativity, and perfection guided him in all his decisions. He introduced vibrant colors to the traditional world of ties, making the category one of Hermès's fastest growing in the mid-1980s. He also launched the Birkin bag in 1984, and asked Jean-Paul Gaultier, the *enfant terrible* of the fashion world, to become the creative director for the women's ready-to-wear line in 2003. He initiated Hermès's annual themes and sought

out craftsmen from African or Indian villages, giving them the opportunity to use Hermès materials to create one-of-kind pieces. In 1999, we were developing ideas for what the Comité Colbert could do in New York to celebrate its tenth anniversary in the United States and settled on the concept of creating the Villa Colbert, a modern vision of a French château, where each room would act as the home of a Comité company member. We selected Vanderbilt Hall in Grand Central Station as the ideal venue.

Jean-Louis had never been there before our visit; after assessing the proportions and discussing how the space could be occupied, he wanted to sit down and continue our conversation. All the tables and chairs were occupied except for one small table where a lady was finishing a tea. Jean-Louis asked if she didn't mind if we sat at her table. (She had no idea who he was, even though a man came by a few minutes later asking him if he was the CEO of Hermès. At the time Jean-Louis was featured in an American Express advertisement on TV.) Without a word, he took out a small painting set and created an enchanting vision of what the hall would look like once transformed for the Comité. As he finished, he turned to me and said, "Beauty is everywhere, never forget to take the time to love it" and gave me his sketch. That's what passion is: always seeing the beauty around you. Trust me, if you had seen the hall that day, it was not at its best; you would have needed Jean-Louis's incredible imagination to see its beauty. That's what you need to create a true luxury brand—the passion to see beauty. Passion that you can use to transform an item into an *objet*, and that it is worth fighting for.

The crucial aspect of having passion is knowing how to communicate that passion and how to instill it in those

around you. Any thriving entrepreneur will tell you that a success story's biggest asset is its team. As a founder, you might have a great idea or a unique skill or talent, but it's essential to quickly recognize your strengths and weaknesses. No prosperous company is a one-man or one-woman show: You need to have a team, and a great one at that. You need to learn how to pick the right talent, nurture it, retain it, and trust it so you can delegate responsibilities and expand. When you have an established company, you need to find the right leader and entrust that person with the reins so that the firm can grow. That person needs to know how to find the best talent and share his or her passion with the team and—when the time comes—how to pass the baton of leadership on to the next person. We saw how Jean-Louis Dumas mastered the art of sharing his passion with his team at Hermès. He handpicked from among his captains the first non-family member in the company's history to take over after him, Patrick Thomas.

Another leader who shared his passion with brio, humor, charm, and, of course, intelligence is Arie L. Kopelman, who led Chanel in the United States for twenty years until he retired and Maureen Chiquet took over in 2005.

After receiving an MBA from Columbia Business School, Arie began his career at Procter and Gamble. He then moved to the advertising firm of Doyle, Dane, and Bernbach, where he remained as Vice-Chairman until he took the reigns of Chanel USA in 1986.[21] His profile was quite a change from that of a typical senior executive in the luxury field. (Robert Polet's 2004 nomination as head of the Gucci Group caused a stir, as journalists wondered how his previous role as president of Unilever's global ice cream and frozen foods division could

have prepared him for his new functions.)[22] Most luxury brands' leaders were actually sons and daughters of the firms' founders and owners. They first had to work for many years in the family business and would only take leadership after a trial by fire, but part of Chanel's DNA is about breaking the rules. In the 1930s, Coco Chanel created a dress out of jersey, a fabric that was at the time only used for men's underwear. She loved it because it moved easily and let the wearer feel free, and she wasn't afraid of disrupting perceptions and traditions. Chanel carries on Mademoiselle Chanel's spirit; it is, and will always remain, a "modern brand, constantly moving forward."[23] Even when picking its leader, the company does not follow the conventional route.

From his very first day, Arie was perfectly in tune with Chanel's culture, spirit, and savoir faire. His intelligence and business savvy were only matched by his innate gift for finding talent and retaining the best executives, such as Bruno Pavlovsky who came on board in 1990 as Global President of Fashion, or Barbara Cirkva, who joined the company in 1986 and continues to increase the U.S. fashion business in 2013 as Division President, Fashion, Watches, and Fine Jewelry.[24] Arie was never afraid to surround himself with smart people, loved being challenged, and trusted his colleagues to help the business grow. Maureen Chiquet has brilliantly continued this tradition of bringing new talent on board, including John Galantic, who joined in November 2006 as U.S. President and COO. Chanel continues to attract (and retain!) gifted executives to ensure its enduring success.

This is, of course, the best way to lead, but not everyone has the ability and confidence to actually do it. No luxury brand will flourish without talent at all levels. The Chanel brand

is so powerful that one could think it transcends the people who run it, but that is a mistake Chanel has never made. Talent breeds talent, but harmony is also necessary to your brand's success. Yes, disagreement is good and brings new ideas, as long as it doesn't turn into petty fights or escalating conflicts. If employees aren't happy, sooner or later they will leave. Sourcing talent is as difficult as creating a brand, because talent is what keeps a company alive and makes it flourish. Each firm has a soul, and that soul needs to be nurtured by its people. An unhappy company is an unsuccessful company. As a leader, your teams will be motivated if they can feel your passion, if they are infused with the same commitment and dedication you have.

Passion is the one true Philosopher's Stone. It's not something you can learn in a book or a classroom; you either have it or you don't. It's the fire that burns within you, that keeps you working long hours without realizing that time has passed. It is the drive that will help you continue to fight when everyone else is ready to quit, that will give you the last boost to pass the finish line. Passion is what turns mere mortals into magicians. This is the type of obsession that brings success. Jean-Louis Dumas helped Hermès grow from $50 million in annual revenue when he took over in 1978 to $500 million in the early 1990s. It was because of him that Hermès transformed into the $3.2 billion global powerhouse it was in 2010, the year he passed away (Jean-Louis retired in 2006). With these kinds of results, even businesspeople can understand the power of passion.

2

VISION

One of the most fundamental qualities for any luxury brand leader is strategic thinking. It's true for any brand, but people sometimes forget that behind a successful luxury firm there is a lot more than just a handbag or a car. To keep the dream alive you must evolve. You can't stay stagnant and just enjoy your current business model; you must look ahead and be open to taking risks—albeit carefully calculated risks. That is what the fabled winemaker Château Lafite Rothschild did almost thirty years ago.

Winemaking is one of the most traditional segments in the luxury industry. It has been in existence since the dawn of time and has grown exponentially in the last few decades. Château Lafite Rothschild anticipated that the world would change as a result of globalization. Increased travel and an opening up of frontiers, new ideas, tastes, and markets brought about more opportunities for their company. They had the courage to invest in markets that most companies believed to be losing propositions at the time. Following in the footsteps of Pierre Cardin, whom we'll discuss later on, they first entered the Hong Kong and then Chinese market before any of their other *grand cru* competitors (*grand cru* is a wine classification for vineyards known for their reputation for producing the highest quality wines).

Going, going, gone. When three bottles of Château Lafite Rothschild 1869 wine were purchased for $232,692 each at an auction in Hong Kong on October 29, 2010,[25] they became

the world's most expensive bottles of wine ever sold. As the hammer went down, collectors and merchants alike were left gasping. This astronomical record price—while unexpected in its magnitude—was the result of a shrewd long-term plan and wise strategy on the part of the Domaines Barons de Rothschild (Lafite). They were willing to invest in what seemed a risky proposition at the time (the late 1980s), and are now reaping the fruits of their labor.

Even non-oenophiles know the name of Lafite Rothschild, which has been synonymous with exceptional quality for generations. The estate, located northwest of Bordeaux, France, takes its name from its original thirteenth-century owner, Gombaud de Lafite. Most of the vineyard was planted in 1680 and later purchased by Baron James Rothschild in 1868. It has remained in the family ever since, under the direction of Baron Eric de Rothschild since 1974. The vineyard is one of the largest in France's Medoc region, producing around 35,000 cases ever year. While around fifteen thousand to 25,000 are considered first growth, the rest are sold as a second growth under the label Carruades de Lafite.[26] Lafite is a "first growth," a classification created by the French government in 1855 during that year's Exposition Universelle de Paris. At that time, four châteaux—Lafite, Latour, Haut Brion, and Margaux—were classified as first growth, with Château Mouton joining the illustrious *appellation* in 1973. The French government's strict regulation of *grand cru* wine production makes it impossible for these great châteaux to increase their output. The good news for wine aficionados is that Bordeaux winemakers have almost no other option than to focus on quality rather than quantity.

Until the 1970s, wine connoisseurs were part of a small gentlemen's club that really understood wine. Their

language was a code filled with obscure expressions about grape color, intensity, fragrant subtlety, *fruité* wines' evolution, and smoothness of texture. In a way, it was a mysterious cipher for the uninitiated until Robert Parker came along in the 1970s and revolutionized the way wines were rated by creating a 100-point system. Obviously, the closer a wine gets to 100, the better it is; even a neophyte could understand that. It opened doors to a whole new world for timid wine novices, who could suddenly walk into any wine store or restaurant and feel confident about their choices. No longer were sommeliers able to look down on them. Thanks to the Internet, online research in that vein is now empowering a new generation luxury-lovers to enter an established firm and not feel that they will be mocked.

In the last decade, the appetite for Lafite Rothschild wine has exploded in China, having become one of the most sought-after symbols of fine taste and boasting a legion of followers. This phenomenon is fairly recent; until the 1990s, the alcoholic beverage of choice of the upper class in Hong Kong was cognac, now considered passé.[27] (Cognac is still strong in China, though, and it will be interesting to see if its popularity recedes as it did in Hong Kong.)[28] Because dinners are an important part of business etiquette there, *grands crus* quickly became a sign of sophistication for successful Chinese entrepreneurs. "It would be wrong to say wines are not drunk for pleasure, but these wines are usually drunk as part of the business process," says Nick Pegna, the managing director of the British merchant Berry Bros. & Rudd's Hong Kong branch.[29] And Lafite Rothschild has been by far the most requested by the Chinese über-rich. Chinese leaders pick it as their wine of choice because everyone knows its value. If a senior

government official needs to entertain, he knows that many of his guests would be familiar with Lafite Rothschild and they would feel honored to be served the esteemed wine; with other first growths, there is a chance that not every guest would recognize them. Increasingly, the average Chinese consumer has also become more knowledgeable about the wine industry and better understands alternatives among other expensive wines. Because of this, demand for other *grands crus* will continue to increase, and Château Lafite Rothschild might lose some of its competitive advantage. They will have effectively paved the way for increased demand for all fine wines.

Many reasons have been presented for Lafite Rothschild's current supremacy. Obviously, the quality of all *grands crus* is undisputable, so how can you explain the special fascination with this specific château, particularly in China? Some say that Château Lafite Rothschild is the best suited for the Chinese palate, that it is the most silky and round. Also, according to the wine columnist Will Lyons in a 2010 *Wall Street Journal* article, "Lafite is more elegance than power."[30]

Another reason that has been evoked for Lafite's success in China is the name itself: "The real problem is that for most of us Chinese, we cannot pronounce the names, but Lafite— La Fee (two Chinese characters)—is easy to pronounce. As a result, Lafite has become the most famous," explained David Chu, one of Hong Kong's wealthiest men, in a 1997 interview with the *South China Morning Post*.[31] With all the reasons I mentioned so far, personally I would agree with Robert Shum on the primary reason for Château Lafite Rothschild's success. Shum is the founder of Aussino, one of the largest chains of wine shops and bars in China. For him, the main reason for Lafite's current supremacy is that it was the first *grand cru*

to enter the Chinese market in the late 1980s, through Remy Fine Wines of Hong Kong.[32] This is precisely what I mean by having a long-term vision, understanding trends, and being willing to take risks.

In the 1980s Japan was the main focus for luxury product expansion, including wine. China was not on many executives' radars, yet Château Lafite Rothschild took the risk and subsequently was the first to enter the mainland market. It helped that Lafite was already an acclaimed wine coveted by wealthy oenophiles in Europe and the United States, but the winemaker invested time and energy in a budding market, and had the patience to wait over ten years for the first significant results. They had the long-term vision to realize this particular market's opportunity way before any of their peers felt it was a risk worth taking. This is the kind of patience needed in the luxury field. Investments do not bring immediate returns, and you must have the patience and financial solidity to wait and see your strategy bear its fruit.

Today, the château's biggest challenge isn't really its competition, but rather its own success. As far as rare vintage wines go, the Chinese actually consume them as opposed to stockpiling them, as many counterparts in other regions of the world do. As a result, there is an increasing shortage of Lafite's older vintages seeing as it's impossible for the wine to come back onto the market. The increased demand due to newly accumulated wealth in China keeps pushing prices higher. Given its recognition and current scarcity, counterfeiting is on the rise. According to the *China Telegraph* in its January 7, 2011 issue, counterfeiters are now purchasing empty Lafite Rothschild bottles and replenishing them with second-grade wines in order to rip off rich Chinese consumers. "A particular

favorite is Château Lafite Rothschild 1982, which sells for over £2,000 an intact bottle at auction." Some analysts estimate that 70 percent of the wine labeled as Lafite that is consumed in China is fake.[33] This is the price of success for the ultimate status symbol for China's big-league rich, who are the driving force behind the unstoppable rise in fine French wines. Lafite is, and will remain, in a class by itself. For example, 2000 Lafite wines have appreciated by more than 500 percent since 2005, compared to 180 percent for the overall *grand cru* market.[34]

In addition to their classic quality appreciated by expert connoisseurs, Lafite has also managed to expand its brand recognition to a wider audience. The Château Lafite Rothschild Estate has developed other labels and wines—including Château l'Evangile for Pomerol and Château Rieussec for Sauternes—and has managed to do it "without brand name dilution."[35] This product portfolio expansion is actually rooted in one of the Château's traditions: For many years, Baron de Rothschild created wines that were more appropriate for daily consumption, such as the Reserves des Barons, originally made only for close friends and family. To continue this tradition, the Château decided to make them available to a wider audience and created the "Collection" with the intent to develop wines that can be enjoyed regularly and more immediately than its more esteemed "brothers."

In 2010, Château Lafite Rothschild decided to go even further in the expansion of its product offerings and entered into a partnership with CITIC, China's leading state-run investment company. Together, they envisioned creating a new vineyard in the wine region of Penglai in the Shandong province, an area said to be China's Bordeaux. The vineyard is being planted with the goal of producing a "Chinese *grand cru*" to

quench some of the mainland thirst for Lafite. In addition to this partnership, the winemaker further celebrated its mutual love affair with China by announcing that its 2008 vintage of Château Lafite Rothschild would bear the Chinese symbol for the figure eight on the bottle. A spokesperson for Lafite Rothschild commented that the "shape of the symbol seems to offer a perfect representation of the slopes of the vineyard and commemorates the launch of our Chinese wine project."[36] But let us not forget that eight is considered a very auspicious number in Chinese. The word for the number eight sounds similar to the word meaning "prosper" or "wealth." In some regional dialects the word is similar to "fortune" (in Cantonese, for example). You may also remember that the opening ceremony for the Summer Olympics in Beijing began on 8/8/08 at eight seconds and eight minutes past 8 p.m. Lafite has not only embraced, but also reciprocated China's culture and its love for its products, recognizing the importance of its growing appetite for its wines.

The fine wine trend that Lafite Rothschild began will not recede any time soon. The desire to belong to a special club of the very sophisticated—a necessity for the Chinese elite—has now reached the mainstream. Wine lovers who live in Beijing can now take off for a weekend in Miyun and visit the Château Changyu, built in 2006. The property boasts a wine museum and a vast cellar, located in a castle where wine is served directly from oak barrels imported from France. The Medieval-looking structure has become a favorite spot for young brides who might not yet be able to afford Lafite, but will soon have the opportunity to taste its Penglai *cru*.

When launching your own luxury brand, you'll need to have a vision, set multiple goals, and develop a five-year

strategy (that you must be willing re-adjust regularly). You need to be flexible enough to realize that your plans might have to be totally changed to ensure that your brand's overall vision stays on course. You don't necessarily have to predict which market will be hot thirty years from now, but you will have to make sure that your company answers a demand, and that you will continue focusing on the growth opportunities that the market offers you.

3

CRAFT AND TALENT

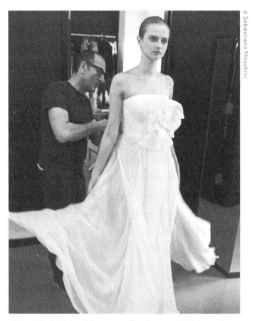

Gilles Mendel behind the scenes of his Spring 2010 fashion show.

"Young designers need to understand the importance of craftsmanship. Talent might be the essential building block for success, but you need to learn your craft to transform fabric into a whimsical dress, and you need a vision to transform a collection into a brand."

GILLES MENDEL
creative director and CEO of J. Mendel

When you meet students from the prestigious Parsons The New School for Design, their eyes are filled with dreams of glory and success. They're hoping to follow in the footsteps of the school's illustrious alumni, such as Marc Jacobs or Donna Karan. They are all young and talented, but the unfortunate reality is that very few of them will actually succeed in creating a unique style or look that will distinguish them from other talented designers. To achieve this goal, you need to channel your talent and master your craft, and that is something that Gilles Mendel certainly has accomplished.

When you mention J. Mendel, everyone immediately thinks of their exquisitely made furs and striking evening dresses. The company keeps expanding in more categories as the recognition of Gilles Mendel's immense talent continues to disseminate. After being inducted into the CFDA in 2003,[37] he received the prestigious National Design Award from the Cooper-Hewitt National Design Museum in October 2011. The dresses he designed for Taylor Swift (2011 and 2013) and Claire Danes (2012) for the Met Gala were all heralded by the media as the most beautiful gowns of the night. So how does Gilles do it? Where does his unparalleled talent come from?

Well, it started a few years ago. Gilles grew up in a family where fur and fashion were part of everyday life; his family had been in the fur business for generations.[38] From his father, who taught him his *métier*, to his elegant mother, who loved fashion and was close to designers the likes of Bernard Perris and Azzedine Alaïa, he was constantly surrounded by beauty, craft, and luxury.

Despite his upbringing, Gilles never thought he would become a creator and designer. He did intend to work for the family company, however, so he decided to go to

business school. He wanted to know how to expand the business beyond the family's one store, located on Paris's Rue Saint-Honoré. He apprenticed with his father and mastered the trade the way the previous four generations did—by working long hours, learning how to select the best skins, cutting, and sewing. But even as a teenager, Gilles wished to go further than what he had been taught; he wanted to "fly with his own wings" (from the French expression, *voler de ses propres ailes*). He saw the magic in the work. Gilles still remembers how, as a child, he would watch his mother put on a fur, and how this simple act transformed her. She would get up on her tiptoes and walk around feeling and looking equally glamorous and happy. For him, any woman wearing fur is transformed; she has a different attitude and feels beautiful and attractive. This power of transformation has been at the core of Gilles's creativity. The same way that fur transforms women, he transformed the world of *fourrure*; from there he went on to unleash his creativity on eveningwear, then ready-to-wear, and, most recently, accessories.

Fur was sacred in Gilles's world, pieces shown in their most striking simplicity, but he was yearning for a different way to present them. He wanted to experiment with different techniques, to push the envelope and be irreverent. He was not afraid to experiment with his craft and he had a relentless work ethic. Coupled with his hard work and tenacity, his indomitable talent led him to revolutionize the treatment of fur by interpreting it like fabric, which no one had done before.

Given his desire to change the family business, France was just too conventional for his new ideas. Gilles needed a country open to change and iconoclasts, so he saw no choice but to go to New York in the early 1980s. He quickly recognized that

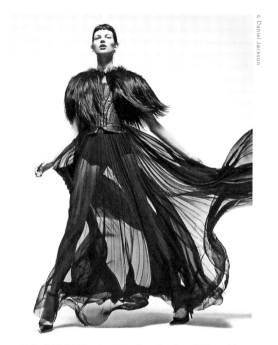

J. Mendel Fall 2012 advertising; Bette Franke at DNA models.

his dreams were quite ambitious, even by his standards. After visiting several locations on Madison Avenue for the perfect storefront, he realized that they were all out of his budget. He could not believe that he might be forced to return to Paris defeated. Instead of doing that, he redoubled his efforts to conquer the New World. Through an acquaintance of his father's, he arranged to take his sketches to Elizabeth Arden's salon.[39] Elizabeth Arden had built a cosmetics empire in the Unites States in the 1930s, and her beauty salon on Fifth Avenue continued to attract the most sophisticated ladies of New York society after her death in 1966. It was there that Gilles met Joe Ronchetti, then President at Arden, and Jerry Solovei, the company's Retail Fashion Director and

General Manager, who immediately recognized the young creator's incredible talent and offered him space in the salon. Thanks to this opportunity, Gilles met the women who made or broke designers during the 1980s, and he was the immediate *coqueluche de ces dames*, the It designer. From Betsy Bloomingdale to Liza Minnelli and Nancy Reagan, Gilles's creations adorned the most in-vogue ladies of the time. They understood his sensibilities and recognized the amazing talent that allowed him to manipulate fur as if it were just a simple fabric.

As Gilles continued to work fur into new and innovative patterns, it became obvious to him what new challenge was ahead of him: transforming fabric into artwork. One night, he was setting up a display window at his Madison Avenue store (he had managed to make it onto Madison Avenue by then). It was during springtime, and he knew that women weren't thinking about fur with the warmer temperatures. Wanting to highlight a smaller fur that could be worn in warmer weather, he came up with a little dress to place underneath it on a mannequin. The next day, three women entered the boutique asking to purchase the dress. That was the beginning of a new phase for the company, the first step of the firm's transformation into a real luxury brand.[40] Gilles's greatest satisfaction was the immediate acceptance of his 2003 ready-to-wear line, the moment when he finally took the plunge.

His ready-to-wear collection started with the same thought process applied to his reinvention of fur: craftsmanship, transformation, lightness, transparency, mixing of fabrics, high and low elements, artistry, sophistication, and modernity. For Gilles, fashion allowed him to enter a season-free world of beauty. He combined the principles of the 1920s and 1930s,

as executed by the couture great Madame Grès, with his own vision in order to create a "modern heirloom"—a unique piece, whether fur or fashion, that is both modern and vintage.[41] His goal was to make women feel beautiful and sensual, no matter the medium.

Today Gilles Mendel carries out his vision in every single detail of his creations. For him, J. Mendel is about effortless chic as embodied by his original muses, 1970s icons Jane Birkin and Charlotte Rampling. They represent agelessness, sophistication, independence, and confidence. Whether in her early twenties or late sixties, the J. Mendel woman appreciates and understands craftsmanship, which Gilles delivers. His New York atelier is an idiosyncrasy in today's world of fast fashion. His creations are not just about design; they incorporate a savoir faire that only experience can provide. For his first ready-to-wear collection, Gilles had Madame Colette, Yves Saint Laurent's couture director, flown to New York from Paris so that she could critique his work. With her encouragement, Gilles put on his first fashion show, which was widely praised by the media and clients alike. The designer community immediately recognized him as not only one of their own, but one of their best and most talented.

Like most companies, expansion has its challenges, and J. Mendel also faced inevitable growing pains. From outgrowing your flagship store, controlling your image, and entering new markets to attracting new clients, expanding product offerings, and creating an e-commerce platform, all of these issues require attention while still running a day-to-day business, and you can't put them on pause. Everything looks easy on paper, but it's not so simple to execute. Finding the ideal location on Madison Avenue is already a challenge in itself,

but being the lucky tenant is also a battle because the few available appealing spaces are in high demand. Deciding to launch an e-commerce site is an important decision as well, but finding your own voice is another story. Ensuring that you have the right platform, a suitable back end, an inventory system, as well as selecting the appropriate merchandise and the right people to handle this new process are all tasks to master. As J. Mendel continues to expand, the good news is that Gilles's reputation as a designer and the force behind his brand is stronger than ever. Nowadays no red carpet event is complete without a J. Mendel gown, and every young woman dreams of wearing one!

In the fall of 2012, the company took a major step to enter the world of accessories. Gilles, his creative team, and his financial partners, The Gores Group, developed a five-year growth plan with accessories as the first building block—a *must* for any successful luxury fashion brand. When you decide to create an accessory line, you need to make sure that it's consistent with every single aspect of your brand's DNA. In order to do so, it's imperative to really understand what your company stands for. Of course, Gilles and his team knew what a J. Mendel creation represents, but how do you communicate it to your clients? Even trickier, how do you share it with potential customers, people who only have a vague understanding of who you are and what you represent?

As mentioned in the beginning of this chapter, most people who know J. Mendel automatically think of fur. That's a good start because it's a true differentiator, but how do you go beyond the obvious? How do you translate the creator's talent and vision into a new product? For Gilles, fur is about lightness, which is not the first thing that comes to mind when doing

word associations. To help figure it out, the company asked Laird + Partners—a leading New York–based creative agency specializing in luxury branding—to work on the company's brand book. J. Mendel's leaders wanted the new branding to highlight the company's essence, so that each detail of the first bag collection (and other future creations in different categories) would be consistent with the rest. From a purse's feet to its lining, every detail must reflect the

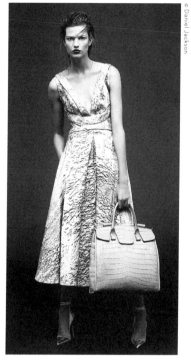

J. Mendel Spring 2013 advertising; Bette Franke at DNA models.

fundamental elements that make J. Mendel Paris different from all other brands: transparency and lightness, luxury and craftsmanship. In the same way that Gilles managed to combine these qualities in his clothing, he also did it for the first (and subsequent) bag collections—from the Kylie bag's transparent Lucite clasp and the Midi Bugatti's silver fox highlights to the Matin Tote's intricate work of mixed exotic skins, the J. Mendel bags incorporate the *maison* "codes" and are already bestsellers!

To this day, Gilles continues to refer back to his craft, which is what roots the brand and its history. He always begins his

work on a mannequin (never on a flat surface), and creates his dresses as if they were sculptures. This is the reason why his garments are so flattering on women's bodies. Gilles's motto, "never compromise," is apparent in everything he touches! To maintain a successful luxury venture you must always maintain the highest standards and stay true to your DNA. And Gilles has! Through his talent and savoir faire, Gilles's gowns have enhanced the beauty of countless modern-day goddesses, from Natalie Portman to Taylor Swift to Angelina Jolie.[42]

Gilles's limitless talent, knowledge of his craft, and business acumen are a rare combination. You most likely will not find (or not be) such a creative genius, but you can still establish your own luxury brand and be successful. You'll need to know how to surround yourself with the right talent, nurture it, and help it blossom. Few designers also possess good business judgment, which is the reason why many creative types also have a business partner, as Yves Saint Laurent and Pierre Bergé do. If you are a gifted creator, the biggest challenge is knowing how to find the right business partner and mentor. That person needs to believe in you, even when you have doubts. Sometimes they will not follow every idea you have because they might not be good business decisions. Talent and craft will be the base of your successful brand, but great management, strong leadership, and a resourceful team are all indispensable. In order to find the correct partners, you need to be open to different ways of thinking and recognize good chemistry. Then you grab the opportunity when it appears and run with it!

4

SEIZE OPPORTUNITIES

"Life is full of opportunities, and it is all about [. . .] taking advantage of these opportunities and making something out of them."

REEM ACRA
fashion designer[43]

As we have seen with Château Lafite Rothschild, a successful luxury brand must be willing to challenge itself, reinvent itself, and be open to different ideas, even if they're centuries-old. It means embracing change, even—and maybe especially—when business is good. It's very easy to become complacent and assume that because you have done things right so far business will continue to thrive. You must also make sure that new challenges will help your company grow in the right direction while staying true to its origins. You must be willing to seize new opportunities, but with insight. That's what Reem Acra has done with brio!

The first thing that strikes you when you meet Reem Acra is her smile—it's the kindest, softest smile you will ever see. You may then notice her eyes, which communicate a sense of curiosity without being intrusive. It becomes instantly apparent that there is a lot more to Reem than appears.

Reem was born and raised in Lebanon in the 1960s and 1970s, a time when Beirut was called the Paris of the Middle East and movie stars the likes of Brigitte Bardot would vacation there. Back then the city was all about glamour,

beautiful women, enchanting evenings, grand soirees, and stunning dresses. It was also a time when sophisticated women had their gowns and frocks made by private seamstresses; they would have never thought of purchasing dresses in a store—that would imply that the garments were not created just for them. Despite the fact that Christian Dior and Coco Chanel had changed people's notions of fashion as early as the 1950s and the cult of brands had already begun, many elegant people still considered buying ready-to-wear as "*déchéance*" (humiliating degradation).

Reem developed her understanding and knowledge of textiles after years of observing and learning from her mother. As a child, she would accompany her mother to the market in Beirut to select fabrics for their tailor. She saw, felt, touched, and worked with more rich and sumptuous fabrics as a child of ten than most designers do in their entire careers. During her childhood and adolescence, she developed her taste for luxurious and lush fabrics, embroidery, elaborate textures, and rich colors—all characteristic of Middle Eastern opulence. It seemed completely normal to Reem that a woman would have a dress designed and made for just one special occasion. That was her culture.

As a teenager, she wasn't aware of her unique talent and thought that everyone made their own gowns. She had even transformed some of her mother's old clothes into beautiful new garments—the first sparks of a lifelong passion for vintage clothing—and she continues to collect antique dresses from the 1920s. At ten years old, Reem was already a skilled dress designer. Her mother decided to trust her with money so that she could learn how to spend it wisely and purchase the best quality fabrics. She quickly learned how to acquire the most for her cash.

In addition to learning beside her mother, Reem appren-ticed with a number of other masters through her adolescence: her grandmother, who taught her how to fashion artistic flow-ers with scraps of fabric; her father, a scientist, who instilled in her a love for intellectual curiosity and a strict work ethic; the live-in seamstress, who taught her how to sew, cut, drape, and create unique dresses for each party she attended; and her art teachers, who taught her how to draw and sketch. Reem ab-sorbed it all, accumulating the tools that would one day allow her to transform her passion for beauty into a luxury brand.

By the 1980s, when she attended the American University in Beirut to study business, she had accumulated a wardrobe fit for a princess. When her friends convinced her to do a fashion show, she was able to pull it off in less than two weeks. By the day of the show she knew for certain that she wanted to be a fashion designer, but she was also aware that she had a lot to learn. So Reem went to the Fashion Institute of Technology in New York, determined to take full advantage of the opportunity and work as hard as she could. While attending classes there she won award upon award, but the one she cherished the most was the chance to study in Paris at the esteemed ESMOD (l'École Supérieure des Arts et techniques de la Mode). According to Reem, "the French taught me how to think and to think and to rethink, and the Americans taught me how to be ambitious and go and get it—two ways of thinking."[44]

After finishing university, Reem felt she still needed to learn more to fully understand the fashion industry, so she accepted a position as a product designer in a large firm. A dear friend then asked Reem to design a dress for her wed-ding, to be held at Paris's Hôtel de Crillon. Reem's dress was

an absolute triumph; everyone in the room admired it. After the wedding—and at the urging of all around her—she decided to sketch a few more wedding dresses. She completed eleven sketches and managed to obtain a meeting with the bridal buyer at Saks Fifth Avenue. Reem expected them to like only one or two of her designs, but they loved them all! When asked if she could deliver thirty dresses in a mere ninety days, she immediately said yes. She knew she could not pass on this once-in-a-lifetime opportunity. The reality was that she didn't have the money to produce the dresses and didn't know where she could have them made, but that didn't matter. She was prepared to not sleep or eat for the next three months to make it happen.

Reem maxed out her credit card buying precious fabrics, but then she had virtually no money left over to actually construct the dresses. While she could have easily created a few dresses by herself, she recognized that she couldn't create a collection of thirty gowns in ninety days all on her own.

Reem found the name of a gentleman in New York's fashion district and knocked on his door. His name was Max Kane, and he had an atelier of eight seamstresses and tailors. She convinced him to take a risk on her and help her cover the costs of making the dresses—after all, she had a solid order from one of the most prestigious retailers in the world. Because she didn't have any money, she offered to share the profits instead of directly paying Max for his work. He agreed. The next three months were among the most nerve-racking (yet exciting) of her career. Reem delivered her full collection to Saks, and her line became an instant success. This all happened in 1997. Less than five years later, in 2001, Reem's company had quintupled in size and she opened her own showroom. Reem continued to

work with Max until he retired later that year, and, as her orders multiplied, the atelier began working exclusively for her.

As her business was expanding, Reem knew it was time to take the next logical step and move her sensuous and glamorous aesthetic beyond wedding dresses. Everyone was telling her that she was a niche brand and that it would be too much of a challenge to go beyond the bridal world, but Reem believed in herself and decided to shoot high. She went to Hollywood.

She traveled to Los Angeles just before the 2003 Oscars and brought her latest creations, with which she quickly seduced her first star, Halle Berry. After that, the red carpet love affair with Reem was ignited, and some of the most glamorous actresses in the world, from Kate Hudson to Angelina Jolie, became addicted to her creations. Reem not only stepped into the eveningwear world, she conquered it—with talent and hard work. By 2003, Reem had opened a flagship store in New York's Upper East Side and had expanded into the ready-to-wear market.

So how did Reem steadily grow, keep her control, and assure that she took the right steps for her company's expansion? One evening in the fall of 2007 Reem came to speak to my MBA students, and her candor was somewhat disheartening to them. No, she does not believe in business plans. Instead, she relies on her greatest assets, which haven't failed her yet: her gut, her talent, and her ambition. Throughout her journey, Reem knew what made her different: her upbringing and what she represents—creativity, passion for beauty, craftsmanship, and vintage aesthetic. She looks to the past to create the future, blending old and new; her Lebanese roots and life in New York. She looks East to create for the West. These are the pillars of the Reem Acra brand. If you scrutinize its advertising you will find

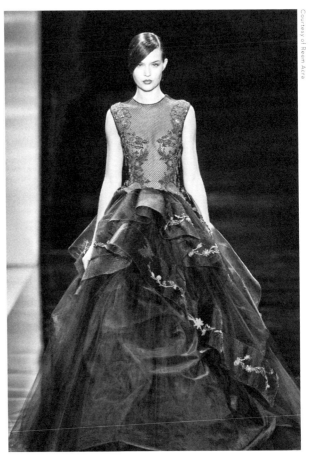

Reem Acra's Fall 2013 RTW collection exemplifies "looking East to create for the West," inspired by her recent travels to Japan and Tights, a collection of photographs by Japanese artist, Daido Moriyama.

all of these signature elements—elements that make Reem Acra unique and distinguish the brand from its competitors.

Reem knows and feels when it's time to take the next step, whether it's opening a new account or starting a ready-to-wear line. In order to do that, she needs to control almost every single detail of production, which means that she cannot grow

too fast. When it's award season, Reem essentially camps out in Los Angeles, ready for her special red carpet clients, all of whom expect perfection from her. When she is asked by a member of a royal family to design a personalized collection, she is also there. Her work is her passion; her company is her life; and she loves every minute of it (which is a good thing because she basically works eighteen hours a day). As Reem puts it, "Loving what I do is a big part of [my success], when you love what you do, you do it well."[45]

Loving what you do is another essential for all entrepreneurs. Having fun, enjoying your work, and being positive to the point that people around you might think you are not in touch with reality are all key components to finding success. If you don't fully believe in your dream, who else will? It goes beyond tenacity, because being an entrepreneur requires the willingness to take risks so that you can achieve your goals. Reem is a real entrepreneur and one of those rare people who incorporate both halves of the brain: the creative side and the business side. As she says, simply and naturally, "I happen to be one of those who can do the art part and can do the business part. I have a good head on my shoulders, but at the same time I work hard. I would not have been able to achieve what I have achieved had I not put in all the hours."[46]

In the fall of 2008, when the financial crisis was wreaking havoc across the globe, Reem knew that luxury would never go away, that the world would keep spinning, that people would always love beauty, and, even when one region suffers, another would thrive. You need to stay on your toes, look for the right market, be daring, take risks, and seize opportunities. That's what Reem does, and it's how she created a brand that has stood the test of time.

5

REINVENT YOURSELF

The world has changed at an unprecedented pace in the last thirty years as a result of multiple factors. From new developments in technology and fundamental shifts in behavior and societies, such as improved healthcare and education, to women joining the work force en masse, and a number of other deep structural changes, these factors have all affected consumer habits.

Luxury became an industry in the nineteenth century when greater amounts of wealth were spread out among a larger number of people, heralding the ascension of the bourgeoisie, a new class who made their fortunes with the rise of Industrialism. However, the number of customers was still small and limited, and most luxury companies changed little in the way they created products or did business until the 1980s. Luxury is excellence, and excellence takes time to perfect; no one really expected seismic changes in this very specific world. Yet the luxury industry also had to learn how to reinvent itself and adapt with new markets opening and behaviors changing.

One of the industries most affected by these societal transformations has been tableware. Most people don't entertain in their homes the way their parents or grandparents used to, or, if they do, it's fairly informal. Today, many people work full-time and have little chance to organize dinners at home. Luncheons at home are even less common, especially in a world in which most people have their midday meal standing up or at their desk—except for business lunches that take

place in restaurants. The formal table settings that a young couple would put on their wedding registry a generation ago have been replaced by lists of pots and pans, informal dinnerware, or, sometimes, by sponsoring parts of a honeymoon trip. Wedding registries are now available in multi-brand stores, such as Williams-Sonoma, Pottery Barn, and Crate & Barrel. These companies spotted the trend early on, and positioned themselves as the fast fashion for the table.

So what are prestigious brands in the field to do? How do you handle this new trend of casual and informal dining when you have been making porcelain in Limoges, France, for the last few hundred years? How do you adapt to these new phenomena? The family-owned company, Bernardaud, founded in 1863, studied these trends and changing patterns and saw an opportunity to turn them in its favor. How did they do it? By zooming in on two main shifts: the mix-and-match informal mentality of younger generations and the dining out trend they embraced. In the late 1980s, before China became the buzz, everyone was fascinated by the sophistication of the decade's It country, Japan. While the Japanese used pure lines in their architecture and embraced simple furnishings, the complexity of their ceremonies surrounding the table attracted outsiders even more. Bernardaud became one of the first traditional Western tableware companies to embrace Eastern restrained elegance. This is especially evident in the company's "Fusion Collection," which remains one of their top-sellers. Along with pure lines, the company embraced new shapes and disrupted the formality of traditional table settings. They embraced this new high-low mentality, which was diametrically opposed to what Limoges porcelain traditionally stood for. Instead of imposing their views, they adapted to new tastes, embraced

novel ideas, and won the hearts of younger generations while sharing with them the gift of craftsmanship and quality. The owners and artists at Bernardaud knew that while embracing new concepts was a brilliant idea, their expertise was in crafting the highest quality porcelain. Their factories were not set up to produce inexpensive pieces, so they didn't try to enter a more affordable segment of the market. They needed to stay true to their original DNA.

In order to help expand the business, one reinvention wasn't enough, even if it was the right decision. The company had to find a way to appeal to new markets, and so they did. They took the strategic choice to focus on the hospitality industry. With a growing number of people favoring dining out at restaurants over eating at home, the number of dining venues has proliferated in cities across the globe. The trend has been multiplied by increasing business travel, even though that way of life has been challenged in the last few years by the sagging world economy and the rise of video teleconferencing. Overall, though, the desire to eat out is unlikely to be overturned.

Bernardaud realized that they needed to invest to develop this new focus in its business: invest in people, training, and an aggressive development plan. Thanks to their early focus and considerable investments, Bernardaud positioned itself ahead of its competitors in the hospitality sector, cultivating relationships with young and innovative chefs who, in turn, became successful and loyal to the Bernardaud brand. They listened to their clients' needs and provided offerings suited just to them. While restaurants want to present their dishes beautifully, their focus is on the food and not necessarily the dinnerware, though that is another critical component. Durability is essential, but replacements are a reality, as porcelain does

indeed break. While Bernardaud continued to create elaborate presentation plates, it also focused on different designs and aesthetics that were more appropriate for restaurateurs than private homes. They implemented a unique service, assigning people to follow each account and ensure that replacement items were delivered on time. By doing so, it cornered an important part of the hospitality market, and is now considered by most luxury hotels and restaurants as *the* luxury tableware provider.

A similar challenge faced the flagging, illustrious crystal house of Daum in 1986. The company was named after its founder, Jean Daum, and Jean's son, Antonin, propelled the Nancy-based crystal company into fame when they became the champions of art nouveau by winning the Grand Prix at the 1900 Universal Exhibition. (Nancy is a city in Northern France where many high-end glass and crystal makers are based.) They even overshadowed Émile Gallé, who had won the high honor at the 1889 exhibit. The Frères Daum revived the forgotten art of *pâte de verre*, a technique once used by ancient Egyptians that can still be admired in the Valley of the Kings, notably in King Tutankhamen's tomb. In order to create *pâte de verre*, crushed glass is mixed with enamel or paint to create a paste that is then applied in a mold. The mixture is placed in a kiln and fired, and sometimes requires longer than a week before being unmolded. The Daums created their *pâte de verre "au goût du jour"* by interpreting the art nouveau movement with natural forms. They boosted Daum into the international art scene as the premier designer and provider of artistic vases and objects. The firm's pioneering spirit continued into the 1960s, when Salvador Dalí created his famous *Montre Molle* with Daum crystalware. Arman, a French artist

from the New Realism movement, also incorporated it with his famous *Tranchelucides* sculpture series, but the company's creativity had slowed down by the 1970s. Daum was near bankruptcy when a group of French financiers bought it in the 1980s for a minimal amount with the blessing of the French government. The deal they struck was that Daum wouldn't cut any of the 1,200 jobs at their three factories because the region's economy was suffering and the jobs were needed to keep the area afloat.

In order to rejuvenate the brand, the group turned to a respected fashion consultant, Clotilde Bacri. Clotilde was not only one of the shareholders, she became vice president and artistic director for the company and brought a true vision for Daum, renewing its creative energy by bringing in some of the era's hottest artists. It's important to remember that in the mid 1980s, luxury brands didn't turn to outside artists to create what we now call "capsule collections." It was only in 2001, when Louis Vuitton collaborated with the fashion designer and artist Stephen Sprouse, that these collaborative collections found real traction. Since then, Louis Vuitton has continued to surprise us with partnerships with Takashi Murakami (beginning in 2003) and, more recently, Yayoi Kusama in 2012. When Clotilde decided to turn to the American-born designer Hilton McConnico in 1986 and ask him to create a special collection for Daum, her peers vehemently criticized her because something like that was simply not done, but Clotilde knew she had to shake things up. McConnico's work as a set designer and art director for the cult movies *Diva* (1981) and *Moon in the Gutter* (1983) had really struck her. He had never created a collection for any brand, and she took the leap to bring him on board to infuse modernity into Daum. He

effectively aided the company in finding what it had lost and returning back to its original DNA: *pâte de verre* and nature.

The result was the famous Cactus creations, which became such an iconic success for the company that President François Mitterand even offered one of the limited editions to President George H. W. Bush. The second creator to come on board was the designer Philippe Starck, who was already a celebrity in France at the time. In 1988, the newly elected Mitterand had appointed Starck to redesign his private quarters at the Palais de l'Elysée. That same year, Starck created for Daum *Une Etrangeté Sous un Mur*, a super-modern *pâte de verre* sculpture.[47] When innovative interior designers Garrouste & Bonneti accepted the Daum challenge, they had been revolutionizing the design scene in France with their anti-bourgeois "barbarian" creations, considered to be some of today's most thought-provoking furniture pieces. They had recently exhibited the collection at the Venice Biennale, and had completed Christian Lacroix's living room. All of these initiatives brought a lot of exposure to the brand, and their situation quickly improved.

In order to grow, however, Daum needed to regain its former international glory and venture beyond France. The company decided to re-conquer the "new world" and opened its first store in the United States on Madison Avenue in 1989. The store remained at that location until early 2012. The move they made in the 1980s seems quite logical from today's perspective, but many foreign luxury brands didn't have stores in the United States in the late 1980s, the same way that most brands didn't have boutiques in Shanghai or Beijing in 2008.

Daum was not a household name in the United States beyond a small circle of erudite collectors of Art Nouveau and Art Deco *objet d'arts*. In order to garner publicity, the

company decided to capitalize on a major find: Right after purchasing the company, the new owners had the pleasant surprise of discovering a large inventory of *pâte de verre* vases in a dilapidated factory. They organized an international auction of these valuable pieces, both to finance the restructuring plan and to raise awareness of the brand. It was rare to see such a large collection being sold, and the auction attracted international attention. It was decided that the sale would take place in Tokyo, as most major Art Nouveau collectors at the time were based in Japan. Daum, however, wanted to take advantage of the opportunity to organize previews, especially in the United States. How does that help build brand awareness beyond the collectors' world? Daum set up the launch of its new collections with a traveling exhibition in Neiman Marcus's key markets, including Dallas, Los Angeles, and Chicago, thereby introducing the brand to a new group of potential buyers and opening up the U.S. market.

Thanks to its presence at Neiman Marcus and their store on Madison Avenue, Daum was able to regain its lost aura. The company continued to focus on its heritage and true differentiator, the *pâte de verre* technique. This technique makes the production cost of a crystal vase pale in comparison. Each piece requires its own mold and an entire week in a kiln, so the costs involved are expectedly high. That means that Daum had to target a specific clientele that could understand this type of artistry and rarity. In addition to collectors, Daum sought out another audience that would appreciate its uniqueness: decorators and designers. This focal point remains today. Clotilde's willingness to reinvent the brand put the firm back on steady ground, moving the company forward while still maintaining its essential character.

The same visionary perspicacity explains the success of Austrian glassmaker, Riedel. Over the last fifty years, Riedel followed the boom in the number of wine aficionados and apprehended that it had grown into a sizeable market. There was a real demand for glassware designed according to the character of particular wines. While traditional crystal makers have maybe five different shapes and sizes of glasses, Riedel has almost one hundred, with various types of glasses for Burgundy, Bordeaux, or Merlot. With respected wine critics explaining the differences these shapes have on the enjoyment of fine wines (and such wines reaching the astronomical prices discussed earlier), one can easily understand Riedel's phenomenal success.[48]

While few sectors of the luxury industry were as fundamentally shaken by society's evolving habits as high-end tableware, all have had to learn how to adapt to the luxury consumer's change in expectations. What do I mean by that? While luxury brands were born from the skills and talents of their founders, the early dialogue between creator and customer was replaced over the decades by a monologue from brands to clients. Luxury creators made amazing *objets* that people "in the know" would understand, while brands would teach newcomers about luxury. It's true that we may not always know what we want, and would have a hard time imagining a new design, yet we fall in love with great creations when we see them.

It is also true that the luxury world is all about dreams and aspirations, and defining those aspirations requires control from the brand. Today though, there is a new reality that luxury brands must take into consideration: One-way communication with customers does not fit today's world of sharing. The luxury sector has had to re-learn how to listen to their clients, absorb

75

their feedback, and act upon it. They have had to learn how to reinvent their magical worlds in 3-D and on virtual platforms, away from the comfort of their brick-and-mortar stores. This has actually unleashed a new wave of creativity and brought about new freedom and energy: From the Burberry social media trench campaign and Zegna apps, to the Victor and Rolf Web site, one could spend hours discovering these companies' beauty and talent with new platforms. That's what will continue to make us marvel and dream: creativity, originality, new ideas, and modern ways of looking at traditional *métiers*.

Today, entrepreneurs must remember that what they might consider an "old" brand was most likely an innovative force when it started. With your company, you will need to be ready to adapt to circumstances and realize that even desperate situations can turn into opportunities!

6

THINK OUT OF THE BOX

It's difficult to come up with a new concept in the luxury field, which is rooted in craft and heritage. I am always surprised (and sometimes happily surprised) when a newcomer succeeds in the already crowded watch, handbag, or accessory categories. Hasn't everything been done already? In the watch industry, the last really disruptive force was Swatch, which single-handedly revolutionized the sector in the 1980s. Before Swatch, you either had inexpensive and accurate functional quartz watches that no one really purchased for aesthetic reasons, or, at the other end of the spectrum, you had one-of-a-kind masterpieces with jeweled casings and *tourbillon* movements handcrafted by *virtuosi* watchmakers. There was nothing in between. Then Swatch came up with the unique concept of creating appealing yet inexpensive watches that had great accuracy and also were made with fun materials. It was serendipitous that this happened at a time when most thought the Swiss horology industry was dying, squeezed by the Japanese newcomer Seiko. As mentioned earlier, desperate times can provide great opportunities. Swatch transformed what most people thought was a soon-to-be obsolete industry and gave it new life. By re-energizing the Swiss watch industry, Swatch also allowed more Swiss craftsmen to continue their trade and train young people in their *métier*.

Keeping this in mind, it is extremely rare to really invent (or reinvent) in the luxury field, but it is something master chef Daniel Boulud has successfully accomplished.

The Luxury Alchemist

Almost thirty years ago, my then soon-to-be husband (who is a true "gourmet") spent a lot of time with Francis Layrle, then chef at the French ambassador's residence in Washington, D.C. Francis introduced my husband to a young chef working at the European Union's embassy there. Shortly thereafter, we moved to New York and I met this industrious young chef. He had moved to New York to become the sous chef at the Westbury Hotel's Polo Lounge. His name was Daniel Boulud. As time went on, Daniel was named chef at Le Regence, a high-end restaurant in the newly opened Plaza Athénée in New York. He then moved to the famed restaurant owned by the charismatic restaurateur Sirio Maccioni, Le Cirque. In the 1980s, Le Cirque was *the* restaurant where you went to see and be seen; no one could dream of a better platform to get their talent recognized, and get noticed he did. After years of hard work, it was only natural that Boulud open his own restaurant, and in 1993 he opened *Daniel*. It was an instant sensation, but that was only the beginning.

You might wonder why I'm including a talented chef in a book focusing on luxury brands. Well, it's because Daniel Boulud did create a luxury brand. What he did was unheard of at the time, and it took—in addition to talent—vision, courage, and countless hours of hard work. In the early 1990s the goal of any talented chef was the same it had been for generations: to create consistently amazing dishes, offer flawless service, receive the Michelin Guide's coveted three stars, and fill your restaurant with adoring patrons. He did all of that, but it was not enough for Daniel; he wanted more. So he changed the rules. He opened another restaurant, which is the current *Daniel*. "How could he have two restaurants at the same time," food critics and patrons

pondered. The chef was the reason why people went to his restaurant, and it was obviously impossible for him to be in two places at once. The concept of chain restaurants could work for McDonald's or Macaroni Grill, but not in restaurants where cooking was considered an art, where the chef's magic had to be felt in every dish, every day. But Daniel's idea worked and patrons and critics approved, so he opened another venue, and another. As he became the It chef in the world of haute cuisine, Daniel wrote books, was given his own column in *Elle Decor* magazine, and later his own television show. He continued opening restaurants in other cities and in other countries.

Today it seems obvious and easy, but it wasn't at the time. Other talented chefs also felt that having a wider reach was the new way to succeed in an ever-increasing global world. They have succeeded with the same format. Restaurateurs like Alain Ducasse, Jean-George Vongerichten, Nobu Matsuhisa, Gordon Ramsay, Joel Robuchon, and Wolfgang Puck worked together to change the rules. Through vision and hard work, Daniel Boulud effectively created a luxury brand in one of the most delicate fields: fine cuisine. In the realm of fine dining every dish must live up to the highest standards, otherwise your brand will be immediately shot down. The challenge for Daniel and his peers is even greater than a more traditional brand, as quality control is basically done at "point of sale." Imagine wanting to purchase a Louis Vuitton bag and having it created in the store; it certainly would give you a better sense of the details and challenges associated with producing it. Daniel and his peers do this in every single one of their restaurants across the globe. So how did Daniel create a modern luxury brand? He thought outside the box and reinterpreted his own field.

The Luxury Alchemist

Daniel grew up on a farm outside Lyon, France. At age fifteen he was one of the finalists in a competition for best culinary apprentice, which allowed him the opportunity to train under some of the most renowned French chefs, including Roger Vergé, Georges Blanc, and Michel Guéard. He always challenged himself, pushed boundaries, and experimented. His vision, shared by his generation of chefs, helped create a new category in the haute cuisine world called "the gourmet restaurant chain." Today the Daniel Boulud empire includes fourteen restaurants around the world: From New York to London to Beijing, Daniel's name is synonymous with epicurean cuisine and impeccable service.

His brand will convince investors to fund his new ventures, but Daniel is mindful of growth and knows that expanding too fast or in too many areas can be risky. He assesses his potential ventures with a passion for his craft and the vision for his brand. I often wondered why Daniel had not launched a line of frozen gourmet food—I am pretty certain it would be a huge success—but the challenges in ensuring that a frozen dish is mistake-proof are too high today: If the consumer misreads heating instructions or does something else to produce an unsatisfactory meal, they would probably blame the Daniel Boulud company, not themselves.

This is the reason why most luxury brands are cautious about following the example of companies like the Italian jewelry firm Bulgari, which is now running several hotels. Unless the delivery of the experience is flawless from the moment you arrive to the moment you leave, your client will associate any negative experience—from the night clerk being grumpy to the tea tasting like coffee because the wrong pot was used—with the brand.

Modern-day luxury brands need to constantly reinvent themselves, think outside the box, and come up with creative ideas to keep enchanting their clients. Customer loyalty is never permanently acquired and the love between the firm and the customer must be rekindled like any lasting union. Many luxury brands carefully studied Apple's Genius Bar concept and tried to come up with their own version of the pioneering program. They realized that Apple's innovative approach to customer service changed the rules. With its Genius Bar—their tech support station where trained staff members offer all kinds of help for free—Apple provides a reason for customers to return to the store, enticing devotees to test new products while experiencing outstanding service.

Only brands that are able to provide the best and most relevant service will continue to grow. And let me tell you, not many people understood the Genius Bar concept when it started. What was the point of offering a free service for anyone who buys an Apple product? Wouldn't the company's expenses for this free service make the products too costly in the long run? Wouldn't all these people clutter stores and take valuable retail space away from actual customers? How could a company afford such a service? Wouldn't that create a huge burden? Well, it worked. Apple wasn't scared to break the rules and come up with their own notion of service. Of course, it doesn't hurt that they regularly launch pioneering products. Apple has transformed the world of electronics (the ultimate commodity) by creating cool, design-oriented items and positioning itself into what I consider a luxury brand. For example, you might not *need* an iPhone—another cell phone or smartphone could do the job—but you *want* one. You might not need to have the Genius Bar to answer your

questions or help solve your problems, but you enjoy having it. Several subjective elements, such as desire, aesthetics, and appeal (all criteria for defining a luxury product) make Apple a true contender in the industry.

When Apple CEO Steve Jobs returned to the company in 1996, the brand was struggling and electronics stores were not keen on carrying Macintosh computers. Apple decided to create its own stores to showcase its products instead. Not every brand has the financial backbone to do that, but Apple wanted its retail environment to focus on the customer experience. This translated into a store layout that was drastically different from major electronics retailers of the time. Most stores were very cluttered, but Apple's vision gave birth to the open and airy glass spaces we are all familiar with today. The Genius Bar concept is actually credited to Ron Johnson (who had previously been head of merchandising at Target), who joined the Apple company as its Senior Vice President of Retail Operations in 2000. Johnson had been recruited by Millard Drexler, the former president of Gap Inc. who had joined the Apple team in 1999. (Gap stores were considered *the* success story for branded stores at the time, and many Gap alumni were among those who developed Apple's initial retail strategy.) Together they revolutionized another retail taboo: sell, sell, sell. Apple wasn't focused only on selling; they wanted clients to use the products, and the staff to help customers find solutions to their problems. Rigorous and extensive employee training was necessary before they were even allowed to speak with customers. This kind of customer interface required college graduates whose sole job was to help guests and understand what they needed, but not really sell. (Apple's appeal among young graduates during the poor

economy has also helped the company in hiring young talent, even for modest wages.[49] The brand's strategy certainly worked: In 2011, Apple stores had one of the highest sales per square foot in the retail world—far ahead of Tiffany's and indeed many other highly successful luxury brands.[50]

By revolutionizing the way electronics are sold, Apple went beyond its products and redefined the customer experience. The company continues to rethink existing business models and deliver creative products consistently—all with advanced technology and great service. This is why some people, including me, feel that Apple should be considered a luxury brand.

Looking at other industries, constantly reassessing your service, and embracing "disruptive" and groundbreaking practices can keep your company on its toes. The examples set by Apple and Daniel Boulud should be scrutinized and emulated by all aspiring entrepreneurs. It takes more than talent to create a luxury brand; it also takes time, patience, sleepless nights, and twenty-hour workdays!

7

WORK HARD

To be a successful entrepreneur, you need many strong attributes, among them talent, intelligence, and perseverance without stubbornness—a fine line that's sometimes hard to walk. But you must also have leadership, courage, and, maybe most of all, stamina—the kind that allows you to work nonstop for hours without a break and without ever losing your concentration or your temper. All entrepreneurs will eventually know the full meaning of countless work hours and sleepless nights.

One Sunday in 2011 I was exercising while listening to one of my favorite shows, Fareed Zakaria's GPS on CNN, and I was captivated by his conversation with the Pulitzer Prize–winning author and historian David McCullough about his latest book. McCullough's book, *The Greatest Journey*, discusses nineteenth-century writers, artists, and inventors who went to Paris to immerse themselves in the global capital for not only the arts, but also science and research. What struck me most was McCullough's following statement: "We receive such ballyhoo constantly about ease and happiness being synonymous—[yet] again and again people [at the time] were saying on paper in their diaries and letters: 'I've never worked harder in my life and this is the happiest time in my life.'"[51] That thought struck me because I could not agree more with his assessment. When you love and are interested in what you do, I believe that you do not count the hours and you just do it. (Well, maybe sometimes you do, especially on a Saturday afternoon if you've promised your significant other to go out

but you still have work to do). You put in the time because you want to do it perfectly, and perfection almost always seems just a few more minutes (or hours) away. I am certain that Vera Wang would also agree with David McCullough's statement.

Vera Wang is now the name of a fashion empire, but it used to be simply the name of a woman, a wife, and a mother. She is still all of that, but she is also one of the biggest success stories of the last decade. It all started when Vera was planning her wedding in 1989 and couldn't find a dress she liked.[52]

As a child growing up in New York, Vera constantly worked hard on the things that interested her, always giving 110 percent of herself. Her youthful passion for ballet, coupled with her tenacity and desire for perfection and innumerable hours of practice, allowed her to be accepted into the world-famous American Ballet Theater school. As a teenager she became a competitive figure skater and placed fifth in the U.S. National Championships with her partner. Upon graduating from college, she started working at *Vogue*, where she was quickly promoted to senior fashion editor, the youngest the magazine ever had. After fifteen years, she left and joined Ralph Lauren as the firm's design director for accessories.

Vera met her future husband when she was in her twenties. They dated for a year but Vera felt it wouldn't work out, so they became friends. She describes it as similar to the main characters' relationship in *When Harry Met Sally*: They had been best friends for years and were scared that getting romantically involved would ruin their friendship. After fifteen years of being friends, however, they decided to tie the knot and start a family. Thus Vera began looking for the perfect dress for the big day. Most of the brides-to-be she knew were in their twenties, and the stores and dresses were catered to

them. Vera didn't see anything she really liked. She was almost forty years old and didn't want to be dressed like someone half her age; she wanted a dress that suited her personality. The entire process was quite frustrating for her, and she was certain there were other brides out there who felt the same.[53]

After her wedding, she decided to do something about her experience and opened her own bridal shop in The Carlyle, one of New York's beautiful landmark hotels.[54] At first, Vera decided to have a full bridal house and carried some of her favorite designers' wedding gowns, such as Carolina Herrera and Christian Dior.[55] She also began designing her own dresses, which entailed sleepless nights spent tirelessly sketching in addition to running her salon and managing buying, merchandising, and selling. As time passed, she was more confident in her own creations and felt that she had a vision. Vera wanted brides to be able to find something that reflected their style and personality; she rejected the cookie-cutter approach that forced brides to wear just a wedding dress as opposed to *the* special dress. Vera hoped to bring fashion into weddings.

One of Vera's first creations—one that I fell in love with—was a long red velvet dress she had designed for herself to wear at a mutual friend's party. It was December 1991 and the theme of the party was "*Le Mariage de Madame Bovary*." While we now associate wedding dresses with white, that only became the case in the nineteenth century, after Queen Victoria wore a white dress to wed Albert of Saxe-Coburg. Until then, European brides picked any color for their wedding gowns. In Eastern culture, red has been the traditional color for wedding dresses and is associated with good fortune. As Vera was giving the other guests a little lesson in fashion history, everyone admired her red wedding dress.

When Vera opened her store on Madison Avenue in The Carlyle, she became an instant success: Her innumerable hours of hard work were paying off. After Pamela Fiori became the editor in chief of *Town & Country* in May 1993, one of her first goals was to make the illustrious magazine more fashion oriented.[56] An early cover under her direction featured an original Vera Wang wedding dress: It had a dramatic V-shaped back with many little buttons, and readers just fell in love at first sight. The phone in the Vera Wang Bridal House didn't stop ringing with calls from brides-to-be asking her to custom-design dresses for their big days.

When Vera speaks about designing wedding dresses, it's obvious how much she enjoys what she does. She doesn't speak of all the hard work she puts in, but only mentions the joy she has unleashing her creativity. Brides are often willing to go all-out on their big day, so in this sense bridal wear allows Vera to experiment as much as she wants. In an increasingly casual world, the field of bridal wear lets Vera go wild with her imagination, which in turn permeates into her other collections. Vera loves the drama associated with wedding dresses, and she knows that while the bride will mainly focus on the front of the gown, most guests will see only the back during the ceremony. (We all saw how Pippa Middleton's back at her sister's royal wedding made the front cover of all the magazines.) Vera pushes the limits in her designs, "flexing her drama muscle" with the train, bows, and detailing. She ensures that the bride looks stunning from all angles.[57]

The finished product is where you see how everything that Vera has done in her life comes together. When she speaks about creating wedding dresses, she also compares it to figure skating, where you also need a 360° view. She feels that figure

skating gave her "the love of beauty, that love of line, of telling a story, and reaching people emotionally."[58]

The same goes for dance, which Vera uses as inspiration for some of her collections. For her 2009 collection she drew inspiration from famed dancers Isadora Duncan and Martha Graham. In her words, dance was "the fluidity, the movement, the *joie de vivre*" of that collection.[59] But her designs go beyond inspiration, embodying the same overall philosophy that leads Vera's life: hard work, talent, and practice, practice, practice. When Vera designs a collection, she doesn't just sketch; she plays with fabrics and experiments with them, letting it evolve organically.[60] It is not unheard of for a piece that was first designed as a jacket to end up being a skirt on the runway. Her 2010 collection was the end result of such a progression. She had bought eighty or ninety amazing fabrics and started experimenting with them the way she always does—cutting, draping, washing, and testing. Despite all of this preparation, she wasn't happy with what she was creating with them. After weeks of frustration, she decided to start all over, even though she had only three weeks left before the fashion show. She felt relieved that she could begin with a clean slate, and with some luck and her hard work it all came together. Everyone embraced her collection.[61]

From 1991—when the Vera Wang Bridal Salon came to life—to today, the Vera Wang empire has expanded naturally, and it keeps growing. With special occasion dresses in 1993 to a full bridesmaid collection in 1996, many aspects of women's fashion have been addressed: shoes, fragrances (which debuted for the company's tenth anniversary), and eyewear.[62] Celebrities turn to Vera not just for their big days, such as when Chelsea Clinton came to Vera for a wedding dress, but

also when they walk the red carpet. The Vera Wang brand has become synonymous with elegance, sophistication, and luxuriousness. Vera's talent and ceaseless work ethic have allowed her to create icons in the luxury fashion sector for the past twenty years.

Any entrepreneur with a passion will eventually become familiar with what kind of hard work success requires. Because Vera was driven and had a clear vision of what she wanted to do, she was able to spend countless hours sketching, designing, and experimenting in order to produce her beautiful creations. Even if it meant staying until midnight in her atelier or working through weekends, it was all worth it, as attested to by the immense success of the Vera Wang brand.

8

CONTROL

Trust is the most precious and fragile element of any relationship. It represents a luxury brand's intangible value more so than in any other field. How do you ensure trust? You do it by always delivering the very best products and experience. It sounds easy, but it isn't. For luxury brands, the challenge is to create consistency in a dream. In order to accomplish that, you need to make sure that every step is taken according to the same vision and criteria, from production to purchase. The best way to ensure consistency is to control *everything*.

Things used to be simpler when craftsmen could create objects in the back of a shop and sell them in front, but then the shop became shops, the atelier became factories, and the gap between creator and user kept growing. Despite these changes, some brands have managed to maintain tight control on everything at all times, and one such example is the Italian clothing company Loro Piana.

I visited Loro Piana's first store on Madison Avenue just after it opened in 1993. A senior executive had left Hermès to run the firm in the United States. I was intrigued by her decision because I wasn't very familiar with the brand, so I decided to visit the boutique. Like everyone who has ever touched their cashmere and fabrics, I became an overnight brand devotee. As I learned more about the family-run company, the more I saw parallels with Hermès. Both companies were, at that time, fully family-owned businesses and both had the highest standards of quality and craftsmanship. They continued to excel in their original *métier*.[63]

The Loro Piana business began in the mid-nineteenth century with wool merchants operating the firm in Piedmont, in northern Italy. In 1924, Pietro Loro Piana established the company in its current location, Quarona, Italy. In the mid-1940s, Franco Loro Piana, Pietro's nephew, began exporting fabrics to the Unites States and Japan. Under his leadership, the firm became known as a supplier of fine fabrics, and especially cashmere. In the 1970s, Franco's sons, Sergio and Pier Luigi, took the reins of the company and turned it into a true brand. In the 1980s they launched their first finished products—fine cashmere sweaters and elegant weekend clothing for both men and women—and opened their first New York store in 1993. Today, the company has two major divisions, luxury goods and textiles, and, as of February 2013, they boast 139 retail locations around the world. Loro Piana continues to excel in luxury sportswear, fine clothing, and accessories for men, women, and children and also offer leather goods, a gift line, and an exclusive range of personalization services.

Loro Piana's quest for excellence led them to decide to control all stages of production, even going as far as raising their own animals. This uncompromising insistence on quality has had global benefits. The company purchased nearly 5,000 acres of land in Peru's Andes Mountains and set up a reserve for vicuñas (South American animals that resemble llamas). Local campesinos (farmers) sheer the vicuñas using ancient Incan methods that aren't harmful to the animals.[64] By controlling their supply chain, the company came to work closely with the Peruvian government to protect vicuñas from poachers. They have also helped reintroduce vicuña fiber globally, which has greatly aided the Peruvian economy. In Mongolia, a number of herders raise Hyrcus goats for Loro Piana at an

altitude of 17,000 feet. These goats are combed to gather their under-hair every year in May, when—due to the milder climate—they naturally shed their coats, which provides some of the world's finest cashmere, for which Loro Piana is lauded.

Loro Piana also introduced the use of baby cashmere, made from the under-fleece of Hyrcus kids that are at most twelve months old. This process can only be done once during the animal's lifetime and only thirty grams of usable fiber can be gathered from each baby goat. The whole purchasing process of the fleeces takes over a month to complete, which further explains the rarity of baby cashmere.

Over the last few years, Loro Piana has additionally been working with the Intha people in Myanmar to develop products from hand-woven plant fiber obtained from the lotus flower; 6,500 lotus stems are required to fabricate a single jacket, and those threads are woven using traditional techniques from the country's Inle Lake region. While Loro Piana's fundamental approach never changes, the company continues to be at the forefront of innovation by cultivating new processes that remain rooted in traditional craftsmanship.

If you ever visit the Loro Piana factories near Milan, you will be struck by the attention paid to the details involved in every step to produce the finest fibers. The individual responsible for quality control needs to use a special electronic magnifier to assess purity and quality of the fibers. Finished fabrics are examined by experts who decide if the tiniest flaws can be repaired or if the fabric should be placed in less prestigious groupings. From the plains of Mongolia or the Peruvian highlands, to their boutique in Milan, every step of the process demands the attentive scrutiny of Loro Piana textile experts. The family knows that its continued success

comes from the promise of impeccable quality. They realize that only total control of the production process can deliver such standards. It is precisely this consistency in the quality of its creations that has allowed Loro Piana to become a major player in the luxury field.

Of course, Loro Piana isn't the only firm with such high standards, but the number of companies that have not given in to the temptation of outsourcing is shrinking every year. Many companies feel pushed by consumers demanding lower prices and pressured by shareholders wanting better earnings. However, when you are a family-owned business like Loro Piana, you can grow at your own pace. You are able to have a long-term vision and accept that growth demands investments.

Loro Piana also actively and continuously seeks and recruits the best talent. When they get involved in a project, they do it with unparalleled commitment. In the fall of 2010, as part of the Luxury Education Foundation's programs, Loro Piana offered a challenge to the students in my class at Columbia Business School (which also included students and faculty from Parsons The New School of Design): how would they expand Loro Piana's gift offerings. Fabio Leoncini, the Managing Director in charge of all Loro Piana luxury divisions worldwide since 1999, came to New York four times during the fall semester to participate in the project (he is based in Milan). Fabio knew that his personal involvement—in addition to that of his dedicated and talented team—would ensure greater success for the students. Loro Piana went beyond what any other firm had done since the Luxury Education Foundation programs started: They produced actual prototypes of two of the students' recommendations—one for iPad covers and another for travel pouches. The Loro Piana engineering team and craftsmen

worked closely with the students via e-mail and teleconferences (they, too, are based in Italy) to create "workable" sketches. It required time, commitment, dedication, passion, and the drive for excellence to produce the final product in less than twelve weeks—an incredibly short span of time! The fact that Loro Piana also controls the elements of its manufacturing was also a factor in its success. Through this small example, everyone involved in the project concretely understood the enormous advantages of being able to control your brand completely.

This is the kind of control that many luxury companies try to have over their products and image. As we discussed earlier, the luxury field is about dreams, and in order to create dreams, the story needs to be told flawlessly with the brand guarantee that every single client has the same experience and shares the same dream. The ideal situation is to control everything—from the raw materials used to create your products to the placement of ads in magazines, from store design to the sales experience and post-sale customer service!

While it's challenging for companies that need capital to grow, it's important for entrepreneurs in the field to understand that control is essential to success, at least during the initial stages. A July 6, 2011, *Women's Wear Daily* article analyzed the pros and cons of acquiring outside capital, which is one of the ways you lose control when selling parts of your company to raise money.[65] The article offers Milly and Nanette Lepore—businesses that have thus far refrained from giving in to the various private equity offers they received—as examples. Beyond financial autonomy, control is important for production and distribution.

Financial analysts believe one of the key reasons Louis Vuitton was able to weather the economic crisis of the past

few years is the fact that its products never go on sale. If everyone knows that your products will never go on sale, it creates a sense of intrinsic value. Nobody wonders if the bag they desire in September could be purchased in December at a lower price. The price is and will remain the price, period. Either you are willing to pay or you are not. The price is the fixed exchange rate between Louis Vuitton and its customers, and therefore represents the value of the bag. This notion might defy the laws of supply and demand, but Louis Vuitton has been able to carry it forward for the decades, and I'm confident they will continue doing so. Even though potential customers may not be able to purchase the object of their desire, the fact that Louis Vuitton products never go on sale creates trust in their value and in the brand. And that is another benefit of control.

9

TRUST

Trust is, without a doubt, the most important asset for a luxury brand. In this industry, consumers might even turn to the brand's reputation rather than the actual design of the product when making decisions about their purchases. According to the 2011 Fashion Brand Index, as reported by *Women's Wear Daily* on June 6, 2011, "Seven years ago, fewer than 3 percent of apparel purchasers felt fashion brands and logos were important (in the USA), but that number jumped to 14 percent in 2009, and doubled to 28 percent in 2010. This year, it has inched up to 29 percent."[66]

Especially after the global economic crisis, a reason for this increase may be the fact that people who spend their money want to be sure that they get real quality, and the brand is the ultimate seal of approval. Consumers trust certain brands and feel they will not be disappointed when buying their products. One of the consequences of this, however, is that young creators have a tougher time getting recognized. It also means that consumers may be unsure of their tastes and judgment and look to a higher authority for approval of their purchase. I'm sure you have seen some individuals wearing unusual outfits or accessories made by well-known brands and you must wonder: If these creations were from an unknown brand, would that person have purchased it and, more importantly, be wearing or carrying it? In some cases, the power of brands seems to cloud personal judgment. Of course it might just be that people are more exposed to major brands and that they are easier to find.

Generally speaking, however, brands stand for trust: trust between the company and its consumers. As shoppers, we now have access to so many sources and choices that it can be hard to understand all the information out there. Sure, if you have the time and if it's a really important purchase for you, you might spend the time researching other customers' feedback. This also is why luxury brands are starting to embrace social media, as they realize that customers are the best ambassadors. The brand by itself gives consumers the knowledge that their purchases will live up to the company's standards.

Sometimes a luxury brand decides to seize opportunities for growth and enters a category in which it feels it lacks the know-how. In this case, a license makes total sense. Licensing is when a company authorizes a manufacturer to create a new product line for them that requires specific knowledge or training, such as eyewear or fragrances. The brand doesn't deal with production, but it is able to retain control of the product. As the passion for sunglasses has exploded over the last decades, two companies have established themselves as the world's leading optical purveyors, Luxottica and Safilo.

You might not know their names, but you certainly have heard of Carrera, Ray-Ban, Oakley, and Oliver Peoples, just to name a few of the brands these conglomerates now own.[67] Both Luxottica[68] and Safilo[69] began as family businesses in northern Italy, where farmers had to develop other means of income during harsh winters. In the 1930s the region began focusing on optical manufacturing (similar to La Chaux de Fonds in Switzerland, which became, and remains, the historical center for watch-making). The technical knowledge and expertise that the two companies developed over the decades allowed them to position themselves as the leaders for other

brands wanting to enter the eyewear sector. In this high-end segment, there are a few large manufacturers and a multitude of small factories. In the last decade, smaller companies have been suffering, and their number keeps dwindling. One of the reasons is that a large part of the production has moved to China, where wages are lower and quality is considered to be adequate to good.

A few years ago, I was doing research in the optical sector and went on a reconnaissance trip to northern Italy to understand how the industry works. While examining the family-run eyewear industry in the region, I was struck by its incredible fragmentation. In essence, each little screw and every single piece of the frame is made by a separate family-owned factory. This doesn't even include the lenses, which are produced by yet another specialist. In the case of corrective glasses, the final step is completed at the optical store at the time of purchase. These small Italian companies' facilities are doing their best to adapt to the new landscape and still use the same equipment that previous generations used, but the reality is that the techniques they use to make glasses have not evolved much over the years. The workers are the essential elements, not the equipment. Yet many of these niche companies have young entrepreneurs at their heads trying to adapt their family business and expertise, even traveling and outsourcing work to China.

The Luxottica factory is immaculate. The company produces the various parts needed to create and assemble glasses all under one (granted, one very large) roof. Each part requires different tools and skills. The production chain is studied to ensure minimum loss of time and maximum efficiency, and each part is coordinated in zones that work in

unison. In contrast to other companies, Luxottica's equipment is state-of-the-art. Despite this, the human element is still the key to its production. Each worker is highly specialized, like in smaller factories, and the tools are variances of the old ones. Most of the work, however, is still done by hand. Even in this mega factory the machines can only do so much. For example, a company craftsman individually applies by hand all of the Swarovski crystals that encrust one set of sunglasses. At the time, in 2008, Luxottica was testing a new machine to take over this tedious task, but it still needed to be perfected. The machine would often malfunction when trying to glue the crystals, adding too much glue to one hole and none to the other. After this first initial testing phase, the machine was perfected to be flawlessly calibrated and has now been in use for some time with excellent results.[70] At the end of these production chains, there was a final quality control inspection by yet more people. So even though a machine was supposed to be doing the work, skilled workers were still needed to make sure it had been done properly. In a way, it gives customers a renewed appreciation not just for their glasses, but also for the labor that goes into each mass luxury product purchased. We all expect our It bags to be handmade by craftspeople, but I don't think many people know the labor of love that goes into their glasses.

Given the complexity of this manufacturing process, it makes total sense that such control-driven luxury brands, such as Tiffany, Prada, or Bulgari, would entrust their eyewear collections to Luxottica,[71] and Dior, Gucci, and Yves Saint Laurent to the other giant in the industry, Safilo.[72] These companies know they can trust the licensing company to fulfill their own promise of quality to their consumers.

The Luxury Alchemist

If you want to create a luxury brand that will be around for the next hundred years, you need to ensure that you control every aspect of your business as much as possible, from production to point of sale. In the minds of customers, your brand represents your company's stamp of approval; it must tell the consumer, "I am Brand X and I can assure you that anything you purchase from me has been made with only the finest materials, in a process directly supervised by us, and I stand by my name and my standards." That trust is your most precious asset and you must never lose it.

10

LEARN FROM YOUR
(OR OTHERS') MISTAKES

As much as you would like to control every aspect of your brand, sometimes the wisest choice is to outsource, especially in categories where the savoir faire is very specific, such as eyewear or fragrances. Licensing offers growth opportunities, as it requires little to no investment up front from the licensing brand and can bring substantial revenues through fees the brand receives. In the late 1970s and 1980s, licensing became a temptation that very few brands were able to resist.

The father of licensing was Christian Dior who, in 1948, signed a licensing agreement with a New York–based hosiery company, Prestige, to produce Christian Dior nylon stockings.[73] Instead of accepting a flat fee to let Prestige sell products under his name, he negotiated a percentage.[74] This model has been used ever since. By the 1980s, Dior had over two hundred licensing agreements in place, and that number steadily increased. When Bernard Arnault, the founder of the LVMH group, took control of Christian Dior in 1987 and began the difficult process of closing the licenses (which took over ten years and a lot of capital), Dior had slipped away in the image of consumers.[75] Today, Dior only licenses its eyewear, like its competitors. By closing all of its other licenses, the brand regained its original luster and is once again praised for its creativity, craftsmanship, femininity, and sophistication.

Christian Dior, however, was not the only brand to have to go through that arduous exercise. In the 1990s, Gucci had to

do the same when it nearly went bankrupt after over-licensing its name.[76] In the 1980s, Lacoste's U.S. licensee, Izod, seriously damaged the company's exclusive image in the United States by producing poorly made shirts.[77] It took years of legal battles before Lacoste finally won the right to cancel the agreement. All of these luxury brands have learned from their mistakes; they have taken back control of their production and are only licensing very specific categories. Thanks to this regained control, these brands' equity value has exploded and trust has been reestablished with their clients and the public.[78]

There are some companies, however, that don't really seem to care whether or not they are considered a luxury brand. Pierre Cardin certainly appears to feel that way. He has been licensing his name since the late 1960s, when he was among the first designers to enter the Chinese market. Pierre Cardin began his career in haute couture.[79] Originally from Venice, his family moved to the south of France after losing their wealth during World War II. After the war, young Pietro[80] (as he was known then) moved to Paris and started working for Jeanne Paquin, "one of the first couturiers to achieve international fame." He then joined Christian Dior as a master tailor and subsequently left to create his own couture house. In 1953, Cardin debuted his first haute couture collection, and in 1959 he launched his ready-to-wear line. From the start, Cardin looked toward the future, and his designs came to embody the mod movement of the 1960s. Like many other luxury entrepreneurs before him, Cardin was a rule-breaker. Ultimately, he decided to do the unthinkable by selling his ready-to-wear collection to a *grand magasin*, Le Printemps, in 1959. For that, he was criticized and expelled from the prestigious Chambre Syndicale de la Haute Couture.[81]

Cardin didn't care that his reputation among other designers was waining; he was intent on doing things his way and changing the rules. In 1968, he began licensing his name outside the fashion world. He had already been chastised in 1976 for having licensed his name to companies offering products as wide-ranging as cars and jets, towels and chocolates.[82] In the 1980s he even launched Cardin sardines.[83] He didn't care about the repercussions then and doesn't seem to care now that he's reached his nineties (he was born in 1922).[84] However, one thing is certain: He paved the way for mass retail the way we know it now.

I'm not sure what the name of Pierre Cardin means for younger generations, but in the 1960s, it was synonymous with couture and revolutionary design, not with kitchen pots and bicycles. By the early 2000s most luxury brands had either finished or were still cleaning house, and their goal was to regain control of their brands. Licensing was almost a bad word in the luxury world, as consumers no longer trusted brands that would step too far out of their core competences.[85] The mantra for a luxury brand was, is, and will continue to be, control.

Luckily for Pierre Cardin, the financial results of this vast licensing exercise appear rather positive at first glance: In 2009, he sold thirty-two licenses of various products in China (but not the brand name itself) for 200 million euros.[86] And in May 2011, he announced that he was ready to sell his group for one billion euros.[87] Today, Pierre Cardin states that he has roughly one thousand products sold in about one hundred countries. This business model seems profitable, and money is the reason why most entrepreneurs start a business, so who are we to criticize? However, if you study the sky-high returns on

invested capital for luxury brands such as Prada or Hermès, or major luxury conglomerates such as LVMH or Kering, you may wonder how much more the Pierre Cardin brand might be worth if it had not over-licensed its name.

The good news for Pierre Cardin—who is widely respected and has accomplished many things, such as revolutionizing 1960s fashion and revamping Maxim's restaurant—is that he doesn't really have to worry about his legacy, as he will be remembered as a true visionary.[88]

So what happens when the deprecation of your brand is not a result of the company's mishandling, but rather to its success? How do you deal with it? Burberry reinvented itself in the early 2000s under the leadership of Rosemarie Bravo, and once again became a hot brand. The British company was featured in countless fashion magazines, movie stars were wearing Burberry clothing, and sales were exploding. The brand was edgy and creative, but in the process of reinventing itself it also gained some unexpected loyalists, the "chavs" (an acronym used by the British police for "Council Housed And Violent," even though some suggest it comes from the nineteenth-century Romany word *chavi*, meaning delinquent youth).[89] Whatever the etymology, chavs meant bad news for Burberry. The brand's luxury image was effectively tarnished in its home country, and it swiftly fought back. They aggressively went after street vendors selling counterfeit copies of their wares, but that wasn't enough. The company also challenged its creative team to come up with different designs and rely less obviously on their classic checkered pattern, and it worked. Today, the brand is admired for its fashion-forward designs, and the company's worldwide revenue reached almost $3 billion in 2012, with pre-tax profits of around $600

million.[90] This expansion comes mainly from China, where Burberry took back control of over fifty stores that had been previously franchised, and from Latin America. Even in Great Britain sales are principally due to international tourists. The quick and decisive actions taken by the company's executives allowed them to regain control of a situation they had not even created and thereby ensured the brand's continued international success.

Apart from this, Burberry has succeeded in other domains: It also became one of the social media leaders in the luxury fashion sector. From their interactive Web site to their "Art of the Trench" social media site, Burberry has understood the importance and power of customer engagement. As of May 2013, the brand has more than fifteen million Facebook fans and twenty-four million views on YouTube.[91] Their clients and fans feel like they are being heard, that their voices mean something to the brand. Cultivating this kindred spirit is an important lesson that all luxury brands are rediscovering.

11

LISTEN TO YOUR CUSTOMER

Without a doubt, one of the key contributing factors to a successful company is the art of listening to customers. In the luxury field, this concept is not exactly endorsed by all, which makes sense: When you create a dream, an intangible feeling, an unessential object, what is the point of asking the customer what they want? Customers might not yet know what they want or that they could come to covet what you have to offer. The creator is the master, the architect of the dream, the magician who turns bits and pieces into objects of desire. For this reason most luxury brands have a limited trust in focus groups when it comes to their creations. Of course they want to know how their products make customers feel, how the purchase experience was, but most often they are not concerned with opinions concerning the products themselves. More often than not, designers feel they know best.

In the luxury field this has not always been the case, at least historically. Originally, most luxury items were created at the request of a patron. Think of it like art: Back in the day, most works of art were commissioned by powerful families for their palaces or by religious leaders for places of worship. Think of the Medici family and Donatello, Fra Angelico and Michelangelo, whose Sistine Chapel was commissioned by Pope Clement VII.

In 1846, King Louis-Philippe ordered a Christofle Silverplate suite for his Château d'Eu in Normandy. In 1894, actress Sarah Bernhardt commissioned René Lalique to create

a magnificent crown with beads draping down to the shoulders for her role in *Theodora*.[92] And not so long ago, the famed Hermès Birkin bag was born out of an event that happened during a plane trip. Jean-Louis Dumas was seated next to the actress Jane Birkin, who explained to him that she couldn't find a large casual bag she liked and had been resigned to using straw bags. Jean-Louis went back to his atelier and challenged his creators with new shapes that would be more pliable than the Kelly bag (he wanted a bag with more of a weekend feel, which the actress was looking for). He also wanted to create a bag that would securely close. The conversation between Jean-Louis and Jane Birkin began because the contents of Birkin's straw bag fell out, and he wanted to incorporate a safe closure into the new bag's design. *Et voilà!* A new classic was born.

Today, you or I can still walk into Hermès or Louis Vuitton and ask for a bespoke creation; it may take a few years (and some cash), but it's possible. It might not become a bestseller but it will suit your needs. Knowing how to listen to your clients is another one of the Magic Ingredients that is required to build a successful luxury brand. It is an art that Patrick Alès has certainly mastered.

With his white beard and kind demeanor, Patrick Alès reminded me of Santa Claus from the moment we met. He doesn't wear a red suit; he is always dressed in black, but like Santa Claus, he makes you feel like you're going to receive a present when you see him. He is the founder of the hair care company Phyto, and his Alès Group also owns the skincare brand Lierac and Parfums Caron, created in 1904. Patrick Alès's career is a success story marked with curiosity, tenacity, hard work, and humility. When you speak with him, his sense of modesty never hints at the fact that he's created a global

empire with over $200 million in revenue in 2011. Instead, he makes you understand his passion for nature and beauty.

Patrick began his career as a hairdresser. He listened to his clients: how they wanted their hair styled in a certain way, how they desired a very specific shade of color, what their hair meant to them. Realizing that chemicals used in many salons were damaging their hair, he was inspired to create Phyto, a line of natural hair care products. Already passionate about flowers and plants, his inquisitive mind drove him to study everything about them. He began experimenting with roots, leaves, and flowers. In his native village in Spanish Basque country (at the border with southwestern France), he had seen healers cure sick people with wholly natural remedies, and he was certain that he could use the same techniques to find a way to make safer hair products. Patrick almost went bankrupt during this process, but his passion for his craft saved him. He eventually revolutionized the way plants are used to create beauty products; it all happened through observing, listening, and experimenting. His love of nature and gift for listening to his clients propelled him to create Phyto and Lierac, and his passion even translated into a tree being planted in Central Park that bears his name.[93]

When I met Patrick in 1999, he told me: "I have always dreamed of creating a fragrance." When he bought Parfums Caron, he wanted to keep this small luxury brand as a special jewel, not create a mass-market phenomenon; he had already proved to himself he could do that with Phyto and Lierac. He was happy with his decision to go against the tide of massive promotions for new fragrances, where the mere cost of a launch forces your brand to keep investing. He wished to stay true to Caron Founder Ernest Daltroff's original

vision: using the best ingredients and maintaining a small and intimate ambiance where women could personalize their own fragrances.

I still remember when I first walked into the newly opened Caron boutique on Madison Avenue in 2000. Large crystal urns were being installed around the room so that women would be able to come in and create their own unique blends from among all the various individual scents. This was a true haute couture experience in a field mainly driven by the mass market. For many luxury brands, fragrances are the entry point for others to experience their world. Haute couture fashion shows help establish a brand's mystique, which is what women want to reference when buying a fragrance; it is a little part of the dream. But creating an haute couture fragrance experience is not what most beauty executives would consider, especially back in 2000 when Patrick was first pursuing this vision. Today, many luxury brands are reverting back toward uniqueness and personalization of high-end fragrances.

Patrick Alès's desire is to empower women who want to be unique; his talent for listening to his clients and his curiosity, tenacity, and humility are all virtues that every luxury market entrepreneur should emulate. He has been courted by all the mega groups, each of them asking that he sell his company, but, as he once told me, that's not what it's about for him. He is more focused on sharing his passion for plants and flowers and listening to his customers—being able to go back to his garden and feeling that he has created something he can be proud of.

Even if you don't share Patrick Alès's romantic vision, you would be well advised to learn from his approach as an entrepreneur. Today's luxury clients are more discerning, and

they want their voices to be heard; they want to know that the brand they purchase, the company they support, shares their values. Luxury consumers possess a sense of social consciousness, which will only continue to grow in coming years. Fueled by the younger generations for whom the "me generation" is over, luxury brands must fully realize how global our world has become, and the desire to give back and save our planet keeps growing among its newer clientele.

12

GIVING BACK

One important point that has defined many luxury brands, and is now receiving renewed attention, is the companies' commitment to giving back to society. There are some Americans who believe that Europeans do not have the same commitment to the not-for-profit world that the U.S. has, but that's not correct. Both Médecins sans Frontières (Doctors Without Borders) and Action Contre la Faim (Action Against Hunger) were founded in France, and a significant number of young French people spend a year abroad volunteering for these, or other, organizations.

As many of today's luxury brands originated in Europe, this sense of civic duty has permeated through these corporations from the beginning. The Hermès company is one such example. Hermès has made giving back a part of its corporate strategy for at least thirty years, but it does so *à la* Hermès, just like everything else they do. When working for Hermès USA in the 1990s, my team and I were asked to identify a charity with which we would be working each year. Since the early 1980s, Hermès has developed a different collection theme every year to communicate an aspect of the company. Jean-Louis Dumas always personally selected the theme for the following year, and now his son Pierre-Alexis continues the tradition. The theme is the prism through which Hermès will communicate its magic to the world: in its advertising, *bolduc* (their gift packaging ribbons that are specially embossed with the year's theme), and store windows. The theme also

determines which not-for-profit organization Hermès will salute and work with for an entire year. That theme has to be wide-ranging and fit with the brand, and some examples are the Year of Music, the Year of the Sun, the Year of the Sea, and the Year of the Dance.[94]

I particularly remember the Year of the Sea in 1992, when the Jacques Cousteau Society was the main organization that Hermès supported and the New York flagship store was aiding Scenic Hudson as our local cause. Scenic Hudson aims to preserve the beauty and nature of the Hudson River and champions the protection of the local environment. Working closely together with Scenic Hudson and a team of science teachers, we put together a program for middle school children in local public schools, creating beautiful coloring books and educational materials that would inspire children to help preserve the environment. The creative team at Hermès used the patterns of an ocean-themed scarf to make the coloring books. Additionally we organized events to clean portions of the Hudson River. Despite working extra long hours, we felt good about what we were doing for our community. When you think about it, that's what luxury is supposed to do: make you feel good and happy.

Without a doubt, however, the person who single-handedly made giving back and making a difference truly fashionable worldwide is Evelyn Lauder. Evelyn Lauder was not only one of the most beloved figures in the beauty industry, but she was also a beacon of inspiration for all in the nonprofit world. Evelyn was a savvy businesswoman who, among other accomplishments, helped create the Clinique brand. Despite this, she considered raising awareness for breast cancer her biggest achievement.[95]

In the early 1990s breast cancer was not a topic that
women discussed openly and was still considered a bit taboo.
Though the National Breast Cancer Awareness Month had
been created in 1985, Evelyn Lauder is the one person who
can truly be credited for turning it into a household fixture,
making the fight against the disease a top health priority
across the globe.

She was able to do this because she used the power of the
Estée Lauder brand to spread the word. It was not something
that other luxury brands were (or still are) really willing to do;
disease and death don't necessarily evoke beauty and luxury.
Evelyn employed her willpower, business acumen, charm, and
intelligence to bring about a change. Like other luxury entre-
preneurs, she was not afraid to break the rules and this time it
was for a greater cause: Evelyn had been diagnosed with breast
cancer in 1989 and she was determined to fight it not just for
herself, but for every woman.

At the end of 1990, my company was selected as the firm
that would create the marketing and promotional campaigns
surrounding the opening of Escada's new flagship store on
57th Street in New York. The company was still owned by its
original founders, Margaretha and Wolfgang Ley. The name
of the brand comes from a horse they had bet money on and
that won, which showed that they were certainly willing to
take risks. I was asked to put together a proposal for them. I
first studied what the brand stood for. It had become an icon
for women who were not afraid to stand out (Escada's use of
color defied the then-current trend of wearing only black)
and wanted to dress smart. With clothes featuring real,
lasting quality, Escada developed the concept of building a
wardrobe one piece at a time, one season at a time. Instead

Evelyn Lauder in 2009 with Pink Campaign products, supporting the Breast Cancer Center.

of fundamentally changing styles and colors through the seasons, Escada encouraged women to buy a piece or two each season and to keep expanding their wardrobe slowly and thoughtfully. They wanted to accompany women from morning to night, address every aspect of her needs, and take care of her from A to Z through all the various facets of her life.

That was the approach I presented: The Escada woman represented the New York woman through all the diverse aspects of her city. New York is about beauty, pioneering hospitals, and giving everyone a fair chance (among *many* other things). As a result, the proposal was vast: a salute to New York by recognizing three deserving charities covering

these three ideals: "Beauty" with the New York Botanical
Garden; "A Fair Chance To Children" with the Kips Bay
Boys and Girls Club; and "Pioneering Medical Research"
with the newly established Breast Cancer Center at Memorial
Sloan-Kettering hospital. Escada helped each of these causes
with generous donations, celebrated the women behind the
organizations and, most importantly, raised awareness for
their messages.

The Evelyn H. Lauder Breast Cancer Center at Memorial
Sloan-Kettering had not yet opened its doors on East 64th
Street in Manhattan. Evelyn had not yet fully developed
the famous pink ribbon, which was inspired by the AIDS
red ribbon and that she designed with her friend Alexandra
Penney, who was then the editor of *Self Magazine*.[96] The
pink ribbon campaign was launched in 1992 and eventually
became the symbol for the fight against breast cancer, but
by that time Evelyn had already been working relentlessly at
the Breast Cancer Center, and Escada didn't hesitate for one
second to support it. I didn't know at the time that Margaretha
Ley had been diagnosed with cancer, and that the New York
store would be her last big venture. Margaretha and Wolfgang
could not have been happier to work hand-in-hand with the
Breast Cancer Center, and I started working closely with
Evelyn Lauder, especially for the *pièce de résistance*—a private
charity dinner held at the renowned Frick Collection.

Receiving the authorization to host an event at the Frick
was quite an achievement; only Christian Dior had ever
been able to organize a dinner there before, and we were
told it would be impossible. With everyone's contributed
efforts and the power of a good cause we eventually,
surprisingly, managed to obtain permission. As the Escada

store's construction plans advanced, the deadline for its completion was pushed to late September, then to October, then to November. I was petrified by these delays because I was pregnant and due in early December. However, the baby decided to arrive early and I panicked wondering who could orchestrate the last details for the Frick dinner. Evelyn Lauder came to the rescue, just as she did for so many other women, all of whom had graver issues to contend with than organizing a dinner. While I never witnessed the scene, I feel that it's engraved in my mind as if I had been there: Evelyn, my husband, and Janet Ley, who had just joined my company and accepted this challenge as her first job, sat down in our dining room with pink and blue cards and did the seating arrangements for all 250 VIPs who would attend the evening at the Frick Collection. The event was a huge success, and all thanks to Evelyn. The Escada boutique opening was one of the first of the countless initiatives that helped to raise awareness about the terrible disease.

Evelyn taught the world that companies and brands can fight diseases with charm and elegance and save lives while selling make-up, fragrances, and other things designed just to help women feel beautiful. Throughout all of this, Evelyn displayed her own grace and professionalism, made everyone feel important by treating them with kindness and deference, and utilized her talent to motivate her team. Those are the qualities that made her Estée Lauder's driving force for many years, and her kind of leadership is what cements a firm's spirit and makes employees want to move mountains. Evelyn galvanized the Estée Lauder salespeople, who went on to fight the battle and share Evelyn's passion. Since 1993 they have distributed over 120 million pink

ribbons globally. Thanks to the company's Breast Cancer Awareness campaign and other initiatives, the Breast Cancer Research Foundation, a 501(c)(3) not-for-profit organization that Evelyn launched in 1993, has raised over $400 million since its creation.[97]

Estée Lauder paved the way for luxury brands, showing them that they should not be afraid to support causes that initially seem foreign to beauty by their nature. In the last twenty years, innumerable luxury brands have realized that their clients want to feel good about themselves, and that their company's ethics are just as important as their aesthetics.

The concept store Merci that opened in Paris in 2009 went even further in their charitable works and continues to do so: All of their profits go to charities.[98] Some well-known brands, such as Stella McCartney and Yves Saint Laurent, agreed to forget their margins for the products sold at Merci and donate them to charity as well. Nordstrom followed suit when they opened their concept store "Treasure & Bond" in Soho in the fall of 2011.[99] Nordstrom had been looking for the right space to open in New York for years. They decided to begin by learning about the idiosyncrasies of New Yorkers' shopping habits by launching a store in the same vein as Merci, with all of the store's after-cost profits going to nonprofit organizations in the community. Their inventory all comes from young designers, and some creations even feature a link to a specific charity that the line supports (there was at some point jewelry made by A Peace Treaty, a company that donates money to reconstruction efforts in Afghanistan among other philanthropic organizations). Most importantly, the company shows its commitment to giving back to society and to causes that are dear to local

customers.[100] The experiment was such a success that it is still going on!

When launching your own luxury brand, you might not be in a position, like Merci or Treasure & Bond, to donate such a substantial part of your profits to a charity you embrace, but it should be at the top of your considerations and not treated as an after-thought. Luxury clients are eager to feel good about their purchases, combining shopping for beautiful things that make them happy *and* doing good for others. You should find a cause you are passionate about and integrate it into your brand's identity. It may hurt your bottom line if you don't.

13

SUSTAINABILITY

You should consider another important aspect of doing good when setting up your production chain: sustainability. Sustainability means using environmentally friendly materials and production methods, and making sure your workers are paid fair wages, which might mean paying them more than your manufacturing country's minimum wage. This is the new challenge for companies in the luxury field.

Historically, luxury has been connected with craftsmanship, excellence, and timelessness. It is about passing the craft on to the next generation and valuing quality over quantity. These are all values that are well aligned with sustainability, but the luxury consumption binge of the last two decades—most recently in emerging countries—has also associated luxury with excess. In their book *Deeper Luxury: Quality and Style When the World Matters*, Jem Bendell and Anthony Kleanthous highlight the importance for luxury brands to ensure greater sustainability at all levels, from sourcing raw materials and manufacturing to the marketing and distribution of their products. These companies can influence thinking but also merge with their clients' ethical considerations, which are increasingly concerned with social and environmental issues. The authors point out that, while the luxury sector's impact on the environment is much lighter than most industries, their power can have a determining effect on our future. These companies are in a unique position to nurture well-being, not just for their customers, but for everyone they deal with at all levels.[101] Luxury brands are in a

position to do more to help their fellow man and protect our fragile planet, and they should.

Les Artisans d'Angkor is one example of how a company can create exquisite *objets* while maintaining sustainability. The organization was created at the end of the 1990s with the aim to help young Cambodians find work near their home village. Given the devastation the country had seen in the decades of civil war leading up to that point, knowledge of their ancestral craftsmanship had been lost to the disadvantage of the younger generations. Les Artisans d'Angkor set up educational programs, teaching thousands of young people these forgotten arts. They now have forty-two workshops in Siem Reap, the city where the temples of Angkor Wat are located, and have trained over one thousand artisans, whom they not only pay above-average wages, but for whom they also provide a number of social services. Through this process, they have revived the traditional Khmer (or Cambodian) know-how in silk, stone, woodcarving, and lacquerware. Their works' quality far exceeds that of any other local craft center, and their designers integrate a fresh, contemporary interpretation into their creations, making them even more appealing to modern tastes.[102]

While this might be a difficult model to replicate, luxury brands are nevertheless paying greater attention to the fundamental shift in their clients' expectations. Large luxury groups have stepped up their efforts to integrate local products, healthier manufacturing practices, and artistic traditions. LVMH has been focusing on sustainability since the early 2000s, with a particular emphasis on energy consumption and renewable energy sources. Another example is the Swiss holdings company Richemont, which has been a leader in

sourcing diamonds from conflict-free countries. In 2011, ten years after its first initiative, Kering (known as PPR until spring 2013) launched PPR Home For The Long Run, now Kering Sustainability Department, a multi-tiered program that goes beyond traditional corporate social responsibility. Kering's achievements to date include Stella McCartney's handmade recycled tote bags made in Kenya, which were launched in 2011, and Gucci's sunglasses crafted with biodegradable liquid wood in 2012. The group is also developing an "Environmental Profit & Loss" account to calculate the value of its supply chain's environmental footprint. This tool, to be rolled out by 2016, will measure the use of water, waste, pollution, greenhouse gases, and other resources used in production processes.[103] But I don't think any brand could go much further than John Hardy.

I met John and Cynthia Hardy in the summer of 2000. A dear friend, Guy Bedarida, had moved from New York to Bali to become John Hardy's creative director, and we decided to get together while my family and I were visiting the island. Guy and I became friends a few years earlier when he was living in New York and designing for Van Cleef & Arpels. We shared similar backgrounds: We were both Italians who had grown up in Switzerland, lived in France, and landed (by choice) in New York. I had been surprised to hear that he was leaving the Big Apple to live on such a faraway island. I attributed his decision to one of those moments in life many people have when they question everything they've done, want to reinvent themselves, and are ready for a major change and a new challenge.

When we arrived in Bali, Guy wanted us to meet his "new family," John and Cynthia Hardy and their children, who had kindly invited us for dinner at their "home." There is a reason

why the word home is in quotes: John and Cynthia's home is more like a fairy tale construction straight out of a children's pop-up book. I felt like I'd been transported to Neverland and was expecting Peter Pan to come and greet us! Arriving at dusk, all we could see was a huge pond with thousands of candles floating on it (I didn't know that John was developing candles, but given the quantity he used, it made sense when I learned it later on). In the center, there was a house that looked like *Robinson Crusoe* meets *Vanity Fair*—the ultimate in casual elegance and chic. Every detail of their home was exquisitely crafted by commissioned local artisans, from the small bowls in which we were served the most delicious coconut soup to the bamboo dishes to the candelabras. It was no wonder *Architectural Digest* praised their home in a feature story a few years later.

We accepted their invitation to visit the company's factory the following day. On the way there, our local guide told us a bit about John and Cynthia. They were local heroes. They employed over six hundred men and women at the time, and everyone wanted to work for them. Not only did they provide health care, education to workers' children, and meals during the day, but they also paid generous above-average wages compared to other Bali-based companies. They had no problem attracting the best talent and craftsmen and retaining them—one of the biggest challenges luxury firms can face. We arrived at an idyllic setting with a series of large Bougainvillea-covered bamboo hut buildings and traditional Balinese wooden structures.

The John Hardy company had just finished their new factory kitchen, complete with a brick oven powered by natural energy. Each edifice housed a different atelier for the various components of their business: jewelry settings, jewelry frames,

a candle production atelier, a prototyping sector, and so on. At every corner, workers were busy working on new projects. It seemed like John's imagination had no boundaries (and Cynthia is always there to make sure things get done!). His idea of fun involves dreaming up new creations and trying to make them work. He may look back at works from a bygone era and try to turn them into unique creations, such as a bamboo cane with an elaborately crafted silver pommel that twists to reveal a light that pops out to help you hail taxis. Ingenious!

At lunchtime, all employees—senior management, designers, guests, craftsmen, and journeyman workers—gather at large communal tables where they share a delicious Balinese meal. Much of the food served is grown in the fields that surround the factory and is collected every morning, fresh and organic. Workers then take a nap under traditional Balinese settees. This happens every day in the idyllic world the company has created and continues to foster. This all happened in 2000, long before the *International Herald Tribune* decided to organize its first conference on sustainable luxury, which took place in New Delhi in March 2009. John and Cynthia Hardy's visionary dream of sharing beauty with everyone while also nurturing sustainability is the first complete example of a truly sustainable production center, which all luxury firms should strive to emulate.

It's not just brands that are taking such initiatives, but the media as well. One of the unintended results of the explosion in demand for luxury products has been the proliferation of counterfeits. Counterfeiting isn't new (the first reported case dates to Roman times with counterfeit wine), but it is only recently that it has taken global proportions and become a danger to society. How can fake luxury bags be a danger? While it's

easy to grasp that taking a fake medication can endanger your life, my statement might seem like a stretch, but it isn't.

Workers who produce counterfeit products are subjected to conditions comparable to slavery. In her book, *Deluxe: How Luxury Lost Its Luster*, Dana Thomas recounts a bust in a factory in Thailand where child workers were chained to the floor manufacturing counterfeit bags, their legs broken so they could not run away.[104] This image is enough to deter anyone from purchasing counterfeit goods, is it not? Once you see those images, you'll never want to purchase any fake products ever again, or be part of a process that truly hurts people. The fashion magazine *Harper's Bazaar* launched its campaign "Fakes are Never in Fashion" in 2008, and continues to work on educating the American public about the negative impact that purchasing counterfeit items can have. Their goal is to expose the criminal activities behind counterfeit products, from human trafficking, the abuse of women and children, and unregulated and unsupervised factories around the world to the use of methods and products that hurt people and the environment. They do this through in-depth articles, events, research, and blogs. No matter what our tastes are, no matter how full or empty our wallets are, if you want the style, you should support the real thing. Whether you purchase from a well-known brand or a young designer, depending on your personal style or how much you want to spend, it is always better to choose quality. It will make you feel positive, and that's really what luxury is all about. Sustainability and luxury go hand-in-hand, and will only continue to forge a stronger relationship. Luxury groups are improving metrics to measure the positive effects that sustainable luxury has on the world and on their companies' bottom lines.

14

HAVE FUN!

When your goal is to make people feel happy and beautiful, to encourage them to dream, to feed their desire to then purchase your products, the last little ingredient of the Luxury Magic Potion is *fun*. Having fun, conveying happiness, and *joie de vivre* should be a big priority for your business. Art can be about darkness and craftsmanship can be very serious, but luxury sells happiness. In order to communicate that feeling, it's important that the people behind the magic also feel an inner joy and have fun while working, even if it is for eighteen hours a day!

When you visit the Hermès Web site for the first time, you might be surprised to see fun little drawings. Those might make you think you have accidentally landed on a children's Web site (that's what some students told me). These drawings actually look like the kinds of sketches Jean-Louis Dumas used to draw. Hermès wants their patrons to look through their childhood eyes, and their creators to continue to marvel over the little things in life and never become jaded. The Web site conveys this aspect of the brand that is challenging to translate in a store, seeing as Hermès is synonymous with luxury. However, even in its search for sophisticated perfection, Hermès goes about their business with a lightness and an approach that can make you want to smile, even while working long days. Their ethos is about work, perfection, craftsmanship, but it's also about family and fun. That's what company team building gatherings are

meant to do: share the company's values and reinforce the team's importance while everyone has some fun.

Hermès took the concept a bit further when they decided to host their first American "family reunion" in Princeton, New Jersey, over the first weekend of October 2011. All U.S. Hermès employees (515 total) gathered together for two days of family fun. The reunion entailed closing all of their twenty-four stores in the United States for two days. It meant losing business. It meant a tremendous organization machine that was deployed for months prior to the event. It meant puzzled customers arriving at the doors of every Hermès store in the United States and seeing a "closed" sign on a weekday. But Bob Chavez, the CEO of Hermès USA, knows the company's deep values. When nervous counterparts in Paris were making calls a few days before wondering if it was really happening and how it would effect the company's operations, Bob was confident that it would be positive in the long term. What he didn't know is that it would show immediate benefits. After two days of having fun—celebrating the spirit of Hermès, its creativity and *joie de vivre*—everyone went back to work energized. In fact, they were so energized that not only did each store catch up with potential lost sales but surpassed them beyond anyone's wildest dreams. Everyone went back to the roots of why they do what they do: sharing beauty and joy. They got out of the daily rush and remembered the essence of their craft. They came back more eager than ever to spread the word. This is what successful luxury brands should be.[105]

While it is extremely important to create teambuilding opportunities, it's also essential to make sure that there is positivism within the company on a daily basis. Negativism and constant tensions will most likely result in losing key

employees who will eventually look for opportunities where the stress of the job itself is not compounded by tensions resulting from internal conflicts. As much as possible, senior management should try to infuse some fun into everyone's workday, especially for those who work long hours. With imagination and fun, you can realize that a lot can be done with a fairly limited budget.

Many people associate luxury brands with huge promotional budgets, but that's not always the case. Most luxury brands are actually quite conservative with their budgets. I remember one such occasion when Aquascutum had hired my consulting company to develop their marketing strategy, which included the opening of their Boston store in the fall of 1992.

Aquascutum was founded in 1851, five years before Burberry, its historical competitor, by entrepreneur John Emary, who patented the first waterproof wool in 1853. They renamed the company Aquascutum after the Latin world for "watershield."[106] British officers wore their coats during the Crimean war (1853–1856), and British soldiers used their trench coats during World War I. In the 1950s and 1960s, Aquascutum was *the* brand of choice of sophisticated aristocrats and cosmopolitan actors and actresses, including Humphrey Bogart and Sophia Loren. The company remained family-owned until 1990, when a Japanese textile conglomerate, Renown Incorporated, purchased the brand.

Under the new ownership, Aquascutum embarked on a major revamping of their brand. They first hired a veteran luxury menswear retailer as their U.S. CEO, George Santacroce, and then a talented young American designer, Karen Darby. They opened a number of stores, including the one in Boston. Renown focused heavily on Japanese markets when it took

over the company, so, with the Boston store's renovation budget continuously increasing (like all renovations), the opening budget kept shrinking. Most events of this type provide light meals, which don't affect the launch event's budget too much, but in this instance there was a request to cut the budget for informal modeling of the new collections. The wonderful thing about Boston is that, being a university town, there are many smart and beautiful young women! We were able to recruit a few of them for our informal modeling luncheons.

In order to have a successful modeling event, you need to have great music and choreography. We didn't have any budget left over for these vital aspects of the event, but I knew it was imperative, so I became the DJ and choreographer. I thought about the brand's DNA (trench coats and glamour of a bygone era) and selected some songs that made sense, from "Singing in the Rain" to "Putting on the Ritz," among others. You must remember that mixing tapes was not as easy before the Internet, Apps, and iTunes made it commonplace. Ellen McGovern, who was in charge of the Aquascutum account within my consulting company, KM & Co., and I not only created the choreography but even became the dance masters for our young models! We worked virtually nonstop that entire week, but, more than anything else, I remember the fun we had, the explosions of laughter when we were pretending to be models. It was this positivism that helped us through the events. (And I'm happy to report there were no glitches.)

Unfortunately, while our events were a success, the owners failed to embrace the new design direction and didn't update its image while then-competitor Burberry totally reinvented itself. As it continued to struggle, Aquascutum was purchased in 2009 by British entrepreneur Harold Tillman,[107] who sold

the intellectual property rights to the Hong Kong–based YGM Mart Ltd. with the idea of broadening its customer base while developing its luxury positioning. Sadly, Aquascutum went into the equivalent of Chapter 11 bankruptcy in the U.K. in May 2012.[108]

Of course, the concept of having fun while working isn't the exclusive prerogative of the luxury field, and Google has set the bar pretty high in its offices throughout the world. In their various headquarters, the layout and design team's goal is to have all employees working in a relaxed, playful, informal, and colorful environment. Slides, pool tables, gyms, and cafés encourage interaction between employees and teams, and foster creativity. That way people can actually enjoy working long hours.

I doubt that most new companies can afford an office *à la* Google, but you must ensure that from day one you create an atmosphere in which a positive attitude is a requirement. A company's morale can go down because of just a few employees' negative energy, which can sap everyone's spirits and infect the company with a disease worse than any bug. You'll have to take immediate action and restore joy and fun.

Now that we have covered examples of all the Magic Ingredients that are required to have a truly successful luxury brand it is time to see how you can go from an idea, concept, or design into launching your own luxury brand and becoming a true Luxury Alchemist!

How To Create a Luxury Brand

Over the last five years, I have started a new phase in my business life. I don't think I would call it a career change because that would imply a determined plan on my part. Life took me in directions that I could not have anticipated, but looking back, each step makes sense. Despite the fear of failing, I've always been open to new challenges. I think it's fascinating to reinvent yourself, to have another dream, and to capitalize on what you've accomplished to write a new chapter in your life. Of course, there's also learning, which is the most important part of our journey!

I believe that 80 percent of what drives luck is the way you approach the opportunities that present themselves—from random encounters to simply listening and being willing to seize new prospects as they appear. Luck is a frame of mind, an attitude, and a willingness to say "yes" to the unknown. It's an opportunity to get out of your comfort zone, to test your own limits and competencies, and expand your knowledge. Of course you still need the other 20 percent, which entails meeting the right people and listening to the good ideas.

By 2003, I felt it was time for some new professional challenges. I was missing two key elements in my daily work: passion and fun. When I came to that realization, I knew it was time to do something else. I was running my own successful marketing, public relations, and special events agency, KM & Co., but I was ready for another chapter. I didn't want to sell my company, although it might have been financially beneficial, but I also knew that I didn't want to continue doing something that didn't bring me the kind of joy it once did. I told my team at the beginning of that year that we were not going to continue public relations and special events and that they had one year to find other opportunities. (I kept only my assistant

and everyone else found amazing jobs.) I let my clients know that I would help them find another company to assist them for their events and public relations needs—I only continued the pure business strategy consulting part—and my transition to the unknown was very smooth. After all of this the question was: What's next?

Fortunately, I've always been involved in a few not-for-profit organizations: the National Dance Institute, Action Contre la Faim USA, and the Kips Bay Boys and Girls Club. I embraced the extra time I had to be a more active board member and didn't feel the urgency to make a drastic move. I believed that I would know when I was ready for the next professional step.

When my dear friend Professor Safwan Masri, then Vice Dean of Columbia Business School, asked me if I'd be interested in resurrecting a course on marketing luxury products between Columbia Business School and Parsons, I jumped at the challenge! The course was the concept of none other than Jean-Louis Dumas and Arie Kopelman, which they had developed at the Colbert Foundation. First introduced in the early 1990s, the course had encountered many challenges given the fact that it involved two different institutions with different student profiles and goals. After a few years it had been discontinued.

I knew that I'd never taught before, but I had mentored and trained almost one hundred young women (and a few young men) over my fifteen years at KM & Co. I truly loved the mentoring aspect of my work, so that was a good sign. I had taken only one marketing class in my life, at Sciences Po. Despite this shortcoming, I had lived and breathed in the world of luxury product marketing for long enough that I felt I could at least give it a shot. I harnessed my inner nerd and read more books on luxury and marketing than I ever thought existed.

I also sat in on classes at Columbia Business School, where I studied how successful faculty members taught, interacted with students, led discussions, and encouraged participation.

I took the challenge *seriously*, which is one important thing about opportunities, luck, or whatever you want to call it: You need to not only seize it but devote all your energy and skills to it. You have one shot, and if you blow that opportunity it goes away and may never come again. It doesn't mean that you will have to pay the price forever, but you should remember that you'll always be judged by your latest mistake, never by your biggest accomplishment.

I taught my first class in January of 2005. There were three faculty members from Parsons and little *moi*. I did an okay job by my standards, especially given the fact that it was my first time teaching. I tried to come up with a teaching model based off of the one I assumed had been used in the early 1990s, when I was President of the Colbert Foundation and when my role was limited to convincing companies to offer projects to students and attending the students' final presentations.

I took on the challenge of teaching with everything I had. I didn't know if it would work, if I would like it (I actually *love* it), if I would be good at it (I'm proud to say that I am a recipient of Columbia Business School's 2012 Dean's Teaching for Excellence Award), or if it would last. When you are an adjunct professor your classes are approved one semester at a time, but I've been teaching since 2005 and think it will continue for at least a few more years.

Most importantly, I didn't know at the time that my new teaching endeavor would lead to yet another chapter in my professional career—that it would give me the opportunity to channel my entrepreneurial spirit and merge

my skills and passion for creativity and discovery. When I was a consultant for some of the most successful luxury brands in the world, I had the best of both worlds: I got to see firsthand how business worked from inside of these large global corporations, but also learned how to manage my own company, comprised of twenty people at its peak. I learned the importance of good budgeting and accounting; for example, I couldn't always make certain investments in equipment or technology because I didn't have the funds. (I remember one of my closest friends coming to my office in the 1990s and calling it the largest IBM museum ever—that's how antiquated he felt our computers were.) Most importantly, I learned that you're only as good as your team. You learn that finding and retaining the right talent is the key to success. You learn that the show must be able to go on with or without you—like when my team brilliantly spearheaded Escada's boutique opening while I was in the hospital giving birth.

In the fall of 2007, one of my students asked me for some advice about an idea he had. I listened, advised, and guided. I didn't realize that the conversation would lead to my new chapter, the one about life as a luxury entrepreneur.

Savelli

1

THE INITIAL CONVERSATION

That student, Alessandro Savelli, asked me a simple question: "Do you think it would be a good idea to create a luxury cell phone for women?" With that one question, I embarked on my new adventure, which has indeed been an *adventure*.

My answer to Alessandro might have seemed disconcerting to him at first. I started out by saying that had he asked me the same question two years before, I would have told him that it was a very silly idea. For me, technology was a constantly evolving business tool. I still remember that summer in 2000 when I decided that I'd be in charge of what our family would do during our sons' school vacation. I dreamed of taking a trip around the world, then scaled it down to four countries. We left New York on July 3 and returned on August 26. In that time we visited China, Tibet, Bali, and Australia. We changed hotels almost every night. The only reason I was able to escape with my family without abandoning my business responsibilities was that I had my laptop and the Internet. Those tools gave me freedom, but at a price. Every morning I would go

online, read my team's e-mails, and write responses throughout the day. Minivans, buses, boats, planes—you name a mode of transportation, I've typed in it. Every evening I would rush into a new hotel room and struggle to find a decent dial-up connection. At the time there was no Wi-Fi, so it was really slow and challenging, but it worked. I found freedom with the help of a little technology. However, while I saw technology as freedom, I certainly didn't view my computer or my phone as luxuries. I felt that my laptop could be mistreated and beaten up as long as it worked, because I regarded it as just a tool.

I first heard of Vertu, a company whose core business is luxury phones for men (and eventually also for women) with starting prices of around $8,000, in 2003. At first I thought, "What a ridiculous idea. Phones are not a luxury product! Phones are a tool. . . . a commodity. It will never work." Then I learned from a friend who worked with Vertu how well they were doing. I realized that my definition of luxury (Chanel, Hermès, JAR, etc.) was a bit too narrow and old-fashioned. Vertu was a real success story. What most people didn't know at the time was that Vertu was actually owned, started, and operated by Nokia. It was not a start-up as most entrepreneurs envision it because it had access to the best technological knowledge, engineers, and factories available. They also had money—and lots of it—which they certainly needed at the beginning. How else would you be able to convince Barneys and the Galeries Lafayette to give you precious retail floor space for cell phones? How else would you be able to open and operate your own retail stores from day one? Vertu literally created a new category of luxury products; they just had to convince everyone that their phones were not fads and would last well beyond a normal mobile phone's standard lifespan of a few years.

The Luxury Alchemist

Vertu's bold move paid off. By 2004, only two years after their launch, they had almost $50 million in revenue. By 2007 that number was over $200 million, with almost 100,000 units sold that year alone. The company even continued to grow during the financial crisis. As of spring 2013, they have sold over 320,000 units since they launched, with a revenue of over $2 billion.[1] If you tried to project the potential for this market, you would have to analyze it within multiple contexts: the mobile phone market (which sold 1.3 billion units in 2007, and 1.75 billion in 2012);[2] the luxury goods market (with revenue of almost $250 billion in 2007); the jewelry market (the top thirty branded players' revenues were around $10 billion in 2008); and the luxury watch market ($27 billion in revenue in 2007). Incidentally, the jewelry and luxury watch segments combined represent over 20 percent of the total luxury market.[3] You could therefore easily understand that revenue from luxury handsets was estimated in 2008 to reach $11 billion in 2009, even if the projection of $43 billion by 2013 seemed a bit exaggerated.[4]

At the time, Vertu's positioning was focused toward men, and especially those men who had everything—men who love Porsches or Ferraris; men who love watches and for whom nothing less than a Rolex would do (and, in 2010, Rolex actually featured a Vertu phone in one of its advertising campaigns). In essence, for men who love expensive toys, the Vertu phone could become their latest plaything. It was a dream come true for the target customer as it was a completely new category of toy. All of Vertu's advertising and brochures feature a James Bond–like man with all the necessary accoutrements: the gorgeous woman, the fancy car, and the big watch. Being the 'ultimate boy toy' was their core positioning.

By the time Alessandro asked me what I thought of his idea, I knew it was a good one. Vertu had cornered the men's market,

but their choices were creating some challenges as they tried to expand to the female segment. Their positioning had been so strategically focused on men that it was difficult to create a female 'Jane Bond' equivalent. This challenge is not unique to Vertu; any luxury brand whose history and product offerings are specifically focused on one gender either decide to stick to their original target, as men's luxury fashion house Ermenegildo Zegna did, or limit their product offerings to a few items, as did Chanel, which only offers a limited selection for men that includes watches, fragrances, accessories, and a handful of ready-to-wear items from fashion shows.

Vertu's feminine phones were basically men's models, only smaller in size and with different color options; they weren't originally designed as a woman's phone. One can easily argue that many successful watches for women are scaled-down men's watches; the brands creating them are undeniably successful, but they aren't truly designing for their new target audience. A recent hot trend has been women wearing large, oversized watches that resemble men's pieces, but those only represent a small fraction of the sales in this category. Going after the female segment for a luxury product is smart economics: Women's products represent 65 percent of luxury sector revenue, with that figure increasing to 90 percent for jewelry.

So how do you compete against a giant like Nokia (which was the main challenge in 2007)? How do you create a piece of technology that can compete with the best? How can you succeed in the world of technology, which is all about the newest version and the latest update?

The first iPhone had been released earlier in 2007; nobody could compete in that domain, but we quickly learned that Vertu's success came from its image, quality craftsmanship, and

concierge service.[5] GoldVish—a Swiss company that launched its "Le Million" phone in 2006—also owed its success to its Swiss craftsmanship and precision, as well as the PR coup of having created what was officially the most expensive cell phone available to date.[6]

This precedent meant that we could create a luxury cell phone for women without having a phone giant's backing as long as we approached the challenge from the luxury/jewelry side of things. Imagine owning a beautiful *objet* with a specific function, and the function would be that of a phone? If you were lucky enough to have visited the Van Cleef & Arpels exhibit at New York's Cooper Hewitt Museum during the spring and summer of 2011, you would have noticed that the storied jeweler engaged in the same practices over one hundred years ago—studying patrons' habits and how they evolve with new technologies and lifestyles. For example, they created a *minaudière* for sophisticated women who went to the opera and wanted to carry their lipstick, powder, and comb with them. They designed necklaces with a zipper that could transform into two bracelets. In essence, they were innovative and attentive to their clients' changing routines then and remain so today.

In order to create a luxury cell phone for women, we could look at it from another angle: Instead of developing a phone that would be bejeweled, what if we created a precious and beautiful object that women would fall in love with that could also serve a crucial purpose in their daily lives. In a world in which communication plays an essential role, what if we could understand the specific ways in which women use their devices and how they perceive them? We could see if they feel something is missing from their own perspective. What functions and services would women love to have at their disposal? As is the

case with any luxury product, it's not about needs. What if we could offer women something they cherish: beauty. In order to make the device beautiful, it would have to look like an *objet*, not a phone. It had to be different.

I had many conversations with Alessandro between November 2007 and the end of May 2008. The first time I saw his idea tangibly translated was in a PowerPoint presentation featuring not just market research and competitive analysis, but also beautiful images of what the phones could actually look like. While taking the course at Columbia, he had enlisted the help of a design student from the Fashion Institute of Technology to develop something more concrete than just an idea. After all, it's true that an image speaks a thousand words. When I saw his renderings, I knew that his good idea was becoming a *very* good idea.

What seems obvious to everyone now was not so obvious in February 2008: Alessandro took the idea of a beautiful *objet* and added a flat touch screen, which was adorned on the back and all around it. Vertu's phone had keys. At the time, only the then newly released iPhone had a touch screen, but they had Apple behind them; it was quite daring to go the flat, touch screen route. But that's what you have to do—be daring—otherwise what's the point? Starting with the initial idea and following with the impressive imagery, Alessandro showed me his business plan in the summer of 2008. We discussed his projections and timeline (which seemed a bit aggressive), but the key elements were pretty much in place. He had done his homework and knew what he was talking about. In September 2008, when he asked me if I'd be interested in helping him transform his dream into a reality, I said yes. That is how our adventure started.

2

WANDERING IN THE WILDERNESS

Why and how did I decide this project was worth pursuing? Besides the fact that I thought it was a good idea, why did I believe it could fly? First, there was the talent. Despite his young age, Alessandro had many of the essential qualities of a successful entrepreneur. He believed in his idea and was passionate about it, so he already possessed the secret ingredient of a true Luxury Alchemist! Persistent, tenacious, and hard working, he was also willing to turn down lucrative job offers to pursue his vision. He was not only confident enough to surround himself with talent, but he knew how to find it and worked hard to convince others to believe in his dream. Not to mention he was also incredibly smart.

I soon realized that we also complemented each other: Besides the fact that I brought experience and credibility he didn't have with his young age, our personalities and styles made for a good duo. While I'm very focused on accomplishing tasks, I can say thank you and move on to other things if someone tells me no. Alessandro, however, doesn't take no for an answer. Even if he has to navigate through another door, the window, or an AC duct, he will not give up—at least, not easily and not for a very long time.

After finalizing the executive plan, we began meeting with possible investors. When you have the boldness of conceiving a luxury cell phone for women and want to do it right, you need money. A lot of money. Yes, I know, I said that money was not the essential component in founding a luxury

brand, but when it involves creating a product that uses technology, Monopoly money will not do the trick. You still need all the other elements, but you also need serious cash from day one.

The first two meetings were exhilarating: Each of the potential backers we met agreed to invest real money. As is always the case with start-ups, we reached out to people close to us, in this case people I knew who trusted me on a personal level as well as for my experience as a luxury specialist. It was a good feeling; we were on top of the world. Then, the first few days of bad stock markets became the new norm. It was October 2008 and the world had changed. Investors and entrepreneurs' optimism morphed overnight into panic and despair. No one knew how or when it would end. Many people were losing their life savings, jobs, and homes. Nobody was in the mood to invest in what could suddenly seem like a crazy idea. Who cared about a luxury cell phone when you could get a perfectly functional one almost for free (many phone carriers try to lure new customers with free phones)? Even during this time of crisis, Alessandro and I believed that things would not come to an end *somewhere* in the world. We believed there were other markets continuing to grow, such as China, the Middle East, and Latin America, so we kept trekking on.

In the spring of 2009, we found the next essential piece of the puzzle: Marc Trahand. Alessandro met Marc in the fall of 2008 at CES, the Consumer Electronics Show that takes place every year in Las Vegas and which showcases all of the novelties in the electronics segment. Marc had both an engineering background and an MBA from Wharton Business School, and had been working in the mobile phone

industry for seven years—first at Nokia, then Kyocera, and most recently at Modelabs, a company specializing in the design and distribution of cell phones and other related accessories. Modelabs was behind the Dior, Versace, and Tag Heuer cell phones, just to name a few of their luxury projects. Succumbing to Alessandro's skills of persuasion, Marc agreed to join the company. It was a true leap of faith. Alessandro was a twenty-nine-year-old with a dream who had not yet raised the kind of serious funding he would need to get the company off the ground. Marc was a senior executive at a company that had both money and a track record. Despite all of this, he still joined us.

We kept working, and the difficult task of finding sufficient funds carried on. Slowly but surely we brought on several "Angels," potential investors willing to provide capital for our start-up. They felt that there was merit in the idea, or at least were intrigued enough by it that they were willing to invest based on our presentations.

The first other investor became a real companion in arms, my New York–based *comparse* (French for accomplice) Guillaume Cuvelier. Guillaume was an entrepreneur specializing in high-end spirits; he had created Svedka vodka in 1998 after spending ten years at Moët Hennessy in France and New York. With his hands-on experience in the sector, he realized there were real opportunities in the vodka segment, which propelled him to create Svedka. In addition to building an impressive distribution system throughout the United States, he also developed a provocative and effective marketing strategy. The result was total success on all fronts. After selling Svedka to Constellation Brands in 2007, Guillaume had been investing and advising a number

of brands in the industry, with Savelli as his first foray into the non-spirits luxury world. As you will see, Guillaume's successful entrepreneurial experience has proved essential to the development of the Savelli brand.

Alessandro was relentless in his pursuit of potential investors and met with over one hundred luminaries in the luxury, retail, and entrepreneurial worlds. They would first be intrigued, then surprised to discover Vertu's success. Many subsequently became interested in Alessandro's plan. He pulled together a growing number of investors, and the company was gaining momentum. In doing so, Alessandro gathered an outstanding group of not just investors, but advisors and specialists in varying fields: Enrico Mambelli, who had been the CEO of Gianfranco Ferré; Peter Ashall, who was the first President of Vertu and had been instrumental in its creation and launch; Elio Leoni-Sceti, who, after leading EMI music, started a venture capital fund focusing on high potential companies in the technology sector; Joel Espelien, a mobile industry expert and technology lawyer; and Cyrus Jilla, at the time a Managing Partner at Bain & Co., London, and afterwards a De Beers executive, just to name a few. It cannot be stressed enough how important investors are for your venture, but you should keep in mind that not all investors are equal. Money is money, but having the *right* investors is also of key importance when building confidence for future investing rounds. It's also crucial in terms of know-how: No matter how great your idea is, no matter how extensive your experience, it's always better to have more expertise at your disposal. That brings us back to one of the necessary ingredients for a successful luxury brand: people. It matters even for financing.

The Luxury Alchemist

By the spring of 2010, the little money we had—which Alessandro had spent wisely and parsimoniously—was running out. Given the substantial needs that this specific endeavor required, what's normally called the "friends and family" seed funding was not enough to get us to an actual product. We had a number of confirmed Angel investors, but we still required one large investor in order to close the Series A funding. "Series A" is usually the first financing round in which professional institutional investors participate and set the pricing and terms of investment. Series A funding is often followed by Series B funding a few years later, the purpose of which is to support the next steps of development and growth, depending on the nature of the business. Series B generally seeks larger amounts of funding than Series A, and the same goes for potential Series C, and sometimes even D.

A successful start-up will see most of its original Series A funders reinvesting in subsequent funding rounds which are typically led by new investors who set the price and terms. As the company matures and capital requirements grow, the start-up could turn to later-stage venture or growth equity investors. The selection of your initial funders is key. The more likely they are to be able to reinvest, the easier your future additional funding will be. The larger the amount of funds required at each subsequent financing round, the more the founders get diluted as more capital is invested and their percentage of ownership keeps shrinking (unless they can also reinvest). Obviously it's better to have a smaller percentage of a growing and well-capitalized company than a larger percentage of one that is wavering because of a lack of cash.

In order to begin working on prototypes, our company needed Series A funding of around $3.5 million. We had

over thirty investors and almost $2 million pledged, but we knew that wasn't enough to start. At that point, we needed one large investor to close the deal and allow us to get started "for real." The good news is that, until the spring of 2010, we had been able to accomplish a lot of the background work required before beginning production. Alessandro and Marc had met with numerous potential suppliers, so we hadn't lost or wasted any time in this area (which was reassuring). However, we still needed that additional vital cash influx to be able to get to the finish line, which we felt—and certainly hoped—was near.

In the summer of 2010, Alessandro met with two great leads, both venture capital firms. One of those companies, Innogest, was the leading venture capital fund in one of the two countries considered a world center for luxury, Italy (the other one being, of course, France!) and became our partner. The roster of talent that Alessandro had gathered really impressed them. As a newbie to the start-up world, I didn't really know the subtle differences between a private equity firm and a venture capital firm until then (without going into too many details, both invest in private companies, but venture capital firms tend to invest in early stage start-ups, while private equity tend to invest larger amounts in more mature companies).[7]

Venture capital firms normally invest the lion's share in Series A funding and as a result impose their terms on the project. Their views may be different from those of other smaller investors. A venture capital investor may also want to get out of the start-up quickly, even if the firm has not yet fulfilled its full potential. You need time when you are set on creating a luxury brand, and these two different views don't

go hand-in-hand. As there are very few venture capitalists specializing in luxury, and virtually none specializing in luxury technology, our project required a certain outlook that isn't easy to find. Our Series A funding plan covered all costs of design, branding, and prototyping of functional phones. It would allow us to have functional phones for meetings with potential distributors and to secure their support before production fully started. As we would require Series B funding before we could hit retail floors, a venture capitalist was the candidate most likely to have pockets deep enough to know that the initial investment would be only the first step. The second financing round would be even more substantial.

3

CLOSING THE DEAL

After months of negotiations, we started in-depth discussions with our soon-to-be venture capital partner, Innogest. That meant that everything we had decided with the other investors had to be re-examined, discussed, and changed. What I call the "Battle of the Term Sheet" is something virtually any entrepreneur will have to survive. Most entrepreneurs in the luxury field reach this phase after they already have a product and a sales track record. While founders and investors all want the same thing (success), they have different perspectives. Successful founders have worked hard and poured their heart and soul into their start-up. In addition to the money they have invested, they also have invested all (or most) of their time and energy into the venture over a long period of time. It has become their life. It has consumed every waking moment. On the other hand, investors look at potential returns and risks involved. It takes a special kind of investor to take on the risks associated with a start-up because projections are the only thing they can review. They must generally look good otherwise there wouldn't be a point. The important question is: How credible are they? To figure this out, you must compare these figures to those of other players in the industry: the benchmarks, growth opportunities, and success stories of your soon-to-be potential competitors. When you're basically launching a new category and there's only one player (which happens to be owned by a technological giant), a lot of your projections are conjectures.

The Luxury Alchemist

Granted, by this point Alessandro had tied together all the bits and pieces of information on Vertu with everything else we had been able to find in the media, so we knew our projections were sound, even conservative. We weren't looking to become a "mass luxury brand." We just wanted to be exclusive, so we only needed a limited number of women to fall in love with our beautiful creations.

The investors Alessandro had lined up all came from different backgrounds: technology, luxury, and distribution among them. Given the still-uncertain economic climate, everyone was only willing to invest a relatively small amount in the project. This meant that everyone was happy to have Alessandro maintain control; after all, it was his idea, his baby, and he had been the one sacrificing almost two years of his life for the project. As explained earlier, when a venture capitalist invests, they usually want control over the project, or at least some part of it. Of course they realize they aren't the ones coming up with the idea and plan, but they have the money (at least the bulk of it) and the expertise with start-ups. Additionally, investors don't want to lose founders, otherwise the start-up would just be an idea without a team and leader. This puts each item on the term sheet back on the table. Each side needs to make concessions, otherwise your company gets stuck in production limbo. Signing the term sheet is only the beginning; afterward you have the shareholders' agreement, which is even more complicated.

Having seen my husband, who is a Senior Managing Director at the investment banking advisory firm Evercore Partners, work countless nights, weekends, and holidays putting together mergers and acquisitions deals in the pharmaceutical industry, I thought I understood how hard it was to convince each side to

agree. I thought I knew what it took to make sure the deal goes through. But you only really understand all the aspects of the process once you live it, like the way I learned how hard it is to teach. Roberto de Bonis, an Italian corporate lawyer, became our "small investors' knight." Roberto and Alessandro negotiated countless hours, and the four of us (Alessandro, Roberto, Guillaume Cuvelier, and I) had innumerable conference calls at all times of the day and night. Our initial investors also spanned the globe, from Hong Kong and São Paulo to New York, Paris, London, and Milan, so we had to be flexible enough to work within their time zones.

During this process I learned about Tag Along/Drag Along clauses and remembered the subtleties of Rights of First Refusal. My legal background came in handy throughout this learning exercise. I think somewhere (quite deep inside, though) I was actually having a bit of fun reading convoluted sentences and trying to solve them. It was like *my* version of the *New York Times* Sunday crossword puzzles). My Italian also came in handy: On one rainy Saturday afternoon, I read both the English and Italian versions of the by-laws—the only document that had to be in Italian for legal reasons—and picked up two inconsistencies. Yes, I must admit that I really enjoyed that moment; it made me feel that all my time spent was well worth it. As we already discussed, you need to learn to have fun when and where you can.

Concerning the shareholders' agreement, I held an ambiguous position, which actually put me in either a good or bad spot depending on the issue. As a cofounder, I saw our shares' percentages and rights diminish drastically. As an investor, I could understand some of Innogest's requests. What I would lose on one side, I could at least reassure myself that

The Luxury Alchemist

I would get it back from the other. This was not the case for Alessandro. It was essential that he and Marc were happy with the results; they were the ones who would be in the drivers' seats. After more than six months of long and sometimes arduous discussions, ups and downs, surprises, and last-minute incidents, we finally agreed on the shareholders' agreement and all other legal documents. It was finally time to get all the investors to sign them. We had thirty-nine shareholders across the globe and a 135-page agreement. Once the terms were agreed upon, Alessandro managed to get every shareholder to sign and return the agreements within five days; time was running out for closing. We had picked a deadline to sign all legal documents and gather all the signatures, but we had underestimated how long it would actually take. The fact that it all came together is a miracle in itself!

By the time we had our first board meeting in Geneva on April 1, 2011 (I know it was April Fool's Day, but nobody dared pull any pranks), we had jointly worked tens of thousands of hours over three years. Alessandro had made thousands of phone calls and sent countless emails. From the very beginning he understood the importance of keeping all potential investors informed (how else do you keep them interested for two years) and had rallied every one of the thirty-nine investors from ten countries. We were ready to roll!

4

FULL STEAM AHEAD!

The fundraising aspect of our venture had lasted longer than we'd anticipated, but the good news is that we hadn't lost those two years. We had been working all along on the fundamental components of the project: technology, design, and branding. The moment the funds came in, we didn't lose a minute, simultaneously sprinting ahead on all fronts.

A. BRANDING

In the process of creating and developing the Svedka vodka line, Guillaume Cuvelier had met independent marketing experts who were highly specialized in specific aspects of branding—individuals who offered "boutique" alternatives to larger agencies and delivered a truly customized approach to their clients' specific needs. The first of these people to come on board was brand strategist Audrey Francis and her firm, Elastic Strategy. Guillaume and Audrey had already worked together on a number of projects, and while Audrey hadn't worked in the luxury sector before, I actually saw that as an asset. It's good to have someone come in with a totally different perspective and able to offer different opinions. I felt we had been immersed in Savelli for so long that we were too "inside" and could no longer think out of the box. That's exactly why companies are happy to have students from my Master Class come and look at some of the questions they're asking themselves. It's not as if they feel their own executives couldn't find the right answer,

but it's always healthy and wise to have an outside opinion with a blue-sky approach. Individuals who don't understand the industry won't come in with preconceived notions of what they're supposed to do; they can muster up more creative ideas. Thanks to Audrey's meticulous analytical methodology we were able to develop a clear brand strategy and a deeper understanding of our target customer.

In April 2011, Audrey began interviewing luxury experts and Savelli stakeholders in order to understand their definitions of luxury and the potential of our new category. Together we referenced general research on the spending habits of affluent women across the globe. We developed a detailed online survey and possible target consumers offered us detailed feedback. Audrey designed a focus group's discussion outline, and came up with various mood boards to elicit women's opinions. We tweaked and modified these materials as we learned from each one.

The focus groups proved to be truly eye opening. While many designers believe that it would be impossible to pre-analyze through focus groups, this marketing tool is incredibly useful when you have a general idea but aren't certain about its execution. We had embarked on the Savelli adventure with a clear vision of our client: She was international, in the know, confident, and didn't take herself too seriously. She acted young, was connected, active, and accomplished and her looks mattered to her. But we also needed to have a deeper understanding of what she particularly enjoyed in the luxury world and how she used her technology, including what brands she coveted and why.

We conducted twelve focus groups among female luxury customers in New York, London, Hong Kong, Rio de Janeiro, and São Paulo. Each event was set up to include groups of women who mostly knew each other and took place in one of

the ladies' homes. The idea was to cultivate a fun and welcoming environment where these private and sophisticated women felt comfortable sharing their personal thoughts. The groups really opened up about themselves and about what it means to be a woman today: as a wife, mother, daughter, and business woman. They talked about how they clearly have more freedom than prior generations to do whatever—and be whomever—they wanted. They shared how they felt challenged trying to juggle it all, being a nurturer, planner, relationship builder, decision maker, and global citizen, especially with the constant pressure of making it look effortless. We made sure to take note of all the feelings and opinions they shared with us; those are the kinds of details that you must truly understand when creating a brand for a target group. Understanding them is the difference between a successful brand and a struggling one.

For these participants, a woman's phone was both her freedom and her captor. It allowed her to be accessible to her family and friends wherever she went, but her work also followed her. Because of this, many women have a love-hate relationship with their phones. They want to take it everywhere they go but are afraid of losing it. They can't find it in their oversized bags. (Why hasn't anyone come up with a beeper to find them in their purses?) They keep their phone on almost all the time and would be thrilled if there could be a way to turn it off and have it ring for only the most important people in their lives.

The women who responded in the focus groups said they would love to have a beautiful phone, but something not too feminine and certainly not girly. They'd be afraid of losing their *objet*. They wanted a cell phone with a "panic button" that would automatically erase all her contents if she activated the "stolen" button. With a tracking device if it couldn't be found.

With a mirror and a flashlight. With tips on how to eat healthy, where to go, where to shop, and which restaurants were nearby. Essentially, the target client wanted a magic wand.

Audrey fine-tuned our brand strategy using all of the feedback we accumulated, which we reviewed and approved at our board meeting in July of 2011. With our outstanding group of accomplished board members, advisors, and senior experts from various industries, we all agreed on our brand's essence, a juxtaposition of two words that Audrey came up with early during her research: Haute Modernity. These two words convey what we were trying to accomplish: bring a twenty-first century attitude to the world of luxury. Why didn't we choose Haute Technology or Haute Mobility? Well, we passionately discussed it! While internal debates lasted beyond that meeting, we eventually came to the conclusion that those two options might put us in a narrow box (the technology domain), and we didn't want to corner ourselves before launching. A luxury cell phone for women should come with accessories (if you look around you, you'll see an increasing number of women who accessorize their phones) and we certainly planned on creating a whole range of them.

Our brand positioning was also general enough that it conveyed what we were trying to create: a different, more modern interpretation of luxury. While this intuitively implied a technological aspect, it also recognized the importance of this type of luxury. It gave users certain powers and freedoms that only technology can offer. We then incorporated a feminine aspect to our branding statement with words that kept popping up from all the women we interviewed, *et voilà!* "The modern luxury that empowers women to take on the world with joy, grace, and elegance."

It might seem strange for outsiders to learn about the kind of meticulous work that goes into each word when developing a brand mission and all the other statements that define your company. For example, you must ask the question: Am I creating a soft luxury product or a hard luxury product? (Hard luxury includes watches and jewelry, while soft luxury covers accessories, fashion, and other related domains.) Semantics, you might think....Wrong! It is of the utmost importance to clearly convey a defined vision of your brand, not only to your customers but to all the various entities with whom you will communicate and who need to buy into that vision. However, the luxury cell phone sector had yet to be categorized. After some discussion, we decided to be general and classify ourselves just as "luxury" and wait for the industry to gauge whether we were a hard luxury brand or not. After long debates over a few more months, our brand mission was finalized: "To become an internationally admired luxury brand that daringly blends modern technology and modern elegance for the sophisticated, well-traveled woman."

It was clear that our brand's personality had come to life through our interviews with the women in our focus groups. During the meetings we showed mood boards that Audrey had developed, each one representing a different female aspiration or value that might capture and enhance the spirit of this brand.

We learned just as much from what didn't resonate as from what did. The participants didn't associate their cell phones with whimsical images from fairy tales or, at the other end of the spectrum, with *femmes fatales*. They did, however, want to be feminine without being girly; they wished to be bold and strong, to evoke a sense of fun without appearing silly. Savelli's essence is represented in these six words: Modern, Innovative, Daring, Empowering, Elegant, and Playful. For our Core Promises,

Savelli will create an elegant, modern cell phone that is Italian-designed and handcrafted in Geneva with the most exclusive, high-quality materials and meticulous attention to detail.

Where technology is concerned, our brand must mean *trust* (after all, why would you switch from an iPhone or Blackberry if you weren't absolutely certain that the Savelli phone would deliver the technological quality we're all accustomed to). We started using the word *reliable*, but it didn't seem very luxurious. Luxury is about dreaming and aspiring, and our goal wasn't to emphasize the "reliable" aspect. The fact that the phones are made in Switzerland should have already implied seriousness and reliability. We decided to remove "reliable" and replaced it with *impeccable*. The next sentences in our Core Promises are: "Impeccable and intuitive technology custom-designed for each woman with the latest and most valuable functionality that will empower her life and lifestyle. And we'll deliver an international service that, wherever in the world she is, spontaneously invites her to spectacular, real-life experiences she is passionate about. Whatever we do, it will always be fun!"

You must be wondering how many more aspects of your brand could you possibly need to define. Well, just two more: the core values and our brand challenge. Then you're almost there!

SAVELLI'S CORE BRAND VALUES:
Modernity: Living at the epicenter of luxury,
technology, and style, we strive to be relevant
for today's international, chic woman.

Exquisite Quality: We passionately aspire for
a rare yet meaningful level of quality/craftsmanship
in each and every detail of what we do.

Irresistible Design: With an Italian sensibility, we are committed to beautiful and innovative design that women love.

Wow Experience: The beauty of modernity is the intrinsic drive to always seek to outdo itself and inspire unexpected "wows."

The Art of Smart: We believe smart technology is intuitive and personalized, seamlessly integrating into and empowering one's lifestyle.

Fun Luxury: Nothing like your stuffy old-fashioned luxury company, we know when not to take ourselves too seriously and let the fun we are having shine through.

OUR BRAND CHALLENGE:
To become a top ten luxury brand by 2020.

And with that, the initial steps of our branding were wrapped up. Step one: Complete!

B. NAMING

After branding was finalized, in parallel with the design process, we had to finalize our company's name. From day one, I felt that Alessandro's last name, Savelli, would be an excellent choice for our brand, as it encompassed a number of elements that we wanted to evoke.

The Luxury Alchemist

First, it was the founder's name, which is a fairly standard practice in the luxury world, from Hermès, Chanel, and Vuitton to Boucheron, Lalique, Puiforcat, and Armani. Alessandro was resistant to the idea of using his name because he isn't a designer (most of the founders of these luxury brands were designers or craftsmen); he was worried about appearing arrogant or egocentric. Secondly, Savelli sounds like an established Italian luxury brand name. Take Bulgari, for example, whose name evokes images of a mystical *dolce vita*: effortless elegance, unpretentious sophistication, voluptuous playfulness, bewitching bliss, and communicative *gioia*. These attributes work well for a traditional luxury brand whose identity is rooted in craftsmanship and heritage, but how could we communicate the fact that our brand was fundamentally modern? How could we continue to convey luxury without sounding too technological?

As we could not come to a quick consensus among ourselves, we chose to embark on a naming exercise to see where it would bring us. Never would I have thought that such a simple task could be so challenging or ignite such heat and passion (starting with my own). We went through multiple exercises under Audrey's skilled guidance, and she did warn us that the process might be frustrating. Seven individuals participated in these first naming sessions, which took place in New York: Alex, Guillaume, and myself along with four young female creative writers. We greatly valued getting fresh ideas from talented women (our target clientele). Audrey started out by establishing the criteria for what the brand's name should accomplish. She said it should:

- Help tell the brand's story
- Be easy to say when you hear or *see* it
- Be relatively short

· Stand out positively from the competition
· Be memorable, even generating conversation
· Leave room for future innovations
· Help foster a lifestyle, experiential dimension
 to the brand
· Convey luxury
· Instill a sense of joyfulness
· Not indicate technology
· Not be overtly feminine
· Be influenced by Italian, French, English, or a
 combination of languages, or could be made up
 or an unknown language
· Work globally
· Create a handle, like "my Blackberry"

Audrey also provided us with a few examples of how it could be successfully interpreted:

· Founder (Chanel, Hermès, Rolls Royce)
· Origin (Bottega Veneta, Shanghai Tang)
· Descriptive (Net-a-Porter, iPhone)
· Evocative (Montblanc, Jaguar)
· Invented (Rolex, Rado)
· Random (Apple, Grey Goose)
· Acronym (BMW, VBH)

After the briefing, we brainstormed and word-associated by themes: animals, nature, cosmos, seasons, locations, names, antiquity, and technology. We transformed words and cut them. We played with them in Italian, French, and English because those were the languages that made the most sense for us. Breaking up into even

161

smaller groups, we mixed and matched. Everyone then regrouped and we all attempted to come up with our top five names.

As Audrey had warned us might happen, the first session didn't bring the sparkle we were hoping for. Alessandro organized a few others in London and Italy, and I reached out to girlfriends to bounce some ideas off them. I even enrolled my husband and sons (obviously not our target consumers) to brainstorm, play word games, and leaf through dictionaries one Saturday afternoon. They randomly came up with ideas and morphed them, following the path that Audrey had expertly laid out for us. We were all trying to find a name that would convey aspects of our brand and story, and everyone came up with many different ideas:

- Acronyms for various capitals in the world (we plan on being a truly global brand), experimenting with New York, London, Moscow, Dubai, Shanghai, São Paulo, Milan, and Geneva with mixed results such as Lodys, Lyndris (too pharmaceutical), or Nighai or Nimun (not occidental enough).

- Names of powerful women, such as Cleopatra, Nefertiti (which turned into Nepatra), or Thayer (for the New Zealand explorer Helen Thayer), or Sakri (for the first American woman astronaut to go to space, Sally Kristen Ride).

- Words associated with our identity: Haute Modernity, Connectivity (we came up with names such as Altai, Alta-X, and DNX); interpretations through the tallest mountains:

Makea (for Mauna Kea in Hawaii), or Golsten
(for Mount Godwin-Austen or K2 in Pakistan).

· More random names such as Roko (for "Sirocco"
the Mediterranean wind, and "rock" as precious
stone), or Odasy (for audacity or Odyssey); Koqo
(from chocolate); Fauve (for the art period);
Sasia; Aragona; and the list went on . . .

Despite all of this hard work, reaching a consensus on a name
that conveyed luxury, modernity, and femininity without being
girly or cute eluded us. Everyone had an opinion and a preference.
The only name that seemed to rally everyone together was our
temporary one, Savelli, but Alessandro still wasn't sold. Over
the next two months, there were multiple exchanges in emails
and long international phone calls about the subject. Finally,
Alessandro emailed me saying that maybe Savelli was the best
option after all. We knew that we would need to be extra-careful
regarding our visual identity to counter-balance a name that
implied luxury, quality, heritage, and craftsmanship but not
modernity. Happily, our original temporary name, Savelli, is here
to stay and everyone unanimously supports it.

With that step out of the way, now all we had to do was
trademark it. We all thought it would be easy given that it's
Alessandro's last name. Wrong! Nothing is easy, and there are
always surprises when establishing a start-up.

C. TRADEMARK

Seeing as we hadn't decided until the summer of 2011 that our
name would indeed be Savelli, we hadn't started the process

of registering the name right away. Honestly, we weren't very concerned because it's not a common name; nobody thought there would be any issues. There were. While I knew that trademarks are legislated by countries, I had never gone through the actual process before and didn't realize all the intricacies involved in this crucial phase.

The initial step is to do some research and confirm that your name is available. Thanks to Peter Ashall, an advisor who was also the first President of Vertu, we were able to find a trademark lawyer based in the United Kingdom who actually had experience in our nascent industry. The first thing the lawyer explained was that most possible names/permutations have already been patented in one country or another, for one product or another. There are some individuals who have made small fortunes by just patenting names all over the world, especially in markets that don't seem crucial to brands bearing the name. They then resell them to established and unsuspecting companies a few years later when they decide to enter that specific market or category, such as Lalique, when it decided to enter the watch segment in the 1980s, or Mellerio dits Meller, when it penetrated the Japanese market in the 1980s. After this explanation, we didn't feel as bad when we realized that the name Savelli had an application in the United States covering clothing (which wouldn't pose a problem for us). There was a German company with a trademark application for the name in two parts—SAV - ELLI—but the company focused on pet accessories and its Web site didn't seem to have been updated in some time.

Our lawyer quickly reassured us that you can be authorized to use your own name in most countries, even if it's already been registered. Of course, members of the same families who

have gone their separate ways might have legitimate fights over their last names (which has happened in a few instances in the luxury world), but most of them settle their issues outside of court. Supporting our lawyer's assessment, in 2010 the European Court of Justice ruled on an interesting case between the audio company Harman International Industries—which owns trademarks for "Becker" and "Becker Online Pro"—and Barbara Becker, the former wife of the tennis star Boris Becker. The audio company was trying to stop Barbara Becker from trademarking her name.[8] The Court of Justice of the European Union ruled that Barbara Becker's celebrity status in Europe qualified her for European Union Trademark protection, even though she had applied for her trademark two years after Harman Industries.[9] After some discussions and additional research, we all felt that the trademark risks for "Savelli" were minimal, so we moved forward with our official name.

Now we had to define what and where to patent. Seems simple enough, right? Wrong again! We first had to determine which geographical zones were necessary to cover to protect our brand. You might think that this would include *all* of them. Unless you have a lot of money to spare, it would be an expensive proposition that you might want to avoid when creating your brand. With that in mind, we chose to focus on the countries in which we planned to distribute first, and Alessandro created a list of them in descending priority. There were many countries we desired, but we had to limit ourselves to the ones that could be registered under a single "International Registration." Each separate filing costs an additional $1,000. You do the math. In our opinion, the best course of action was to first file in the countries we really needed and wait to file in the countries we only wanted until after the Series B funding round.

After selecting your geographical areas, it's time to pick the various categories in which you want to file your trademark. Once again, you'll be surprised to discover how many sub-categories are relevant to your new brand. In our case, we narrowed the list down to eight classes that cover not only mobile phones, but also other categories we would like to enter soon.

Obviously, the more classes to which you apply, the more expensive the applications become. All of this was taking place while we continued to develop the actual company: For any start-up, everything must be done at the same time and should be completed, well, yesterday.

D. VISUAL IDENTITY

After finalizing our brand strategy and name, we had to focus on all the diverse aspects of our visual identity: What would our logo look like? What would be our trademark colors? Our corporate identity? Our business cards and stationery? Our packaging?

The same way we partnered with Elastic Strategy (the agency led by Audrey Francis) for the branding, we had to find specialists in various aspects of design, and different talents and competencies are required for each category. Large creative agencies may offer all kinds of services (from designing your actual product or your logo to online and social media strategy and advertising campaigns), but you can still find smaller boutique agencies that specialize in specific aspects of the creative process. Once you enter the world of high-profile creative design agencies, you grasp the vast amount of talent that's out there: From Saffron Brand Consultants and Laird + Partners to Established or Dave, you know you'll be in great hands. You just need to find the agency that works best for your project, team, and budget.

Guillaume had previously worked with Sam O'Donahue, the founder of Established, on Svedka's visual identity, including its packaging and graphic design. The collaboration had obviously been a great success. Even though Sam and his team are based in New York City, and Savelli is corporately based in Geneva, Switzerland, Alessandro didn't mind coming to New York for this part of the project. Being based in New York ourselves, Guillaume and I felt it could work well because we were extremely involved in this aspect of the project.

At the end of August 2011, we kicked off the visual identity phase with an immersion session for Sam and his team in New York. Audrey, Guillaume, and I shared our vision of the brand and we went over everything that had to be done during the first few months. Sam went for two intense days of meetings in Geneva, where he met the rest of our small group, along with the design team (more about them later on). After a couple of weeks of "total immersion" in our company, Sam and his team organized a debriefing session at Sam's studio in downtown New York.

The meeting began as Sam presented Guillaume, Alex, and me with a few design boards with the vision he and his team developed for Savelli. These boards visually showed us both what the Savelli brand is and what it's not. We started with logos, and Sam took us through various examples to solicit our feedback. We agreed that we wouldn't use a very traditional script font like Loro Piana, given the technological aspect of our product; nor could it be too "fashion-y," like Christian Louboutin; nor too tech-y, like Bose. As a European luxury brand we would be immersed in a classic yet modern world, and we wouldn't want to appear as a pure technology or futuristic brand. Logos like those belonging to Chanel, Dior, and Prada would be what we'd try and emulate: Each is clean and simple, but with a different typeface and personality.

167

The Luxury Alchemist

Other mood boards featured images that were either on or off target with what Sam and his team had heard us discuss:

· Our craft is about precision, the art of hand-made products, and attention to details and perfection, like a rare old watch. It shouldn't give the feeling of a shoe by John Lobb or a suit by a traditional British tailor from Savile Row. We want to convey modernity while speaking to our craft.

· Our European flavor should be modern and break the rules. We were inspired by the pioneering fashion designer Yves Saint Laurent. We didn't want to seem too classical, like Cartier.

· The technological aspect of our DNA must be subtle in its design and avoid becoming too cold and sterile. It should not morph into another "boy toy."

· We should be playful, like in Dior's 2011 advertising campaign for their *Miss Dior Chérie* fragrance. It depicts a young woman lifted above the roofs of Paris with colorful balloons. We wanted to avoid seeming cute, like Juicy Couture.

· We should be feminine but not femme fatale, which is the mood given by Dior's *Poison* fragrance advertising.

After absorbing these elements and providing our feedback, we moved to the more interactive part of the session: visual territories. What do we stand for visually? Are we mainly playful, multifaceted, natural, modern, or effortless luxury? Each oversized board displayed a number of words and images developing the main theme. We had to pick among eight mood boards: Effortless Luxury, Playful, Multifaceted, Naturally, Just for You, Super Modern, Artistry of Technology and Craft, and Movement with Grace.

In some way or another, we felt that we were all of these things. After going back and forth a bit, we all rallied around one board: "Movement with Grace." It really resonated with us and also tied back to the various comments and feedback from the focus groups: Women must run all the time in order to accomplish everything they need to do, all the while making it appear effortless and easy. The words paired with this board mirrored these feelings: Energetic but Elegant, Fluid, In Flight, Poetic, Playful, Calm in a Storm, One Step Ahead, Not Rigid or Cold, She Moves through Her Day with Grace and Style, Technology Flows and Moves Like a Wave, Quietly Powerful, Graceful and Feminine.

After we selected the board, the next homework assignment Sam gave us was to experiment with the associated images. He asked us to remove any visual that we might be less than comfortable with, and to add any image from other boards that felt relevant to the brand. The goal was to enrich and complete the original board. We also had to select images that were definitely *not* for us. As we went on, adding and removing, we realized that we included much imagery from the "playful" board, yet we didn't feel comfortable pegging ourselves as a "playful" brand. Sam and his team had their work cut out for them: They had the challenge

of reconciling Savelli's strong and vibrant colors with its grace and elegance—the appearance of ease despite all the exertion and work. They had to represent the Savelli woman: From mother to business woman, from wife to activist, from daughter to tastemaker, she makes it look so simple and effortless!

Over the next few weeks, Sam and his team began showing us possible logos, fonts, colors, watermarks, and packaging designs. Again, it can be difficult to imagine how much work goes into selecting a font before you've actually done it. We had to think about whether the *v* in Savelli would be thick enough when shrunk on a business card, whether it should be treated differently on a billboard or shopping bag. All of this makes complete sense, but I doubt anyone outside the industry would think about it.

For our logo, we opted for a very clean and simple font, but with the *S* in Savelli rounded to look more feminine. We excluded fonts that looked too futuristic, and those that felt too traditional. It took a lot of work and research from Sam's team and many discussions between each other.

Despite the fact that we had decided against a watermark (such as a crest above the brand's name), we still wanted a signature shape, a mark that we could somehow incorporate into our visuals that could act as a sort of symbol (think of Chanel's double *C* or *LV* for Louis Vuitton). Sam's team played with diverse visual effects related to movement, from stars and snowflakes to computer-like letters, like in the film *The Matrix*. They focused on the *S*, which can appear like an unfinished figure 8—a lucky number in many cultures and countries, such as in China. *S* is also the best letter to depict the notion of movement. We narrowed the signature down to something that's a blend of an unfinished *S*, a comma, and a small feather; the result evokes graceful movement. The additional bonus is that the symbol is

also known as the Hogarth Curve or Line of Grace—a perfect match for our philosophy. It's named after William Hogarth, a British painter who used this kind of serpentine line in an auto-portrait; he wrote about it in his book *The Analysis of Beauty* (1753). In the publication, Hogarth described the shape as the "Line of Beauty," and it became known as the "Line of Grace."[10] Given that Savelli is about "Movement with Grace," the shape was an ideal signature for us!

Sam also created a "users' manual" to ensure that no one would use our signature in a way that's not consistent with our "Movement with Grace" sensibility. The guide spells out the ways in which the Savelli *S* can be used to create other shapes, drawings, or patterns and how they should reflect the idea of "Movement with Grace" through their illustration: The visuals should always appear natural (not man-made, *à la Matrix*) and avoid using symbols that depict something else. The size of the *S* should also vary; it shouldn't be too symmetrical nor too small, otherwise it could look like small ants or grains of rice—certainly not the effect we were looking for.

This level of detail, which every true luxury brand should possess, is developed in the company's brand book so that any newcomer can quickly and easily understand how the various tools should be used. This explains why some creative types feel constrained when working for an established luxury brand: The list of things one cannot do is much longer than the list of things one can do. But it's through such precise parameters that a brand can consistently give the same image to its customers.

Now, on to the color: What should be our Cartier red, Hermès orange, or Tiffany blue? How do you pick a color that conveys luxury, is fun but not too crazy, feminine but not girly? Even though we all associate only one color with a highly recognizable

The Luxury Alchemist

Savelli visual identity, developed by Sam O'Donahue and Established in fall 2011.

brand, you actually need to select more than the key color because there will be instances in which your vibrant color won't work. Sam experimented with different colors and hues, strong to subtle shadings, metallic tones, and warm shades of gold.

After some deliberations, we selected what may seem two opposing colors. However, this duality reflected the messages we had heard from many women during the focus groups. The participants were multifaceted and there was a lot going on in their lives. Our choice reflected that kind of complexity: The dominant color we selected is a fuchsia-like red—vibrant, full of life and energy, but not too trendy. It needed to be relevant to our times and not too pink; the last thing we wanted to evoke was a "girly" look. We settled on Pantone color 1925 C, a beautiful raspberry tone. Keep in mind that this kind of selection is tricky; you'll need to pick a Pantone color from thousands of shades! The yin to that yang was a bright, almost electric cobalt blue. It wasn't too serious, nor too babyish

Courtesy of Established



The Luxury Alchemist

Savelli visual identity, developed by Sam O'Donahue and Established in fall 2011.

brand, you actually need to select more than the key color because there will be instances in which your vibrant color won't work. Sam experimented with different colors and hues, strong to subtle shadings, metallic tones, and warm shades of gold.

After some deliberations, we selected what may seem two opposing colors. However, this duality reflected the messages we had heard from many women during the focus groups. The participants were multifaceted and there was a lot going on in their lives. Our choice reflected that kind of complexity: The dominant color we selected is a fuchsia-like red—vibrant, full of life and energy, but not too trendy. It needed to be relevant to our times and not too pink; the last thing we wanted to evoke was a "girly" look. We settled on Pantone color 1925 C, a beautiful raspberry tone. Keep in mind that this kind of selection is tricky; you'll need to pick a Pantone color from thousands of shades! The yin to that yang was a bright, almost electric cobalt blue. It wasn't too serious, nor too babyish

Courtesy of Established

172

or athletic, and it communicated energy. It may be hard to believe, but you do end up analyzing each color and developing trong emotions for them. Finally, for the more subtle colors to be used on stationary, or where bright colors wouldn't be appropriate, we picked two shades of grey and beige.

With these elements chosen, Sam went on to create the tools that we would use and that had to incorporate Savelli's visual identity—from business cards and PowerPoint templates to shopping bags and advertising. You can never neglect any detail in the luxury field; you must always think of the image you transmit to everyone who comes in contact with you and your brand. From suppliers to lawyers, from wholesalers to your own retail stores, it's the accumulation of such minute details—likely imperceptible to your clients—that actually create the luxury experience. When your clients go to your brick and mortar store or your Web site, they will unconsciously absorb these finer points. The customers probably won't think about, maybe won't realize, and most likely won't care about the steps and thought processes that went into ensuring that the retail experience is indeed a "selling ceremony."

With all this work we had accomplished with Audrey and Sam's individual expertise, we were now officially ready to display our "baby" in a store!

E. DESIGN

Wait a moment. Haven't we forgotten something? What about the actual phone? Isn't the product the reason why we're doing all of this? Yes, it is. You can have the best branding, the best packaging, the best marketing, but if the product isn't great, I can guarantee that you will not be successful.

The Luxury Alchemist

Alessandro had identified a few design firms even before we closed our Series A financing. He leaned in favor of a design studio based in Geneva that was well known in the luxury watch industry for being innovative and focused on women. Many of the other agencies we had met with proposed great ideas and designs, but their work was more geared toward men. Given the limited exposure of any design studio to the luxury cell phone field, this particular team's vast experience in the watch sector was the closest we could find for our category. They understood our goals and interpreted and integrated them with the latest design trends. Their specialists began working on ideas while we were simultaneously working on branding, hardware, user interface, and other details involved in creating our luxury product. Everyone was working in parallel because we had no time to waste; we didn't want to lose the advantage we had in entering the market before it became too awash with competitors.

Indeed, by the time we had finished our Series A funding, the luxury cell phone landscape had already changed. While no one could call it "crowded," there were many more players that had entered the space since 2008, including Motorola, Aura, Modelabs, Dior, Tag Heuer, Goldvish, and Ulysse Nardin. While we all regarded this development as positive (after all, it proves that our concept is good and recognized by others) and the competition as healthy, we still wanted to enter the market *sooner* rather than later.

In order to understand the evolving landscape, Alex, Marc, Peter, and I attended the 2011 edition of Baselworld, the World Watch and Jewelry Show in Basel, Switzerland. It was my first time attending the annual event and it proved to be quite an experience. If you ever want to launch a product that relates to jewelry or watches in any way, you must go to the Basel fair. Everyone is there, from large brands (Bulgari had an entire

pavilion just for themselves, with an amazing exhibit of some of their creations from the 1930s to the 1960s) to smaller stone dealers, you'll be able to meet, connect, and do business with people from all the trades involved in the different stages of your supply chain. Hence the success of the show; it helps people avoid having to fly all over the world because *everyone* is right there.

Vertu's presence had grown over the years and their booth had taken over the entire underground floor of a pavilion. They were displaying some of their latest models and emphasizing their craftsmanship and more feminine offerings with videos and other promotional materials. Trendy women's models were also unveiled—sporty phones with vibrant colors such as orange, bright yellow, and lime green, among others. The problem was that they followed what Audrey called the "pink it and shrink it" mentality, which involved taking men's models as a base design instead of creating a completely different concept for women.

The high-end watchmaker Ulysse Nardin was in another pavilion displaying their most recent creation, a luxury cell phone for men called The Chairman, which had been three years in the making. The phone worked on an Android platform, the same we had also selected for Savelli. With a masculine design concept, the phone melded a touch screen and keyboard as well as a preci-sion watch—the company's specialty. While it was comforting to see that new players were entering the field, it was even better to realize that no one had taken a similar approach to ours. Despite this comforting fact, we still felt we couldn't waste any time.

Alessandro launched the design process at the same time we were working with Audrey on branding. By the time we all met in New York for our first debriefing design session in May 2011, we were able to give informed feedback to the creative team. This first part of the creative process was purposely meant to

have no technological constraints. The idea was to approach our concept from a beautiful object's perspective, not a technological one, and unfortunately there would be ample opportunities to stifle the design team's inventive powers. It was exhilarating to see so many creative ideas, so many different approaches to shapes, materials, and functions.

The two most senior designers came to New York in May of 2011 for the initial design review, and Alex, Guillaume, and I spent the entire day reviewing their presentation. The shapes were truly innovative, inspired from nature or parallel industries, such as women's watches or fragrance bottles. The high-low mélange of materials, including rubber, titanium, exotic skins, and sapphire glass was at once original but also aligned with what we strived to accomplish: a mix of luxury, fun, modernity, and craftsmanship. There were hundreds of sketches to review and our task was to ideally select two shapes and have no more than five. We ended up selecting five and concluded the marathon day filled with enthusiasm.

Then, from total imagination and dreaming, the engineers had to bring us back to reality. Whether for technological or budgetary constraints, some of the concepts had to be shelved. A twisting phone and keyboard was too challenging for batteries; an organic shape was not really possible because it would force us to make the phone too large (batteries don't come in organic shapes); a sliding cover was risky on the mechanical front (it could get stuck and make the phone too bulky); some designs were too close to the competition; others weren't really aligned with our technological or branding strategy (we had decided not to use keypads); and the list goes on. These are just a few of the myriad frustrations that designers face when confronted with the sad realities of feasibility.

176

Beginning in the summer of 2011 and over the next six months, the design studio worked tirelessly to create an object that would be quickly and easily identifiable with our brand, yet technologically achievable. When we decided that our goal was to craft a feminine phone that wasn't girly, Sam and his team had not yet joined the team and Audrey was finishing up her branding platform. We didn't have Sam's input about the design that I shared with you earlier. However, we independently came to the conclusion that if we were to single out one simple feminine shape, it would be a curve. This was even before we had developed our tag line "Movement with Grace" and our "Line of Grace," which proved that we had done a good job at defining our brand! Our use of Hogarth's Line of Grace through our S-curve is considered the best way to symbolize femininity, elegance, and grace, but how do you integrate curves into an object that is fundamentally technological, that is, all about straight lines? It is much easier said than done.

Over the summer we narrowed down the shapes to two major directions we felt were innovative and feminine: We called the first one "the Almond," which would feature a *bombé* shape. This form is slightly rounded and convex and is often used in high-end watches, but it posed technical challenges and cost issues: Sapphire *bombé* glass costs twenty times more than a flat screen. Despite this, we all thought the Almond had an aesthetically pleasing asymmetrical form and seemed very organic. The other proposal was the "Crazy 8." A lucky number in many cultures and reminiscent of a ribbon, the figure 8 is also an infinity symbol when placed horizontally. During our July 2011 board meeting in London, we all agreed that the designers needed to somehow fuse some elements from both concepts. We wanted to continue working on the *bombé*

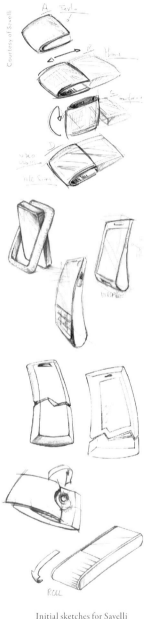

Initial sketches for Savelli
phone from May 2011.

concept featured by the Almond, but not the asymmetrical shape, which would entail too many technical issues and was not timeless enough. We all recognized the potential in the Crazy 8 shape, but had to make sure that our interpretation would not be too classical; the concept had already been seen in the jewelry world—think of Cartier's Trinity ring.

The Almond design eventually evolved into a *baignoire* (meaning bathtub), a more nuanced and symmetrical shape. In order to apply the *bombé* convex glass on both sides of the phone, all the way to the end, we realized that the phone would indeed be very long. As a result, the Crazy 8 became more of a twist. The shape continued to transform itself over the following months.

At that stage, the designers worked closely with Marc and were given precise technological details that had to be taken into consideration: the size of the screen; the location of the camera, the sensors, the microphone; the size and ideal location of the battery; the structure of the user interface and on/off switches; the data and audio connectors; the SIM card position; and the antenna.

While the designers continued to focus on creating an exquisite *objet*, Marc and Alessandro worked on ensuring that our luxury cell phone would function flawlessly. From the beginning we had agreed with Vertu's approach: Our phone would not need to be revolutionary in its technology. Our goal was not to invent the best technology because other companies were better positioned to do that. Our interaction with all the women with whom we spoke confirmed that they only used certain functions on their phones (like a handful of apps), but they expected the technology to be faultless. We had decided early on that we preferred a touch screen to a keypad. We had also settled on Android technology, which was versatile and easy to upgrade remotely. Android is also flexible enough in terms of personalizing your user interface (our own screen's graphic design would engage the user and help her to figure out how to use her phone intuitively), which would obviously be key for us: Once the phone is turned on, the screen must convey luxury, sophistication, and femininity—not necessarily technology.

The good news was that technology had advanced enough that we could be confident in the quality we would deliver to our most discerning clients. However, that doesn't mean that this part of the process was easy. Marc and Peter's expertise were essential in guaranteeing that we would get the best results at every step.

We studied issues that Vertu and other luxury cell phones had encountered and tried to find a solution to each challenge. We would only use the highest quality leather so that—similar to a Hermès bag—it would age gracefully. We would make the radio's performance spot-on by identifying the best place to have the antenna. We realized that making multiple design changes had the potential to create hurtful delays, and that it was best to

avoid the clamshell configuration or any other design elements that could move and create unnecessary complications. By partnering with the best jewelry stone-setters, *pavés* would be of the highest quality possible. We would develop a tight reverse-logistics process and a simple-yet-precise users' manual. These are just a few of the many decisions we made along the way.

While developing a flawlessly operational and truly innovative shape for our phone, we also had to conceive the "dressing." Would the surface have a texture? Would we create patterns? If so, would they be organic or more geometrical? The goal was to execute a design that broke away from all existing cell phone designs. By the time we reached this stage, Sam and Established had already devised its visual identity: The "line of grace" had merged into a more rounded shape at the top of the phone, the Crazy 8 had become the interlace, and he had kept the Almond-inspired *bombé* sapphire glass. Peter and Alex were especially excited by the interlace design, which was unique and set us apart from our competitors. We moved forward with our final shape and slightly tweaked it to infuse the design with even more finesse. We began experimenting with exotic skins, ceramic, rubber, titanium, and other materials associated with design, quality, and modern luxury. At this point we were ready to move on to the next phase: prototypes!

We had to make sure that the size felt right (not too big, but not too small either), and that the weight was correct (not too heavy, but not so light that it would feel flimsy). We first focused on "non-working prototypes" as we had to start meeting with retailers and share our magic with them. Simultaneously we started thinking of the phase following the launch (as you might realize, a great deal of time passes between an idea and a prototype) and products that would expand our space beyond

luxury cell phones. Contrary to men, many of whom carry their cell phones in their pockets, women more often than not carry them in purses. It seemed natural that we offer small pouches in the spirit of Van Cleef & Arpels's *minaudières*.

I was personally extremely keen on designing a beautiful Bluetooth: It would be similar to an earring—a piece of technological jewelry that women would actually wear on their ears. Our first executive summaries, which featured old designs that had to be reworked, offered potential investors, retailers, and other interested parties a sense of our direction. When we initially developed the Savelli summaries in 2008, they included Bluetooth and phone collections. The *Farfalle* design included butterflies on the frames and was reminiscent of 1930s jewelry designs. *Stelle* had black enamel borders encrusted with small diamonds of different sizes, intended to make you think of a starry night. With a fun design and multi-colored stones, the *Caramelle* collection evoked candies. We learned that sales of Bluetooth sets among women makes up, at best, only 10 percent of all cell phones sold, so we haven't pushed it for the launch. I still believe in its potential, and will be one of the first purchasers and bearers of a Savelli Bluetooth!

F. SERVICE

Over the last ten years, the luxury industry has put a greater emphasis on service—not just its products. One of the key reasons Vertu owners give when justifying their purchase is the twenty-four-hour concierge service at their disposal. The staff speaks multiple languages, including Chinese, Russian, and Arabic, and is ready and able to handle anything from mundane requests, like booking restaurant reservations, to the

most extravagant of demands, such as obtaining authorization to play the organ at Notre Dame Cathedral in Paris.[11]

From the very beginning, we were all aware that the service aspect would be a must-have for our target customer. After all, if wealthy patrons were willing to pay a fee of up to $40,000 per year to access luxury concierge services via the UK–based Quintessentially (Vertu offers such a concierge service, but you can also purchase an annual membership at Quintessentially and other similar companies without owning a luxury cell phone), it should certainly be part of our value proposition.[12] Alessandro wanted to go further with our phone: Many Vertu owners rarely used the concierge service because they simply forgot they had it, so Savelli will propose a proactive service that would bring concierge services to a new level. The technology is out there already: Most cell phones have a GPS system, but we would add a near-field communication service that, once enabled, would inform our concierge service of the user's location. Based on the information that customers have shared with us, Savelli would then propose tailored activities, such as going to an art opening in Miami or sharing new opportunities available in a particular neighborhood or city. It could also notify someone's favorite hotel or restaurant of her preferences, which, for example, could include having your favorite salted butter caramels waiting for you in your room at the Hotel Plaza Athénée in Paris. Our service would be different from current concierge services, as they normally receive last-minute requests and therefore have to be reactive. We will provide solutions to our clients depending on their location and our proactive method should enable Savelli to surprise its customers and transform them into the best brand ambassadors!

5

THE MOMENT OF TRUTH

A. DISTRIBUTION STRATEGY

One of the most important decisions for the launch of any product is its distribution strategy. As everything in the luxury world is about control (image, quality, experience) the ideal distribution is, of course, to open your own retail stores. That requires a substantial amount of money (you not only pay all the costs but also carry the inventory), but the rewards are worth the financial weight—if you can afford it, that is. A retail store allows you to deliver your brand's complete message, display all your product categories (that wholesalers might not be interested in), show what your brand stands for, and educate your customers.

The importance of this kind of control is something that Prosper and Martine Assouline fully understood when they decided to transform their publishing company into a real luxury brand. Assouline had been publishing magnificent illustrated books for over a decade when Prosper and Martine, the company's founders, realized they were unhappy with the way their beautiful *objets* were being displayed in bookstores. They embarked on an ambitious venture: opening their own boutiques, in-store corners, and shops-in-shops to position their company as a luxury brand. From Saint-Germain-des-Prés and the mezzanine of the Plaza Hotel in New York to South Coast Plaza in California, and Istanbul, Lima, Seoul, and Neiman Marcus in San Francisco, Assouline's boutiques

have become "engines of culture" in the luxury world. They could have settled for their success, but Prosper and Martine went even further: They had the courage (some might call it heroism!) to go against distributing through Amazon (except for books whose retail price is below $100) in order to ensure that their most precious creations receive the attention and service they require. In turn, they limited their distribution to their boutiques and a few select luxury retailers.

The same way a fashion house doesn't sell its fragrances through the same channels as their haute couture or ready-to-wear collections, Assouline controls its distribution in order to maintain the brand's integrity. As a result of this demand for control, new horizons opened to Assouline in terms of product offerings, allowing them to go beyond *the book*, their core competency, while staying within their domain, the library. From candles inspired by the scents of leather bindings and antique wood to stationary, notebooks, bookstands, vintage bookends, globes, and sculptures, Assouline has it all, including exclusive *objets* designed by the world's most recognized luxury brands, such as their leather trunk by Goyard. The brand also understood the importance of service—it is the key to guaranteeing clients' loyalty.

Assouline didn't stop at the unique gift wrapping bearing their signature red wax seal or their exquisitely designed custom book bindings, they became the *ultimate* reference in library design. From private residences to hotels and clubs, the Assouline library has become synonymous with luxury and sophistication, and it all started with regulating their distribution network.

This is one of the main reasons why many luxury brands are trying to open their own mono-brand stores in China, where

consumers still have a lot to learn about luxury in general and may not be familiar with each particular brand. It might not be a good option, however, for an entrepreneur who has to invest in a nascent business and doesn't have the revenue to invest in such a costly proposition. The next best option is a "shop-in-shop" or "concession," which is essentially creating your own small store within a larger retail space. While that may be another attractive option, you must remember that retailers want to control their space and make sure that the brands they welcome will be profitable. Therefore, this solution might be difficult to materialize. The most likely alternative could be to sell to high-end department stores and specialty stores as a wholesale account. These kinds of retailers must guarantee that their selling space is profitable, so you'll need to convince the buyer that your product will be a hit! In Savelli's case, that is the option we'll have to follow for our launch, so selecting the right retailing partner is crucial.

At a February 2012 board meeting, the final Savelli phone designs and treatments were approved. It was time to go on to

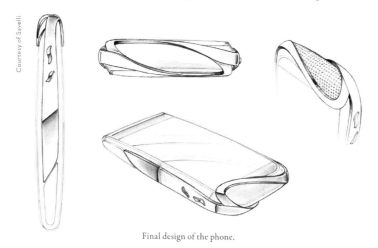

Courtesy of Savelli

Final design of the phone.

the next major test: meeting with key retailers. From day one we knew that if Nokia hadn't launched the luxury cell phone sector with Vertu, it would have been almost impossible for a start-up to convince retailers to carry a new category. When Vertu began, Nokia had to employ all their power and credibility to convince high-end retailers like Harrods, Galeries Lafayette, and Barneys to carry their new product. Each square foot of sales floor is precious for those department stores, and they must generate sales and profits.

In 2009, Bloomberg estimated that Tiffany's generated as much as $18,000 per square foot, and Apple's Fifth Avenue flagship store in New York around $35,000 in revenue per square foot.[13] In luxury department stores, brands battle to get the areas with the highest foot traffic in the hope of converting walk-ins into shoppers. (As a reference, in 2013 most high-end department stores would expect their concessions' spaces to make around $30,000 per square foot.)

One thing we at Savelli had to keep in mind was that Vertu had access to capital, allowing it to open its own stores. Obviously that's ideal—if you can afford it—because it allows you to create your own world and control your customer's experience. This is why powerful luxury brands, such as Louis Vuitton, own every single one of their stores, even those in high-end department stores. Their strength in the marketplace puts them in a bargaining position that few companies can have in such establishments. Very few brands can claim to have full control over their space at Saks, as well as their own salespeople and their own merchandiser.

When Vertu launched in 2002, it opened retail spaces in major cities around the world, including London, Paris, Milan, and Hong Kong. Almost overnight they had a perfect

distribution channel. By May 2012, when it was announced that Permira was interested in purchasing the company for $300 million, Vertu products were sold in over sixty countries. (EQT, a Scandinavian private equity fund, actually acquired 90 percent of Vertu for an undisclosed amount in October 2012, with Nokia retaining 10 percent ownership. The statistics for 2011 were €266 million in revenue and the company had 1,000 employees.)[14]

Unfortunately, Savelli doesn't possess a magic wand (or that kind of capital) and won't be able to open our autonomous stores for some time. We know where we need to be present, just as we know who our customers are. While Vertu targeted men who love their toys, the Savelli woman isn't necessarily his counterpart. She is affluent, travels extensively, and is extremely active, either through her career or the charitable organizations with which she's involved. She juggles her tasks with elegance. She is daring and adventurous, willing to take risks. She is an independent thinker and surrounds herself with beauty and art. So where does the Savelli woman go? Where does she shop? She goes to London, Paris, Milan, Shanghai, Rio de Janeiro, Tokyo, Moscow, Sydney, Mumbai, Istanbul, or Beirut as easily as she goes to Capri, Saint-Tropez, and Bodrum in the summer and to Courchevel, Gstaad, Punta del Este, and Bali in the winter.

While Asia will be key to our distribution, it's crucial to establish our legitimacy in Europe as an Italian-designed and Swiss-manufactured brand. It makes sense that our first steps will be in European destinations that affluent international travelers would frequent: London, Paris, Geneva, and Milan are at the top of our list for Year One. Ideally, there would also be some temporary locations in the Swiss Alps during the

winter and the French Riviera for the summer. Following the launch we will expand to Asia and the Middle East, including Hong Kong and Macao (where Vertu has its most profitable boutiques in the world, along with Dubai and Abu Dhabi). In Years Three and Four we will expand to other countries in Europe, and to Russia, India, Brazil, and the rest of Latin America. International expansion will be fundamental in establishing Savelli as a global luxury brand, just as it was for the jewelry company H. Stern, which grew beyond its original birthplace of Brazil and its acclaimed expertise in colored gems to position itself as a worldwide luxury leader.

Alessandro met with retailers early on, including Jim Gold, who was at the time CEO of Bergdorf Goodman; the head buyer of accessories at Lane Crawford; as well as senior management and buyers at Printemps in Paris; Italy's Rocca; and Rivoli in the Middle East. All had been enthusiastic and told us to come back when we were ready. In addition to luxury department stores, we would also need to reach out to large, medium, and even small watch and jewelry stores. As early as 2009, the CEO of Ethos Watches, India's largest watch and jewelry retailer, sent us a letter of intent and has been eagerly awaiting us!

When you think about distribution parameters, you should also think outside the box—especially in the luxury field. Luxury is about dreaming. Surprising your clients and showing off your imagination in your distribution strategy will also impress your customers. The concept of a pop-up shop, which was born of a practical reason (empty retail space that owners were willing to lease for a short period of time while looking for a permanent, long-term renter) and seemed so novel just a few years ago, is still very effective. In

November 2011, Dior collaborated with the German artist Anselm Reyle to create a limited-edition line of special handbags, scarves, shoes, and small leather goods. To launch this line, Dior opened a 3,100-square-foot pop-up shop in the trendy Design District in Miami during Art Basel. To add to the consumer experience, a specially designed food truck was parked outside serving French pastries and café au lait. Christofle, a luxury silverware and home accessories company, opened a pop-up shop on Madison Avenue and Seventy-Fifth Street in New York in April 2012 and kicked off their opening with a chocolate tasting in collaboration with the famed chocolatier La Maison du Chocolat.[15]

This solution would be ideal for Savelli because it would give us the flexibility to follow our customers wherever they go. The fundamental issue of a pop-up shop is that it's hard to plan ahead; retail spaces in locations you like are scarce, and when you're not an established brand it might be challenging to convince owners to rent to you. One thing that few start-ups think about but that is important to understand is that when the owner of a store has the choice between two or more renters, they will almost certainly prefer the more deep-rooted company: They should have fewer issues paying the rent. If the retailer goes for a smaller brand, they will prefer a company that has a "big brother" watching out, meaning that the company is part of a larger group. The more established the brand, the easier it is to rent the next available store. Luxury likes company, and brands tend to flock to where their peers are. This mode of sales also makes shoppers' lives easier because they are able to go from one door to the next. The recent development of luxury malls is a product of this phenomenon.

The Luxury Alchemist

While luxury brands still prefer to congregate on fashionable streets, such as the Faubourg Saint-Honoré in Paris, Via Montenapoleone in Milan, and Madison Avenue in New York, such options might not exist in every place where luxury brands want to open stores. One of the very first luxurious shopping malls in the United States is South Coast Plaza, located in southern California, which inaugurated its famous "Fashion Island" in 1987 and subsequently attracted the most respected luxury brands. It makes sense because things in Southern California are spread out and distances are vast; not everyone is necessarily willing to drive all the way to Rodeo Drive. The same phenomenon developed in Hong Kong at an even faster pace because of the humid, warm climate, which makes strolling through the streets an unlikely pastime for most throughout the year. These high-end shopping centers have become the destination of choice for luxury brands entering emerging markets after being confined for a couple of decades to high-end hotels. This was the case in China and India, where few natives were previously able to afford their products. The bottom line is this: Even if you have the money, finding the right location for a new luxury brand could be a challenge.

When trying to secure your own space for a pop-up shop, you need to consider the fact that the surprise factor can also play against you. No one will know you're there unless you let them know! In addition to marketing initiatives, the most fundamental asset will be your sales force. If you are an established brand, clients will find you because of the likely media coverage you will receive for your new store. Established companies additionally will be able to pull some of the best salespeople, those who know the history and heritage of the brand, to convey your message to your clients.

When you're a smaller brand and have few or no sales-people to move into the pop-up store, you may end up hiring temporary staff that might not be able to explain your brand properly. Even if potential customers come in, these newcomers might not be able to actually sell your products. There is another important challenge you will face if you decide to go to a more seasonal destination, like a ski or summer resort. You must find experienced salespeople who actually know the VIP clients who come regularly to that resort and would be interested in your brand and could invite them to the pop-up shop. These high-quality salespeople are in high demand, so it could prove difficult to secure them for your pop-up shop unless you are willing to compensate them really well. They might not wish to antagonize—or risk losing the opportunity to work with—a more established brand or store that has been around for a while and that will undoubtedly be around the following year.

A great solution might be to look into creating a pop-up shop within an existing store. This has become a popular alter-native because the existing store and the temporary occupant both win: The visiting brand brings novelty and excitement to the boutique, which is also a great way to bring back existing customers. The pop-up brand experiences instant gratifica-tion within an existing space that acts as a "home" for its own clients, and would hopefully draw in new clients. One thing to keep is mind is that a real synergy needs to exist between the hosting and hosted players. Not only should both share the same customer profile, but also they should share the same domain. In Savelli's case, it would be logical to have a presence in jewelry stores but also in high-end fashion or accessories

boutiques. The hosted brand would be well advised to have its own sales force; few salespeople are talented enough to sell products outside their competency and expertise.

In order for a pop-up store to be successful, you also need it to come to life and attract awareness. The whole concept is that it's a surprise, meaning that people will not be initially aware of it and it won't be around for very long. Depending on your consumer, awareness could come from advertising or special events. Target is considered the grandfather of pop-up shops; it opened its first one in Manhattan in 2002 with the Target Boat at Chelsea Piers, located on New York's Hudson River. Many New Yorkers remember their large 2003 space at Rockefeller Center, which was the result of a collaboration between the company and designer Isaac Mizrahi. The partnership was heavily advertised throughout the city.[16]

In Savelli's case, a pop-up shop would have to host various events for a small group of the brand's friends. It could even be in a format that has been used for decades by other high-end companies—utilizing a luxury hotel in a destination resort (the Gstaad Palace in Switzerland, for example), and transforming it into a private shopping destination. This can even be done in private residences, where the host or hostess would invite their friends. The intimate setting certainly has its advantages. The main drawback to this distribution technique is that the pool of potential clients is limited to already-established connections, but depending on how active these individuals are in their own social hub, it might be extremely effective. This is the basis of buzz marketing, which we'll delve into later. Savelli's future clients need to feel special, and we need to create an inviting environment in which they'll feel pampered. No matter the setting, exclusivity is key.

After our prototypes were finished in the spring of 2012, it was time to confirm that all the hard work was worth it! On Friday May 11, 2012, Alessandro and Enrico Mambelli met with jewelry and watch buyers from Harrods in London—the *ultimate* test for any luxury brand—where they presented our latest non-working prototypes (it would be another few months before we would have working prototypes). The meeting was a success and the buyers began discussing delivery dates, retail floor space, location, and marketing strategy. We had passed this important milestone with flying colors! The next meeting was with Le Printemps in Paris and it too went equally well. We had confidence and felt energized, even though we knew it was just the beginning of a long series of meetings with retailers.

As of June 2013, we have confirmed that our first point of sale will be Le Printemps department store in Paris with our own pop-up store opening from July 11 to August 29, 2013.

Diamond Night

Champagne Diamonds

Courtesy of Savelli

Ardent Red

Savelli initial collection,
summer 2013.

193

Numerous display cases will allow us to present the brand with a full breadth of collections along with our own sales team. It will be located on the first-floor walkway in Le Printemps's fashion building (the luxury watch and jewelry floor), ensuring that we reach not only Parisians, but also international customers hailing from Asia and the Middle East. For many of them, Le Printemps is a must-stop while shopping in Paris. The very same location was used in June 2012 for the *Iconic Watches* exhibition, which featured brands such as Cartier, Piaget, Van Cleef & Arpels, and Panerai—Savelli has big shoes to fill!

Having Savelli's first distribution point at Le Printemps is a testament to the quality of our product and service offerings as well as marketing and branding strategies. We are jointly developing with Le Printemps a number of promotional initiatives to drive up the number of visits to our pop-up shop, both from VIP tourists and local customers. Some of the strategies will be personal appearances by celebrities, large outdoor billboards featuring our advertisements, the use of Le Printemps's VIP client relations team, and reaching out to luxury travel operators and hotels.

We are also thrilled to have confirmed our distribution with Harrods in London beginning on July 25, 2013. Our presence will start in the prestigious fine jewelry room and then move to a pop-up shop in the luxury watch room. We will have advertising signage and videos near the famous Egyptian Escalator, as well as window displays on Basil Street.

Furthermore, we are finalizing distribution plans in Italy and targeting retailers in the right locations—Milan, Rome, Porto Cervo, and Cortina. We have to show them that we are going to invest in the marketing and promotion of our brand through advertising, events, and reaching out to

influential Italian bloggers, such as Chiara Ferragni, founder of "The Blond Salad." We're also pushing on our potential distribution partners in Hong Kong (where we plan on being sold before the Chinese New Year in January 2014), the Middle East, Russia, and India. We're not forgetting the United States, either. We intend to resume our original negotiations with Bergdorf Goodman to target sales for the Christmas and Chinese New Year holidays!

In today's digital world, it's hard to conceive of a distribution strategy without incorporating e-commerce. In the world of luxury, though, e-commerce is still nascent, as luxury brands are still experimenting to find the best way to interact with their clients in the virtual world. How do you go about bringing people in when you're launching an *objet* like the Savelli phone? How can you convey the magic through images when the potential client could have so many questions? Our answer is to create a Web site that will communicate all the facets of our brand. E-commerce will be the second step once we've established the brand and will only target markets we will have already entered. A special online platform will be available for clients from the start, which will act as a personal VIP card to the world of Savelli. We also want to listen to our clients and have an open dialogue with them. We want to engage them through social media platforms, dispelling the notion that luxury brands don't embrace two-way modes of communication, and showing that Savelli is indeed about Haute Modernity.

As we are in the final stages of securing our distribution, Savelli is also working on its retail environment. The point of sale will be your brand's most important touch point with your client. It is the one encounter that will turn a curious

shopper into a devotee, so every detail is essential: the materials you select, the design of display cases, the lighting, the orchestration of each precious object in relation to the other, and the promotional materials explaining the story of the brand. No matter what, every aspect of your marketing strategy should burst with life in your retail environment.

B. MARKETING STRATEGY

All marketing strategies start with defining your target customer. Every luxury expert has their own way of defining the luxury consumer, and I always appreciate the subtle nuances in these different approaches. Fewer brands now analyze their customers by age group, such as Baby Boomers, Generation Y, or Millennials. While it's obvious that consumers' shopping habits evolve with age and are influenced by their peers, more and more shoppers are becoming ageless in their behavior, and psychographic analysis seems to be more pertinent now than ever in the past. Pamela Danziger, an acclaimed author and expert specializing in consumer insights for luxury marketers, splits luxury consumers into five distinct psychographic buckets:[17]

- X-fluents: big spenders who consume every bit of luxury there is.

- Butterflies: affluents who care about the environment and are socially conscious.

- Cocooners: who mainly spend money on their home, but not necessarily on fashion, jewelry, or accessories.

- Aspirers: who don't have the budget yet to
 spend on luxury but aspire to it.

- Temperate Pragmatists: After the 2008
 economic crisis, a new group emerged—
 those who enjoy luxury but for whom it's not
 really important.[18]

In the 2010 scenarioDNA Annual Report on the State of Luxury, consumer insights experts and company cofounders Tim Stock and Marie Lena Tupot analyzed the luxury consumer through a slightly different lens.[19] They leveraged culture mapping to make sense of language and signs. In the case of the luxury consumer, their analysis started with 1900s magnates, continued with the 1980s Gordon Gekko types, and the 1990s "keeping up with the Joneses" syndrome, to settle on what they see as the new luxury archetypes. The archetypes rise from four essential and interrelated codes: Perfection, Guilt, Freedom, and Rank.

- Purists: seek well-known brands that have a
 more contemporary approach and sensibility in
 line with the true essence of the craftsmanship
 behind the brand.

- Guilted Lilies: seek brand involvement
 and desire to demonstrate a connection with
 nature and the environment, and do not wish
 to display their wealth ostentatiously.

- Passport Posse: for whom luxury is a mix of
 acquisition and accomplishment,
 demonstrating an awareness of innovation,
 rule breaking, and global networking.

- New Heavies: for whom luxury is about
 assertion of status and rank; they want others
 to know about their wealth and see it as a sign
 of their accomplishments.

It is crucial that luxury brands understand these subtle differences about their customers and how—even if they might purchase the same bag, dress, or suit—they should still communicate with each of them differently.

In May 2012, I attended a presentation by Andrew Wu, the group president of LVMH for Greater China, and learned interesting facts that made me look at the Chinese luxury consumer in a slightly different way. It was fascinating to hear him explain how rank has always been a part of Chinese culture. Contrary to popular belief, this stratification is not at all a recent phenomenon linked to the economic boom the country has enjoyed for the last decade. Even during Mao's rule (1949–1976), when food and other basic necessities were sparse and the famous "Mao jacket" was used to emphasize equality (in addition to uniformity) of all citizens, the Chinese could still easily recognize officials' rank and importance according to the number of pockets their jackets had! We shouldn't be surprised that today's successful Chinese entrepreneurs aspire to show their achievements with recognizable luxury brands.

The democratization of luxury that reached Europe and the United States in the late 1980s has allowed almost any

purse to show off beautiful design, even if it doesn't have the same quality as a luxury counterpart. As a student recently arrived in New York at that time, I still remember my awe when I discovered Pottery Barn and all the beautifully designed home products I could afford, even if I knew they'd most likely not last as long as Baccarat glassware. This phenomenon spread to emerging countries, with mass luxury becoming the fastest growing retail segment, outpacing the high-end segment's growth rate until mid-2012 (both segments' growth has slowed since then).

Savelli obviously will not go after the Cocooners or Aspirers that Pamela Danziger describes, but will have to reach out to each potential future devotee in a way that speaks to style-conscious women. In the same vein that Vertu determined that their "sweet spot" was X-fluents in all regions of the world, Savelli must create a comprehensive and integrated marketing strategy to reach its target customer. Thankfully, we started thinking of our marketing strategy during the project's early stages (given my background, it would have been scary otherwise). As is the case with all start-ups, things evolve and you need to adapt. It is an essential attribute for any entrepreneur.

As early as 2008, one of the essential elements included in every marketing strategy presentations was the importance of creating "buzz" around the brand. In our case, we must identify major influencers in each of our markets, make them fall in love with our style, and win them over with our products and services. The main goal is to identify individuals who are socially active and at the center of their social hubs—trend-setters, charismatic women who are looked up to as role models, and fashion mavens who are always seeking the

latest products and designs. This is different from what we call expert hubs, which are comprised of individuals who have a broad knowledge of a specific area. Expert hubs are extremely useful for certain brands launching a more technical product that requires endorsements from tech gurus. Savelli will need technology experts to support those aspects of our products, but we're not positioning our phones as the most advanced in the field. Our phones will be beautiful objects that happen to have a number of practical functions that will empower consumers. In all markets, however, one of the biggest draws remains mega hubs that are created by celebrities and which are amplified by the media.[20]

Celebrity endorsements don't always get the anticipated results. That was the case in 2010 for Hairtech International, which had signed a contract with Paris Hilton so that she would endorse and wear the company's hair extensions. According to Hairtech, Paris Hilton wore other brands' hair extensions and didn't appear at some contractually mandated functions. The two parties settled outside of court, so the story ends there, but this is just one of the multiple cases of such disputes around celebrities' endorsements.[21]

Over the last few years, the public discovered that what they believed to be a personal purchase of certain products by a celebrity was in reality not only given for free to the star, but was actually often part of a financial deal with the brand. People are therefore more skeptical of celebrity endorsements, especially in Europe and the United States. Despite this knowledge, we live in a world in which celebrities are worshiped and the trend doesn't seem to be fading away. There are some stars that many still admire, women like Angelina Jolie, Helen Mirren, and Dame Judi Dench. Getting your product in their hands

or having them wear your clothes is worth more than any advertising campaign, which explains why every luxury fashion house congregates in Los Angeles before the Academy Awards. The red carpet has become a worldwide phenomenon, and if your brand is selected by a high profile or rising star, then you'll be covered not just in the traditional media, but also in the blogosphere. This kind of advertising is priceless—or should I say worth a lot of money to the brand. This is also one of the reasons why red carpet events are multiplying throughout the world in cities like Cannes, Shanghai, São Paulo, and Beirut.

Savelli must chase after these mega hubs, but, as a first step, the most feasible option will be the social hubs. By using our shareholders' contacts, friends of friends, and our professional networks, we should be able to reach out to a few important influencers in all key markets. That is the way Vertu launched in Hong Kong before opening their own boutique there. They utilized a suite at one of the city's best hotels, brought display cases and new phones, and introduced the brand to wealthy businessmen and other well-to-do patrons. Vertu also worked with American Express Centurion cardholders, allowing the company to narrow its focus to only the most likely purchasers. This is precisely what Savelli must aim to do as well.

When it comes to creating buzz, product placement is at the top of the list, not just on the red carpet but also with tastemakers. The difficult part of this angle is that it requires access to the right people, who will have to want to use and/or carry your product. While many may believe that anyone would be pleased to receive luxury items for free, getting them in the right hands is actually a tour de force. Gift bags that await guests at the Academy Awards are each worth tens, if not hundreds of thousands, of dollars. They are filled

with the latest products from the most sought-after brands in the world. Why would those brands do that? They hope that their ideal target consumer "follows" and admires the celebrity wearing or carrying their product, and that that celebrity will share their find with fans. The power of celebrities in our modern society isn't new, but it has been amplified with the modern global world in which everyone is aware of what's going on almost instantly.

Traditional advertising cannot be forgotten and remains one of the most important communication tools you have because you can retain complete control. In our ever-evolving world in which the digital media revolution has transformed the way we shop and communicate, one wonders if traditional advertising will become obsolete. Customers no longer want to be told what to do, buy, and wear; they want to share their point of view. The traditional one-way communication instrument has been suffering over the last decade, and successful publications or advertising and promotional agencies are the ones who have come up with creative solutions for advertisers, readers, and viewers. As we now settle into the second decade of this communications revolution, luxury brands and consumers have both agreed that having a beautiful publication in your hands gives you a feeling that's hard to duplicate, even on an iPad. This is why it doesn't seem likely that luxury magazines will disappear any time soon. However, they must be supplemented with a digital component. Most traditional publishing groups now offer brands a 360 degree approach for advertising that includes all media, including magazines, Web sites, mobile devices, and Facebook. Every promotion is echoed with a different yet holistic voice on several platforms.

© Cartier

"L'Odyseé de Cartier," 2012 advertising campaign.

When launching an advertising campaign, you need to start ahead of time and make sure that you've thought about all of the moving parts. The multi-channel promotional campaign that Cartier unveiled in March 2012, "L'Odyssée de Cartier," is a masterpiece of what a luxury brand's 360 degree marketing campaign should be. The campaign was two years in the making, merging the talents of the international director Bruno Aveillan and the composer Pierre Adenot to create a film starring a panther that travels from Russia to India before finally arriving in Paris. The brand's history was translated into a fantastic fairy tale. The 3:30-minute feature was previewed at the Metropolitan Museum of Art on February 29, 2012, and was acclaimed by movie critics for its magical photography and mesmerizing soundtrack. Thanks to its whimsy and beauty, viewers easily forgot that it was basically just a commercial.

After the Met event, the film was released on Cartier's Web site, where visitors may also access behind-the-scenes-details and other interesting elements. The full version of the film was released on Facebook, YouTube, major television

networks (both the complete 3:30-minute version as well as shorter forty-five-second spots), and in movie theaters. Images from the movie were used as advertising visuals and print ads in major magazines. The impact of the campaign will continue to be analyzed, but it has single-handedly guaranteed Cartier's success in positioning its iconic brand as the ultimate dream to aspire to. Savelli would like to attempt the same thing, *modestly*.

Before you can launch your marketing campaign, you still need to take a number of steps and make several decisions, the first one being to find your campaign's "face." Should it be about the product itself or should you also integrate the user? There's no right or wrong choice; it all depends on what you want your customer's focus to be. When launching a new brand, it might also be a good idea to concretely show to whom you're trying to speak, which could help your target customer relate to the brand. The PR agency you select will help you through this very important process. In our case, we need to be allied with a *real* woman, someone with whom our future clients can identify. Some of her qualities will need to be agelessness, energy, and confidence. You mustn't forget the time creating a campaign will take, so plan ahead! When creating a special events strategy around your launch, the key element is to remember the main reason why you're organizing these events: to support sales. The wisest path is to discuss it with your distribution partners, who will share what would help them most. And, of course, you must maintain your focus on the target audience so you can start creating word of mouth among your ideal brand ambassadors.

Alessandro managed to do what most established brands only dream of doing: He brought on both a well-known

photographer and model for our first advertising campaign. Famed fashion photographer Patrick Demarchelier, a man who has photographed some of the world's most well-known models, shot the campaign in New York in February 2013. Demarchelier has worked for some of the most revered luxury brands, including Chanel and Dior, and was one of Princess Diana's favorite photographers. Model Julia Restoin Roitfeld is the face of Savelli and will represent the Savelli woman with all her strength and femininity. Julia is an esteemed model and has worked with Tom Ford and Lancôme. She understands the luxury and fashion worlds, having grown up in them

© Patrick Demarchelier

SAVELLI

GENÈVE

EVERY WOMAN HAS A SECRET

www.savelli-geneve.com

First Savelli advertising campaign, launched in summer 2013, featuring Julia Restoin Roitfeld.

(Julia is the daughter of fashion icon Carine Roitfeld, the former editor in chief of French *Vogue* and the Global Fashion Director for *Harper's Bazaar* as of February 2013). She is also a "real" person who has launched her own brand and creative agency and is a mother on top of all that.

The advertising campaign will translate Savelli's essence as "the modern luxury that empowers women to take on the world with joy, grace, and elegance" through a subtle reference to the intimacy that the Savelli woman shares with her exquisite *objet*: It's all about her secret, the relationship between "her Savelli" and herself. It is Savelli that allows her to express who she is and gives her the means to take on the world with grace and elegance.

The advertising visuals will be used in all of Savelli's promotional activities, from the Le Printemps billboards in July and August 2013, to the Web site, Harrods promotions, and various launch events in Hong Kong and other international locations that we plan on hitting as soon as possible.

Our clientele and target audience won't be aware of the small pieces of the puzzle that went into creating our brand. They will not know (nor should they) about all the branding work that went behind the advertising campaign, all the thought and research behind the logo's design, or the colors that are now part of Savelli's DNA. They will not be knowledgeable of "The Line of Grace" and its importance in our visual identity. Nevertheless, it should all come together intuitively when they see our advertisements and hold our *objet*—it should feel right, as if it were always meant to be. That is what a successful brand should be about, always.

C. GIVING BACK

The last point that Savelli isn't forgetting—because it matters to clients—is what the company is doing to give back to the community. During the last decade, the role of philanthropy has significantly grown in the luxury industry. The key is to be authentic. Pick an organization that reflects your values and that also makes sense for the consumer.

Graff—the jewelry company founded by Laurence Graff in 1960—has established itself as *the* ultimate source for some of the world's most fabulous jewels. Besides creating exquisite bijoux, Graff fully understands the importance of giving back in a way that's compatible with the brand's identity. The FACET Foundation[22] (FACET stands for "For Africa's Children Every Time") was founded by Laurence Graff in 2008 and focuses on developing and supporting programs to help those in need in sub-Saharan Africa, where Graff has strong historical ties through its mining operations. FACET supports a number of charities that help children and their families through education, medical assistance, and other programs. By focusing on giving back to these specific communities, Graff possesses a legitimate connection with them, a unique connection that all luxury brands should strive for, including Savelli.

Savelli's core identity is the modern woman. Our goal is to empower her—to help her lead her life with grace and elegance—so supporting a women's organization is obviously the best choice for our brand. Organizations like Vital Voices, which trains and supports women leaders from emerging countries around the globe would be a natural fit for us. Additionally there is Every Mother Counts, an advocacy and

mobilization organization whose goal is to increase education and support for maternal and child health.

Another side of Savelli is that it stands for forward-thinking design. Partnering with design schools would also be an intuitive move. It's only a question of identifying the right local partner once we confirm our distribution. As we inch closer to the launch date, all of these details will be ironed out.

D. GOING TO MARKET: THE LAUNCH

As this book goes to print, Savelli is in its final preparation stages before launching in early summer 2013! Our worldwide launch event will take place during Haute Couture Fashion week in Paris, on Wednesday, July 3, at the prestigious Musée Jacquemart-André. The evening will include a mix of press, members of the "in-crowd," fashion moguls, international jet-setters, and Parisian VIPs. The fête will be preceded by a day of back-to-back press meetings in order to guarantee maximum worldwide media coverage. Savelli shareholders around the world will be flying to Paris to witness the culmination of the team's relentless efforts to deliver our vision.

The five-year journey will culminate with one exciting moment of truth. In order to get there, we closed our Series B financing in February 2013—yet another important step allowing the company to finance the production of various marketing initiatives. We are now in a position that will permit us to concentrate on the brand's development without having to worry about funding for a while.

We will soon be able to analyze what works best and what needs to be tweaked—no launch is ever perfect. While you

learn valuable lessons from the first phase, it's also important to focus your energy on delivering your brand's promises to clients. Establishing that trust will be key to your future success.

So what should you expect after you finally reach this phase that you've been aiming for? After relishing the moment you will realize that it's just the first step in the journey and that the road keeps on continuing. All of the building blocks, which you've stacked one on top of another, will allow your brand to have a meticulously defined DNA, guaranteeing success for years to come.

As I mentioned in the first part of this book, it's essential to be positive and fearless when you embark on a luxury start-up adventure. You'd better be ready for a roller-coaster ride—and have your Tums and aspirin within reach. As the Savelli journey continues, we learn with every step. I'm proud to be a part of this fantastic adventure. I've learned so much, made amazing new friends, and can't wait to discover the challenges that still lie ahead. With our team, board, and Alessandro's determination and leadership, we are ready to become a true success story!

Virgin Galactic

While I continue to be an active participant in the Savelli adventure, I've also been fortunate to be an involved observer of an astounding endeavor, one that is revolutionizing the way we think about luxury and, even more fundamentally, the way we approach discovery.

In early 2006, I had the honor of meeting one of my personal icons, Sir Richard Branson. To set the stage for my exchange with him, allow me to tell you the following: There are a number of things I'm passionate about—the principle one is my family and the second one is my childhood dream of going to the moon. While I doubt that I'll ever make it to the moon, I have found creative ways of pursuing this dream, such as reading Jules Verne books, watching science fiction movies, and being an avid *Star Trek* devotee.

I met Sir Richard in 2006 at an event organized by Virgin Galactic, his latest venture, which plans to provide suborbital spaceflights to private passengers. Sir Richard and I started discussing our children and the importance of mentoring

young people, and my class at Columbia Business School came up. After explaining my teaching methodology and how luxury brands can submit challenges to my students, I mentioned that it would be a fabulous opportunity for the MBA students to work on a project with Virgin Galactic. Sir Richard seemed interested, and the next day I followed up with Virgin Galactic's commercial director, Stephen Attenborough; Susan Newsam, head of marketing production; and Louella Faria-Jones, who was in charge of external relations.

In January 2008—during the unveiling of the new designs for SpaceShipTwo and WhiteKnightTwo at the Museum of Natural History in New York—thirty-six of my students had the honor of spending time with Sir Richard and Burt Rutan, a legend in the world of aeronautics. My students worked for an entire semester on the Virgin Galactic project, during which time I learned more about the endeavor and what it takes to create a different dimension in the meaning

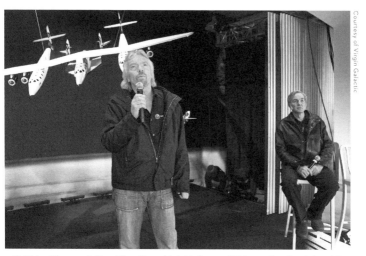

Sir Richard Branson (left) and Burt Rutan (right) in January 2008, unveiling detailed models of SpaceShipTwo at the Museum of Natural History in New York City.

of "luxury." I gained knowledge about the competitive landscape, the project's technical aspects (it helped that some of the students were actually engineers), and this new industry's potential market in order to propose recommendations for Virgin Galactic's marketing initiatives.

You might wonder why Virgin Galactic is relevant in becoming a Luxury Alchemist. What could you learn from this venture if you hope to create your own luxury brand? You will most likely never enter this particular field of expertise, so why is it interesting? Because it's always about the dream, big or small, and learning from someone else's experience. Just because Sir Richard Branson is who he is doesn't mean that things are easy at every step—certainly not when it comes to creating a whole new industry. It's about pursuing the dream and fighting for it, even when it seems lost and no one else believes in it. As you will see, it took decades for a number of amazing visionaries to get to where Virgin Galactic is today. While I certainly hope that it will not take two decades for you to launch your brand, I strongly believe that we all can learn from other entrepreneurs' experiences. And what's better than learning from one of the most admired success stories in the world of entrepreneurship?

PROLOGUE: THE EARLY DAYS OF AVIATION

Each semester, during the first session of class, I begin by discussing the definition of luxury and the fact that it changes with time: Today's luxury might be tomorrow's necessities. Think of refrigerators, which are still a luxury in some parts of the world, or cars, televisions, computers, and telephones. Not that long ago, cell phones were considered a business tool or a display of wealth if you didn't need one for work. In the technology field—more often than in other sectors—what's considered the domain of only a few often becomes affordable so quickly that it can no longer be considered a luxury after a while. This is what happened with air travel.

At the beginning of the twentieth century, only a small number of individuals could actually afford to fly in zeppelins, or rigid airships. The target customer also had to possess a specific profile because flying was considered a hazardous activity; they had better have an adventurous spirit. If it weren't for these intrepid aviation fans—such as Daniel and Harry Guggenheim, the wealthy father and son duo who were instrumental in the growth of aviation in the U.S. during the 1920s—commercial aviation might not be within most people's reach today.[23]

Modern-day commercial space travel is almost where aviation was in its early days. Understanding the early days of the industry will help companies like Virgin Galactic revolutionize space travel, hopefully making it accessible to all in the future. As was the case with the commercial aviation sector, Virgin Galactic first needed to find wealthy individuals who were passionate about space travel. In order to do that, these potential clients

had to be not only enticed with safety studies, but also with the promise of a true luxury experience.

When you found a luxury company, you should study your future competition in order to position your new brand. With Savelli we were able to look at Vertu and other newcomers to learn from their mistakes. If you're bold enough to create a new industry (not just a new category), you don't have that ability. In this case, you should find as many bearings and similarities in parallel industries to help prove your business model and gauge your idea's potential. Regarding space travel, the best way to do that is to look back at the early days of commercial aviation. While it essentially entails studying the past in order to move forward, history is one of the best guides for the future.

The first lesson to learn is safety. While it seems obvious, it's difficult to believe that anyone would dare board an airship given early safety track records. The world's first passenger airline, Delag—established in 1909 as an offshoot of the Zeppelin Company—had its first commercial flight end in a crash: On June 28, 1910, the luxurious LZ-7 Deutschland, by then in its seventh flight (but the first time with passengers), took off with twenty-three passengers on board, mainly journalists. Between bad weather, engine problems, and "the relative inexperience of the ship's military pilot," the zeppelin crashed. Fortunately everyone survived. Its replacement, a new model called the LZ-8 Deutschland, also crashed in 1911, but at least not during its inaugural flight. Once again nobody was hurt, but it certainly was not an endorsement for safety. With time, airship accidents became more sporadic, and between 1910 and 1914, Delag zeppelins carried over 34,000 passengers on more than 1,500 flights without a single injury.[24]

In the early twentieth century, flying was more about sightseeing than reaching a specific destination, as weather conditions made scheduling regular flights impossible. The same will be true for early Virgin Galactic astronauts (as its passengers are called), whose experience must be focused on the journey, not the destination. As technology improved, Delag was able to organize scheduled flights for the purpose of reaching an actual destination. In 1919, it inaugurated a flight between Berlin to Friedrichshafen, in southern Germany, covering approximately 466 miles in four to nine hours (depending on weather conditions), opposed to eighteen to twenty-four hours by train.[25]

For airplanes (as opposed to zeppelins), commercial passenger air travel kicked off during the late 1920s. As was the case with zeppelins, this means of travel was still confined to wealthy daredevils. Fatal crashes routinely made headlines on both sides of the Atlantic. Pilots only used magnetic compasses to navigate and generally flew less than five hundred feet above ground to be able to guide themselves with roads and railways.[26]

In 1919, the first nonstop transatlantic flight took place (using a Rolls-Royce engine) from Newfoundland to Ireland in sixteen hours. Despite this feat, technological limitations in the 1920s and 1930s made commercial transatlantic air travel too challenging, so travelers continued to make the crossing in luxurious zeppelins. Pan American, founded in 1927, was one of the pioneers of commercial transatlantic service. In 1937, they collaborated with Boeing to build the B-314 plane, a double-decker structure that could fly up to 3,500 miles and carry seventy-four passengers. On June 28, 1939, Pan Am inaugurated the first transatlantic passenger route between New

York and Marseille,[27] taking twenty-nine hours air time, with stops for refueling in the Azores islands and Lisbon, from takeoff to landing,[28] versus five days by boat.[29]

Ticket prices were expensive. To travel from New York to Marseille in 1939 cost approximately $375 each way, the equivalent of $6,500 today.[30] There were indeed more comfortable and safer travel alternatives, such as the RMS *Queen Mary* or RMS *Queen Elizabeth*. These ocean liners took longer, but the experience in itself was a true luxury. One famous ship, the *Normandie*, was decorated by renowned artists and designers, including Émile-Jacques Ruhlmann and René Lalique. The cost was similar to that of air travel, but the experience was luxu-rious and comfortable, not to mention safer.

It was only in 1945 that a company called American Export launched regular landplane (instead of seaplane) travel across the North Atlantic. Each one-way flight from New York to Hurn Airport in England lasted about fourteen hours.[31] Following World War II, TWA and Pan American began regular nonstop flights between New York and Europe. A few years later, European airlines joined and the market became more competitive.

Before the 1950s, traveling by air was for a very specific subset of the wealthy. It targeted individuals who possessed a sense of adventure, a love of discovery, great intrinsic curiosity, and a willingness to test boundaries. Early air travel was for pioneers for whom the thrill and excitement were worth all the risks. They felt they were part of something larger than themselves, that they were contributing to advances in science and technology.

The aviation industry really took off in the 1950s after several improvements in safety (it also became more regulated)

and comfort. The very first flight attendants were actually men; Boeing Air Transport was the first company to hire a woman, in 1930.[32] At the time, stewardesses were required to have a nursing background, as many people became air sick or were simply agitated because of "first flight jitters," but this wasn't the only requirement. The first female stewardesses had to be less than five foot four inches tall (the cabins were not very high), weigh less than 118 pounds, and be between twenty and twenty six years old and single. This last rule actually remained in place until the mid-1960s.[33]

By 1940, three million Americans had traveled on an airplane. By 1956, that number reached fifty-five million. One of the main reasons for this boom was the technological improvements developed after World War II. Planes could be pressurized and heated, which allowed them to fly above bad weather. Until then, flying across the Atlantic was faster than traveling by boat, but the luxurious aspect was certainly limited by the fact that cabins were cold and noisy and the flight itself felt like a roller coaster ride. By 1965, 95 percent of transatlantic trips were done in planes versus boats, but air travel still remained exclusive.[34] It was only after President Carter deregulated the industry in 1978 that airlines began competing against one another and offering more affordable ticket rates. By the 1990s, aviation safety had improved so much that a person was more likely to perish choking on food than dying in a plane crash.

While many people today consider air travel to be as banal as taking a bus or train, it's easy to forget that millions of people in this world have never been inside an airplane. There are many individuals who would view flying as a luxurious experience, even though most now regard air travel as a means to an end,

and sometimes as an unpleasant experience. Between airport security, waiting in lines, flight delays, and passport checkpoints, why fly unless you really have to?

There are a select few who can jet off in private planes, which changes not only their perception of travel but also their efficiency because there aren't delays and other stresses. Companies like NetJets, which offers private rental jets, have become extremely successful because of this, but individual airlines are also starting to compete to ensure that the first-class experience is unforgettable—for the right reasons. Lufthansa set the standards very high for its competitors when it inaugurated its First Class Terminal in Frankfurt in 2004. From the minute you arrive at the terminal to the moment you board the plane, a personal assistant takes care of every single detail of your travel, from returning a rental car to making sure your laptop connects smoothly to the wireless network, to serving you a delicious meal, to escorting you through a separate customs line. All of that comes in an elegant and soothing environment—what more could you want?

1

VIRGIN GALACTIC: THE BEGINNING

Most people today see air travel as a means to reach a specific destination, whether for work or vacation. Rarely do they board their plane with the goal of just having an experience. Why would anyone want to pay just for the travel itself? In a way, this is precisely what Virgin Galactic is proposing to its future passengers: the opportunity to purchase a two-hour trip that brings them back to their point of departure. In essence it's like flying in a zeppelin during the early twentieth century—it's purely for the experience. How does Virgin Galactic frame the value proposition for this new category? How does it justify it to potential customers?

Virgin Galactic studied all the aspects of early aviation and focused on one main quality to attract future clients: the desire to explore. Mankind has always dreamed about going to space. The Greek rhetorician Lucian of Samosata is the first documented author to write about space travel during the second century C.E.[35] but Jules Verne is the one who really made generations dream of going to space with his novels *From Earth to the Moon* (1865) and *Around the Moon* (1870). In the former he included celestial calculations that turned out to be quite accurate. He surmised that a spaceship traveling to the moon should lift off from Florida, and at a location that was fairly near to where the Apollo missions actually did take off!

From the very beginning, Virgin Galactic began zooming in on its target customers, which, as we saw earlier with Savelli, is a key element in creating a successful marketing plan.

Virgin Galactic wanted to find the same kind of customers as those from the early days of aviation: risk takers with a passion for adventure. They are betting that there are people who will see space travel as one adventure they simply can't miss. As was the case for the early aviators, these early trailblazers needed a substantial amount of cash. More importantly, they had to be dreamers. For Sir Richard Branson, "If you don't dream, you don't achieve anything."[36] It took a visionary like him to translate the wild idea of space travel into a brand, Virgin Galactic, which certainly can be considered as a luxury product in more ways than you might think. Yes, despite the risks involved, there are the obvious characteristics of a luxury product: the experience, the limited supply, and the price (even though all experts in the luxury world will tell you it is not about price, but about quality and craftsmanship). Virgin Galactic also possesses many qualities that we touched on earlier: quality, creativity, craftsmanship, legitimacy, the art of storytelling, and giving back. You will see how these elements were needed to get to where Virgin Galactic is today, especially our Magic Ingredient: passion! It *always* starts with passion. In Virgin Galactic's case, the passion came from a number of individuals.

For Sir Richard Branson, it is about passion for adventure. As Kenny Kemp explained in his book *Destination Space*, the idea of Virgin Galactic began in December 1995 in Marrakech.[37] Sir Richard was attempting to follow the footsteps of Phileas Fogg (the character in *Around the World in 80 Days*) and traverse the world in a balloon. One evening, Sir Richard was having dinner with Will Whitehorn (who was Virgin Galactic's CEO until 2011), Per Lindstrand, Alex Richie, and Buzz Aldrin, the legendary astronaut who

set foot on the moon during the first Apollo mission. When you have the privilege of being in the presence of Buzz Aldrin, you can't pass on the opportunity to discuss space, and that's exactly what this small group did. Buzz shared his vision of helping bring ordinary people to space—a passion of his ever since returning from his missions in the mid-1960s. Sir Richard's heart was understandably full of new dreams. After all, he was the man who, after revolutionizing the music industry by launching Virgin Records, decided to change the way people fly by creating the airline company Virgin Atlantic. He now had a formidable challenge in mind: flying regular people to space! This was the moment Virgin Galactic was born.

2

THE OTHER KEY PLAYERS

When Sir Richard Branson began reaching for his dream, other talented individuals were working on the same idea. They were unaware that their paths would one day cross and that together they would make history. By joining forces, they would blaze the way to a new era of space travel. One of these amazing individuals, without whom none of this could have ever been possible, is Burt Rutan.

Burt Rutan is a legend in the world of aeronautics. Not until you attend one of the annual Aircraft Association gatherings in Oshkosh, Wisconsin, will you fully understand the extent to which he is worshiped in the field. An American aerospace engineer, Burt is a visionary who has transformed the way engineers design aircrafts. His contributions to the industry are too long to list, but it should suffice to mention that he designed the Voyager—the first plane to fly around the world without stopping or refueling—in 1986. Burt, like Buzz Aldrin, had one particular frustration with the world of aeronautics: He knew that the technology existed to bring everyday citizens to space, but the field had been co-opted by two super powers, the United States and the Soviet Union. Both of these nations claimed the race to space in the 1960s as their exclusive domain. Aviation never had similar restrictions, so it attracted daredevils, visionaries, and entrepreneurs the likes of the Wright Brothers and Howard Hughes. Without their individual contributions, flying from New York to London would maybe not be possible today, and JetBlue or Ryanair would most likely not exist.

Burt's fascination with planes started as a child when he and his brother used to build models operated by radio control. After college he first worked as a civilian test engineer for the U.S. Air Force and then became a consultant for Lockheed. Throughout his career he never stopped building planes. Already considered a trailblazing inventor, in the 1970s he opened his own company, Scaled Composites, which focused exclusively on his creations. After the debut flight of the Voyager in 1986, his talent and craft caught the attention of the billionaire cofounder of Microsoft, Paul Allen, who also had a dream of flight.

Paul Allen has always been fascinated by space—ever since he was a small child. He even named his investment company "Vulcan" after Dr. Spock's planet in the television series *Star Trek*. In 2001, Paul Allen asked Burt Rutan if he was up to the biggest challenge of his life: building a reusable space vehicle. He offered to fund the project knowing full well that Burt would not be able to turn him down. Fortuitously, Burt had been working on the same idea since 1994, and it had taken him three years of development to turn it into a reality. Within weeks, Burt and his team of engineers frantically started working on concepts and designs. The basic concept was not to use a rocket to propel the craft; instead, they would use a carbon composite construction air-launched from an aircraft that was then rocket-propelled into space. The craft would be mounted to a "mother ship" underneath, which would help take the spacecraft into the air. At a certain point the mother ship would drop away and the rockets would be fired to help the vessel reach suborbital space. To return to Earth, the spaceship would use a feathered reentry, which means it would glide back into the atmosphere and make an easy landing.

When Burt Rutan began working on his idea of what would become Virgin Galactic's SpaceShipOne back in 1994, another

visionary, Peter Diamandis, was embarking on his own journey. Peter became the catalyst that allowed all the pieces of the puzzle to come together in order to launch the commercial race to space. Like the others, Peter had always been fascinated by space and his goal was to make it accessible to ordinary people. After graduating from MIT with an aerospace engineering degree, he founded a rocket company and additionally cofounded Zero Gravity, a company that organizes flights that allow passengers to experience weightlessness. With a broad knowledge of the history of aviation, he came to the conclusion that, in order to jump-start the private sector in the space race, it would be necessary to incentivize entrepreneurs.

Peter therefore set out to develop a prize modeled after the Orteig Prize—created by the French hotelier Raymond Orteig in 1909 while he was living in New York City—an award to encourage innovation in civil aviation. The result was the X-Prize, which Peter announced in 1996 and which became fully funded in 2002 by the Ansari family. (Anousheh Ansari became the first self-funded woman to fly to the international space station.) The goal for the X-Prize was for a spacecraft to fly up to one hundred kilometers (about 62 miles) into suborbital space without attempting an orbital flight. Peter realized that this first step was essential before targeting potential orbital flights, which require strenuous training and would be too demanding for the general population. He offered a $10 million award to the first privately funded team that would be able to build and fly a passenger vehicle up to one hundred kilometers into space (this distance is internationally recognized as the boundary for outer space) twice in a two-week time frame. By reaching this latter milestone, a spacecraft would be able to prove that it could be reused—the first step for a commercial venture.

In 1997, Peter asked Sir Richard Branson to help fund the X-Prize, but it took a couple of years for Sir Richard's interest to transform into a concrete plan. He, along with others at Virgin, was interested in Peter's proposal, but more as an active participant than a complete sponsor. In 1999, Will Whitehorn asked Virgin's legal advisers to register the name Virgin Galactic. The idea of bringing passengers to space was one step closer to becoming reality. Around that time, Sir Richard and Will met Burt in the Mojave Desert, an introduction established through another mutual connection, the late American businessman and avid aviator Steve Fossett.[38] Fossett had been working with Burt on the Global Flyer, which would replicate the Voyager's landmark 1986 journey. Sir Richard had long been fascinated by the Voyager and wanted to aid in sponsoring the Global Flyer's solo flight around the world.

While working on what became known as the Virgin GlobalFlyer, Will learned that Burt was also working on a spacecraft.[39] This was incredibly exciting news as Virgin Galactic had not yet found the right partner for their space-craft venture. In 2003, Will learned that Microsoft's Paul Allen was backing Burt's endeavor. After months of negotiations, Sir Richard announced on September 27, 2004, that Virgin had signed a deal with Paul to use the technology Burt had developed for SpaceShipOne to build five separate spacecrafts for the sole purpose of bringing private passengers to space.

While it's unlikely that you will require so many different talents to launch your own luxury brand, you will still need to surround yourself with that kind of expertise if you don't already have it in-house. Learning how to connect with the right people will always be a skill that entrepreneurs need to master.

3

THE X-PRIZE

All the pieces finally came together to make the Virgin Galactic adventure work. The Ansari X-Prize had garnered interest throughout the world, and twenty-seven participants had entered the competition and were hard at work on new technologies to try and win. SpaceShipOne accomplished its first supersonic flight in the Mojave Desert on December 17, 2003—the one-hundredth anniversary of the Wright Brother's historic first flight. On October 4, 2004, history was made again: SpaceShipOne, which had been developed without any government funding, officially won the X-Prize and its $10 million award. The craft had flown twice up one hundred kilometers into space in two weeks. The costs for developing and creating SpaceShipOne were $25 million, but the X-Prize made endless possibilities available, from flying passengers to carrying scientific cargo loads on behalf of research institutions. The whole world was watching as a new era of space travel was entered. During the historic occasion, Burt Rutan proudly stated:

> Since Yuri Gagarin and Al Shepard's epic flights in 1961, all space missions have been flown only under large, expensive government efforts. By contrast, our program involves a few dedicated individuals who are focused entirely on making spaceflight affordable [...] Without the entrepreneur approach, space access would continue to be out of reach for

ordinary citizens. The SpaceShipOne flights will change all that and encourage others to usher in a new, low-cost era in space travel.[40]

On July 27, 2005, Burt Rutan and Sir Richard Branson announced their new joint venture, called The New Spaceship Company. The company, jointly owned by Scaled Composites and Virgin Galactic, owned all the design and launch systems for SpaceShipTwo.[41] The first spacecraft proved that the technology was there and that a product was indeed possible. There was much excitement in the air. It was only a matter of time before Virgin Galactic would be able to send its first customers to space.

All Virgin Galactic needed was to find clients. Interest had been piqued thanks to the international media coverage after SpaceShipOne won the Ansari X-Prize. It was time to find out if anybody would want to be a Virgin Galactic astronaut. Until the end of 2004, only two private citizens had gone to space— through Space Adventures, another player in the field, at the price of $50 million per person. In 2001, Dennis Tito became the first space tourist and spent almost eight days in orbit on a Soyuz (a Russian designed spacecraft) flight to the International Space Station. Mark Shuttleworth followed Dennis Tito's footsteps in 2002. A handful of others have completed trips to space, and today this short list includes Gregory Olsen, who took his flight in 2005, Anousheh Ansari in 2006, Charles Simonyi in 2007 and 2009, and Richard Garriott in 2008. One recent passenger was Guy Laliberté, the creator of Cirque du Soleil, who hosted the first-ever orbital event, "Moving Stars and Earth for Water," which helped raised awareness for his One Drop Foundation. Many celebrities on Earth also helped

organize events to support the organization, which aims to fight poverty and provide clean drinking water.

The price of a Space Adventure trip to the International Space Station certainly limited the potential number of candidates. Rutan's technology and the relatively more modest goal of attaining one hundred kilometers of orbit allowed him to render the price more reasonable. Space-ShipOne's design allows for six passengers to float in zero gravity, each with a large window that would allow them to absorb the view of Earth from space. Virgin Galactic had to calculate the potential size of the market to see how the initial investment could be amortized over time, but how do you determine the size of the market and a flight's initial price when you're creating a completely new industry? It's great to have a dream, but you need to make sure that your time and investments will make sense and be profitable. You need to assess your potential market to determine your share and revenue.

4

PRICING

Most entrepreneurs, especially in the luxury field, have a fairly good idea of what their new product's pricing should be before they start. There are almost always precedents. This wasn't the case for Virgin Galactic. The good news was that the Futron Corporation, "a leader in decision management solutions for aerospace, telecommunications, and technology enterprises"[42] had partnered with Zogby International, a leading polling firm, to conduct an in-depth Space Tourism Market study that was published in October 2002. At the time, there were already a number of suborbital vehicles in the works from a number of reputable developers: Armadillo Aerospace, Bristol Spaceplanes, Kelly Space and Technology, Canadian Arrow, Myasishchev Design Bureau, Third Millennium Aerospace, Pioneer Rocketplane, Space Clipper International, Vela Technology Development, Starchaser Industries, XCOR, and the Proteus by Scaled Composites. The question that everyone was asking and that Futron/Zogby wanted to answer was: When (as there was no real question of "if") you have built a spacecraft for suborbital commercial flights, will you actually have demand?

In order to answer this fundamental question, Futron/Zogby focused on two key potential markets: orbital (two such flights had already taken place), and suborbital. Futron developed a detailed questionnaire and contacted 450 individuals to survey. How did they determine whom to contact? At this stage, they felt that the only necessary criterion was

wealth. Even if the industry's goal was to be like air travel and come within the financial reach of many, they still needed to find customers who could afford the substantial ticket price. The cost would allow the business to cover some of the important initial investments. They set the bar at households with a minimum of $250,000 annual income and a minimum net worth of $1 million. According to the 2008 Wealth Survey by Ipsos Mendelsohn,[43] the leading luxury market research firm in the United States, there were over one million U.S. households belonging to that category: over 2.5 million individuals with over $250,000 in annual income, and 2.6 million with over $1 million in liquid assets. The combination of the two reduces the number to one million. Regardless, it was a significant number of people who could potentially afford this new luxury product.

Now, what else do you need to know about these individuals before you can really gauge whether or not they would actually purchase the product? The first thing that comes to mind is fitness and health. Everyone remembers the astronauts who traveled to space during the first fifty years of space exploration: They were all young men (even though Valentina Tereshkova flew to space in 1963, it is only in the 1980s that women astronauts became more common) who were physically fit and in excellent health.[44] In addition to these basic characteristics, they also had a lot of training, accumulated over a great deal of time. The two commercial astronauts who went on orbital flights to the International Space Station trained for six months in Russia. Even if potential customers could afford the price and are relatively physically fit, how much time could they actually spare for a suborbital flight? How much training would they actually need? No one really

knew for sure, but Futron estimated that one week would be sufficient, so they used that benchmark for the survey.

Futron also needed to make sure that respondents had a good understanding of what this hypothetical experience would entail. They offered two very accurate descriptions of a trip, but from different perspectives; the first focused on the journey itself and the second stressed requirements and possible constraints:

STATEMENT 1:

In a suborbital space flight, you would experience what only astronauts and cosmonauts have experienced. During the flight on a vehicle that meets government safety regulations, you will go fifty miles into space and experience the acceleration of a rocket launch. You will also experience a few minutes of weightlessness and have the unique experience of viewing the Earth from space.

STATEMENT 2:

Space flight is an inherently risky activity. The vehicle providing these flights will be privately developed with a limited flight history. In order to take the trip, you would have to undergo training for one week prior to the launch. Although you would experience weightlessness, you would be strapped in your seat throughout the flight.

Following these two statements, the survey asked respondents to delve into specific points and rank them in order of importance with regard to their willingness to participate in

a suborbital flight. From the first description, respondents indicated that the number one reason to participate was, not surprisingly, to view Earth from space. Experiencing weightlessness followed close behind. Futron learned from the second statement that the biggest concern for respondents was to be strapped in a seat during the entire flight followed by the necessity to complete one week of training. Interestingly enough, the fact that they could potentially fly on a privately developed craft (versus government-sponsored) did not have much of an effect on their desire to experience the journey.

The survey also focused on the respondents' profiles and how they would spend a possible $100,000 discretionary amount. With investors' responses excluded, the top two wishes were to spend it on a dream vacation and suborbital flights. The questionnaire then asked their level of fitness and the kinds of risky activities in which they engaged. (More than half skied or snowboarded. Ironically, most rated suborbital flights as less risky than skydiving or mountain climbing.) The last sets of profile questions focused on their interest in flying to space as well as other space-related activities, and their willingness to possibly feel some discomfort after the flight (more than half said they would be okay with that).

The key question that had to be asked concerned customers' willingness to pay for the flight. Until then, suborbital developers could only reference the $50 million orbital experience. When trying to pinpoint a figure, they settled for a ticket price of $100,000 for a suborbital flight. The Futron/Zogby survey also covered a wider range of potential ticket prices, ranging from $25,000 to $250,000 (at some point prices would go down when the technology would become more mainstream). Almost half of the participants weren't

interested in a trip to space, no matter what the price might be. Sixteen percent, however, were willing to pay as much as $250,000 for the experience. As one might expect, the lower the price the higher the potential market, with an accumulated 51 percent of respondents interested at $25,000. "For 45 percent of individuals interested in a suborbital trip, doing something that only a few people have done before, being a 'pioneer' was either the most or second-most important reason for taking the trip . . . Fulfilling a lifelong dream was a driver for 30 percent of those interested." For those interested in the flight, the majority was willing to pay between $100,000 and $250,000 for the experience.[45] The obvious conclusion was that developers could charge a premium for these early birds.

The research then focused on how the industry might evolve after the first few years, not just in terms of price, but also experience. To tackle the task, Futron/Zogby used a rigorous methodology, starting with the base population who could afford the suborbital flight and then applied filters: the loss of the pioneering aspect of the first few years, physical fitness, and arriving to the target market. They then added a few reasonable forecasting elements: Safety should be less of an issue after a few years of successful flights. Eventually the cost should go down significantly. Certain requirements, such as training, might become less stringent. Improvement in technology might also allow passengers to more freely enjoy the experience without being strapped to seats during the trip. The conclusion was that the burgeoning suborbital space travel industry could reasonably expect to have 15,000 passengers every year as of 2021, with a ticket price of $50,000 and annual revenue of over $700 million. These figures were obviously encouraging for any and all companies looking to enter the market.

Virgin Galactic studied the Futron/Zogby research meticulously. Given the assets they possessed (the X-Prize, Sir Richard Branson, the Virgin brand name) they decided that the Virgin Galactic brand could demand a premium and that the company could shoot high for their first astronauts. The executives therefore settled the price at $200,000 for the first few years. Nearly double what its potential competition had been quoting, it was certainly ambitious, but they felt they could pull it off. This is a rare position for a luxury entrepreneur; in order to ask for a high premium, a company usually first needs to establish its legitimacy. Virgin Galactic was drawing on the legitimacy of the Virgin brand, along with Sir Richard, Burt Rutan, and Peter Diamandis's X-Prize, so the brand equity each of these players brought to the project was astronomical.

5

THE 2005 KICK-OFF

By early 2005 it was time for Virgin Galactic to test the research results and its own pricing strategy. Through the international media coverage given the X-Prize and SpaceShipOne in October 2004, Virgin Galactic was able to capitalize on the massive amount of attention it had received and assess interest. At the end of 2004, Virgin Galactic had set up a Web site and invited people to register. They wanted to test general interest in flying to space in a suborbital mission without considering price as a criteria; Virgin Galactic's ultimate goal was, and still is, to bring costs down as quickly as possible to allow a large number of individuals to experience the journey. This is precisely when the power of the Virgin brand came into play.

Volvo launched its new advertising campaign on Sunday, February 6, during the 2005 Super Bowl, the (or one of the) most watched American television broadcast events of the year. That year, the Super Bowl drew more than 100 million viewers, with advertising selling at a cost of $2.4 million for a thirty-second commercial spot. (For some perspective, almost 110 million viewers tuned in for the 2013 Super Bowl and the cost of a thirty-second spot reached $3.5 million.) What does this have to do with Virgin Galactic? Well, as stated in a Virgin Galactic press release at the time: "Volvo Cars of North America on Sunday will make history during its first-ever Super Bowl advertisement by announcing it will give away a chance to win a seat on Virgin Galactic's commercial passenger-carrying spaceship."[46]

The Luxury Alchemist

In the thirty-second commercial, Volvo unveiled its new Volvo XC90 V8 SUV by comparing its power to a rocket blasting into space. Near the end of the spot, the ship's pilot reveals himself as none other than Sir Richard Branson. "The best way to illustrate Virgin Galactic's mission for the safe, affordable exploration of space is to give one person a chance to win, rather than pay for, a seat on our spacecraft," said Sir Richard, who donated the proceeds from his appearance in the ad to charity. "Partnering with Volvo—which embodies safety and innovation—is a natural fit. And Volvo's bringing this to the Super Bowl is marvelous."

Now that was a coup. Suddenly over 100 million viewers in the United States, most of whom had not followed the X-Prize exploits, were stunned to learn that they might be able to win the possibility to go to space. Virgin Galactic got people dreaming with the panache of the Virgin brand and its founder's charisma. In the first few months after that broadcast, over 65,000 individuals registered their interest. That was proof of demand, so the Virgin Galactic executives duly decided to run full steam ahead. The next mission was to figure out how you sort through the 65,000 applications to identifying the ones who can actually afford the first trips.

By the time Virgin Galactic became part of the Volvo commercial, the company had confirmed the price for the first few hundred astronauts: $200,000. The company's timetable was based on the assumption that, after the first few flights, it would be flying six passengers twice a week and producing five SpaceShipTwo crafts within the first two years. Based on this information, around five hundred passengers would be able to fly in the first year of operation and around one thousand to 1,500 during its second year. Many believed that those who registered early on merited some form of premium. Excluding those who

flew on Space Adventures to the International Space Station, they would have the opportunity to be among the first private citizens to travel to space. Surely that special place in history should be worth something. Then there came additional questions: What should this premium be? How many people can you sign up while maintaining the feeling of exclusivity? Should it be the five hundred people who would fly during the first year? Would the astronaut flying on the last day of the first year feel that their experience is less special than that of the first ten?

Stephen Attenborough, who was appointed head of Virgin Galactic's commercial efforts, devised a brilliant system that would ensure the success of the company's commercial outreach: a tiered system with different obligations and expectations at each level. The first level, known as the Founders, would be the one hundred individuals guaranteed to go to space first. For that privilege, the Founders would have to pay the full price of their tickets upon signing the contract. The second level, Pioneers, would include the next four hundred passengers, who would pay decreasing deposits depending on which group of one hundred they joined. Finally, the Voyagers would be registered on a first-come, first-served basis and would only be required to pay a 10 percent deposit.

Given the leap of faith required of these adventurous individuals, Stephen decided that the full price would be refunded to any Founder without having to give any reason or explanation for wanting their money back (the same is true for Pioneers and Voyagers). Of course, this fully refundable ticket is a great selling tool; it comforts all potential buyers should the project fail to materialize. Or does it? It is indeed a great selling argument as long as potential customers feel the company will actually be able to stand by its commitments. A lack of trust

between potential clients and the company would not make anyone feel comfortable. This is why many friends and family members are often the only investors in a start-up company, as they know and trust the founder, which is where Sir Richard's charismatic persona comes into play.

Over the years, Sir Richard Branson has become synonymous with success. Even his less-successful ventures have been forgiven; the public loves a hero with whom they can relate. Sir Richard is indeed one of the wealthiest people on Earth, but most still perceive him to be modest instead of elitist. He has earned his successes by offering better service and quality to the mass market, so even when he ventures on a project that's exclusive, such as Virgin Galactic, he garners a positive bias from the general public and media.

The Virgin trademark is one of the most recognized and respected in the world. Conceived by Sir Richard in 1970, the Virgin Group has grown into over two hundred branded companies in sectors as varied as music (its original field, with Virgin Records), mobile phones, transportation, travel, financial services, holidays, publishing, and retailing. It employs approximately fifty thousand people in thirty-four countries, with global revenue around $13 billion in 2011. Virgin's group mission statement is: "Virgin believes in making a difference. We stand for value for money, quality, innovation, fun, and a sense of competitive challenge. We strive to achieve this by empowering our employees to continually deliver an unbeatable customer experience."[47]

When Virgin Galactic assures its future Founders that it will reimburse the full ticket price if the program is cancelled, or if the client simply changes their mind, these VIPs know they can trust this pledge. This is the power of a successful brand—the link of trust that exists between the company and its customers.

6

THE COMPETITIVE LANDSCAPE

Even in 2005 Virgin Galactic was not the only company offering suborbital flights. While twenty-seven companies had applied to win the Ansari X-Prize, only a few were still pursuing the venture of sending private citizens to space. It's always healthy to have a bit of friendly competition, and in the case of the creation of a new industry, it's necessary because you want to have proof of concept: The more risk takers there are out there, the more likely it is that the industry will succeed.

One of the original players was the successful computer industry entrepreneur Jim Benson, who entered the world of commercial space flight as early as 1997, when he founded SpaceDev. In August 1998, SpaceDev acquired all of the patents that had been produced by the bankrupt American Rocket Company (AMROC). After its first big success with the launch of the Cosmic Hot Interstellar Plasma Spectrometer microsatellite in January 2003, SpaceDev supplied the rocket motors that propelled SpaceShipOne into orbit and allowed it to win the $10 million X-Prize in 2004. In November 2005, SpaceDev announced its Dream Chaser concept for a four-passenger suborbital ship, which would enter space but not go into orbit, as well as a six-passenger orbital vehicle. On September 28, 2006, Jim Benson announced that he had launched an ambitious new venture focused on commercial space tourism, Benson Space Company, focusing on its Dream Chaser program. Its goal was to be the first to market in the emerging multi-billion-dollar space tourism industry. "I plan to

spend the next several years creating the possibility that anyone who wants to go to space will be able to, safely and affordably," said Benson in September 2006.[48] After Benson's death in 2008, Space Dev was acquired by the Sierra Nevada Corporation, which continues to develop the Dream Chaser and was one of three companies (including SpaceX) to be awarded over $200 million by NASA in 2012 to launch astronauts "from U.S. soil on space systems built by American companies."[49]

Another early bird in the field was Amazon.com founder Jeff Bezos, who had formed the aerospace company Blue Origin in 2000. Blue Origin's existence only became public in 2003 when Bezos began buying land in Texas and the media started investigating. In January 2005, Bezos told the editor of the *Van Horn Advocate* that Blue Origin "is developing a suborbital space vehicle that will take off and land vertically and carry three or more astronauts to the edge of space." In 2007, the company's Web site changed its tagline to "patiently and step-by-step, [to] lower the cost of spaceflight so that many people can afford to go and so that we humans can better continue exploring the solar system."[50] The latest 2013 timetable indicates that Blue Origin will be ready for its first flights to take place by 2014. While the company's initial focus was suborbital flights, the funding it received from NASA in 2009 to develop technologies for spaceflights and an additional commitment in 2011 of $22 million accelerated the progress of their manned orbital spacecraft.[51]

Founded in 1999, XCOR Aerospace is a privately held California company focused in making space "affordable for private citizens."[52] It is aiming to do so on the Lynx reusable launch vehicle for two people (one pilot, one passenger), which is scheduled to start test flights later in 2013. The cost of a thirty-minute flight has been set at $95,000 and, as of May

2013, 220 people have put down deposits to participate.[53] Like an aircraft, Lynx will take off and land horizontally, but will use a rocket propulsion system.[54]

Another obvious entrant into the sector was Space Adventures—the only company that already had true legitimacy in this segment having previously safely sent individuals to orbital space. It was natural for Space Adventures to capitalize on its successes in the field and extend itself in this broader market with a product that stayed within its core identity. They announced their new program with the Explorer, scheduled to take passengers on suborbital flights launching from the United Arab Emirates.[55] In 2010, the company announced that the ticket price per passenger in its vertically launched vehicle (which looks like a more traditional rocket) would be $102,000, undercutting Virgin Galactic by almost half of the price.[56] The company also announced in 2012 that it plans to send "two paying customers [...] on a flight around the moon" by February 2017 for the price of $150 million each.[57]

In June 2006, another major player decided to enter the field: EADS Astrium. A European space company jointly owned by Aerospatiale Matra, Daimler Chrysler Aerospace, and the European Aeronautic Defense and Space Company N.V., EADS has been a global force in the aeronautics industry for decades. It owns the Airbus brand as well as the European Ariane space program and Galileo global satellite system (both through Astrium). With revenue over €40 billion (roughly $53 billion) and more than 100,000 employees, this player is certainly a competitor to be reckoned with. They announced in June 2007 that they would be entering the space tourism sector with development costs in the billions of Euros range. They plan to use a hybrid craft that could fit four passengers and would be

able to take off from regular airports. The experience would be very similar to that of Virgin Galactic, and the price set for this suborbital flight was likewise set around €200,000.[58] In 2009, the company announced it was putting its suborbital flight program on hold due to the difficult "world economic situation."[59]

Another potential competitor in the burgeoning spaceflight industry is Bigelow Aerospace, whose mission is to provide "affordable options for spaceflight to national space agencies and corporate clients."[60] (In 2013, the company's Web site did not mention suborbital flights, instead choosing to emphasize its "historic first commercial space station.")[61] The list of competition continues with RocketShip Tours, a company in partnership with the rocket plane developer XCOR Aerospace, Armadillo Aerospace, and Copenhagen Suborbitals, which was founded in 2008. Certainly others will join the endeavor. There are a few other companies concentrating on commercial space transport, such as SpaceX, created in 2002 by PayPal cofounder Elon Musk. SpaceX is not currently focusing on sending private citizens to space, but it certainly made them dream when it made history as the first privately held company to send a cargo payload to the International Space Station in May 2012.[62]

As of spring 2013, the landscape of direct competitors is slightly smaller and Virgin Galactic remains the leader in this specific segment. All the companies that remain involved have extended their timetables, which is understandable given the enormity of the challenge! Virgin Galactic is happy to have healthy competition because, while it's a good thing to be a precursor in your field, you don't want to be the only player in your category, especially in the luxury field. You might want to dominate your sector, but you want other brands around, too. After all, luxury loves company.

7

VIRGIN GALACTIC ASTRONAUTS

A. THE FOUNDERS

You might be wondering why I refer to Virgin Galactic customers as "astronauts." The first person to go to space was Yuri Gagarin on April 12, 1961. Gagarin was just there as a passenger; he did not pilot the craft. This was the case for all of the first generation of space travelers, yet they are still referred to as astronauts. When Virgin Galactic calls its clients astronauts it is, in a way, correct. They will share the same experience that many of our space heroes had.[63]

In early 2005, Virgin Galactic received numerous requests from potential customers via their Web site. The Volvo Super Bowl commercial had the media talking about Virgin Galactic again following the X-Prize coverage in 2004. Stephen Attenborough personally called each and every one of the potential candidates to understand if their interest was serious, why they wanted to sign up, and to clarify their expectations and anxieties. Then he tried to answer the numerous questions they had for him. Most of these inquisitive individuals were like Sir Richard, Burt Rutan, or Paul Allen—baby boomers who had witnessed the first man on the moon in 1969 and had been dreaming of traveling to space ever since.

Apart from these dreamers, there was an entire group of other individuals who were attracted by the concept. These were the adventurers. This shift in the luxury consumer's mind from products to experiences has helped propel the

The Luxury Alchemist

"Luxury Adventures" industry. From Abercrombie & Kent to Cazenove & Loyd or White Desert, the number of high-end exploration adventures has multiplied in the last decade, with some trips tailored toward adults and others toward families. Today's adventurous spirits can take their pick from a bevy of offers, including climbing Mount Everest, K2, or Mount Kilimanjaro, or braving the cold of the North Pole with a scientific expedition. For the more cautious adventurer, there is hiking in the Andes or cruising to Antarctica.

Abercrombie & Kent boasted annual revenue of over $300 million in 2011, which is certainly an encouraging sign for Virgin Galactic.[64] Of course, a number of different experiences are lumped in this figure, and not all Abercrombie & Kent travelers are the ideal market for Virgin Galactic. Those people who enjoy wellness luxury travel with spas and retreats, whether physical or spiritual, would not be the right audience. Someone who favors more experiential travel, such as learning calligraphy in Asia or helping children in an African village, might be interested, but the perfect candidate would an adventure-driven vacationer.

The latest figures reported by the Adventure Travel Trade Association in its 2011 report are certainly encouraging. In 2010, the adventure travel segment represented $89 billion in revenue.[65] This number represents a 17 percent increase between 2009 and 2010, accounting for around 26 percent of the overall tourism industry. "One in four trips includes an adventure travel component," and some feel that adventure vacations should reach 50 percent of all trips by 2050.[66]

In addition to these two clearly defined adventurer profiles, another profile can be tapped into: ground-breaker. As Jack Ezon, the President of Ovation (one of the accredited

Space Agents for Virgin Galactic), told the Columbia students working on Virgin Galactic's project in 2008, there were some potential customers who would be looking for what he called "bragging rights." These customers aren't necessarily looking to fulfill their dreams; instead they want to be the *first* to do something. This idea was also highlighted in Futron/ Zogby's research as one of the main reasons why people would want to go to space, otherwise known as the "Pioneer Effect." Knowing that they could be among the first private citizens to experience a suborbital flight, 24 percent of the survey respondents expressed that being a "pioneer" was one of the reasons why they would be willing to spend over $100,000 to go to space. Fifteen percent said their number one reason was to see Earth from space, 9 percent said it was their lifelong dream, and a mere 7 percent cited being space enthusiasts.

Stephen Attenborough thought about this essential point and came up with a system that would allow customers in every tier to know where they stood in the launching sequence between Founders, Pioneers, and Voyagers. The details were clearly outlined in this breakdown, which would prevent any confusion for Founders who began registering, but some of the Founders wanted to know how they would be selected among the rest in terms of order of flight. Attenborough initially thought a "first-come, first-served" methodology would make the most sense and be the fairest way of organization, but then, what would count as "first-come"? The date they signed the contract? The date the funds were wired? Or received? Or should it be a random drawing among Founders? As Founders got to know each other through various Virgin Galactic events and formed friendships, some expressed the desire to travel as small groups. Virgin Galactic's view is

that most Founders regard a random draw as the fairest way to allocate Founder seats. The company is willing, however, to adopt alternative methodologies if they command a stronger consensus among the group. Virgin Galactic has tried to adopt a collaborative approach with its customers to determine the best resolution to these important questions.

B. SAFETY, TRAINING, AND REGULATION

This line of questioning leads us to two other essential points for Virgin Galactic's future astronauts: What are the physical requirements to be a Virgin Galactic astronaut and what kind of training would they be required to undergo? This is a question that luxury brands rarely have to ask themselves, even in the luxury travel segment.

In the beginning, no one really knew the necessary health requirements to embark on a suborbital trip. Given that these trips generally would last less than three hours, it seemed logical that the bar would not be as high as that of a journey to the International Space Station. Safety is and has been a top priority for both Virgin Galactic and its potential passengers. In order to sign a contract for a seat on a future Virgin Galactic flight, a thorough medical exam is required. The physician-filled questionnaire is very detailed and states that a comprehensive medical evaluation is necessary. This obviously may not sound very luxurious, but potential Founders agreed with Virgin Galactic that their health and safety are paramount.

Virgin Galactic didn't want to rely exclusively on accepted health requirements that aviation and space experts had come up with for suborbital flights. When Founders started signing up in 2005, there was little medical data or research on

how civilians (not trained test pilots) would react to accelera-tion, weightlessness, and other related aspects of space travel. It seemed obvious that it would be better that passengers be in good health, but did that really matter? No one checks your health when you get on an airplane.[67]

In 2007, with over one hundred confirmed future astronauts, Virgin Galactic had done something that no other private space travel company had done before: They had amassed a willing and able group of individuals of all ages, sizes, and sexes who were passionate and committed enough that they were amenable to submitting themselves to all the necessary tests that would enable them to take the trip of a lifetime.

As stated earlier, many of the Founders had attended events together and developed close bonds, making them feel like Virgin Galactic Ambassadors. As such, they were willing to participate in diverse experiments. They felt a part of something larger. Their pioneering contributions will help Virgin Galactic create rules and set the norms for future flyers, which will also help the space travel industry in general. The sense of camaraderie that some Founders have developed can be traced back to the Virgin Galactic executives who crafted each individual experience for their clients. From the unveiling of SpaceShipTwo in the Mojave Desert in 2006 to centrifuge training in Philadelphia in the fall of 2007, to the dedication of Spaceport America in New Mexico in the fall of 2011, every Virgin Galactic experience is a memorable moment in itself.

There are two main components of the Virgin Galactic in-flight experience: acceleration and weightlessness. A number of companies specialize in providing zero gravity flights to the public, including Zero Gravity Corp, which

was founded by Peter Diamandis and is based in Florida. Numerous people have experienced zero gravity through their program and several others like it. Normally, a zero-gravity experience is simulated in a plane (in Zero Gravity's case, it's a modified Boeing 727) that performs a number of parabolic arcs during its flight, allowing passengers to experience both 1.8 G accelerations (g-force is the term for acceleration felt as per unit mass; the higher the g-force, the stronger the acceleration) and multiple short periods of weightlessness. The only thing one needs to fly is a signed medical release form. Even the physicist Stephen Hawking experienced zero gravity flight in 2007.

The main reported side effect of this kind of flight was motion sickness, so Virgin Galactic was not very concerned about that aspect of the trip. What Virgin Galactic wanted to know was how its astronauts would react to the acceleration part of the flight. The only people who have ever truly experienced that kind of extreme sensation are fighter pilots. Because of this, the company selected the National Aerospace Training and Research (NASTAR) Center in Philadelphia to partner with and help build the ETC Space Training Simulator, a centrifuge that simulates acceleration to space as well as reentry to earth.

In the fall of 2007, Virgin Galactic flew almost all of its registered Founders to Philadelphia and managed to turn the challenging experience into an unforgettable adventure. Each group had between six to eight Founders; they spent their days and evenings together, either at the NASTAR Center or with each other at meals. Each session began with a talk given by Glenn King, NASTAR COO and a former Air Force pilot. He explained the science behind space travel,

the differences between vertical (going up) and horizontal (going down) accelerations, and taught everyone professional tricks to avoid discomfort. The worst-case scenario when accelerating is blacking out, so he showed videos of seasoned pilots, himself included, blacking out for a few seconds and having no recollection of it.

Eventually the time came for the first participants to enter the centrifuge. Before they did, Dr. Julia Tizard, who holds a Ph.D. in astrophysics and is Virgin Galactic's Operations Manager, and Dr. Vanderploeg, Virgin Galactic's Chief Medical Officer, carefully examined the future "centrifuger" to check that their health had not deviated too much from their original medical report. To start the process, each participant would enter a small chamber and be tagged with multiple sensors that would monitor their different vital signs. Once in the centrifuge, the passenger would be strapped tightly in a chair and monitored by video stream. As the simulation started, King would speak to the passenger and talk them through the phases of the "flight," beginning with the powerful acceleration of liftoff. He would offer reminders or pointers for their comfort, like keeping their heads straight and avoiding moving as much as possible. The doctors using the monitor would also suggest relaxing, breathing deeper, or simply tightening up the muscles if necessary. If a medical issue would arise, the centrifuge would be stopped immediately. While many Founders reported that the experience made them feel tired for a few days longer than they would have expected (the body is not used to such strong stimulation on a daily basis), and some of them had felt nauseated during the trial, the medical results were more positive than Virgin Galactic had hoped.

In Dr. Tizard's words, "If you were working from scratch and guessing what proportion of the market that you would think be able to manage a spaceflight—in the specific context of a Virgin Galactic spaceflight, whose G forces range up to 6 Gs on reentry—you might guess 50 percent. At VG, we're hoping that 80 percent of the people we had sold tickets to would be able to go through the program."[68] Once seventy Founders had finished their training, Virgin Galactic was thrilled to learn that all but two had passed without incident. The group's youngest member, at twenty-two years old, was Sir Richard Branson's son; the oldest was eighty-eight. Expectedly, a number of individuals had pre-existing medical issues, including heart bypass surgery in the last five years. As the business model was based on 80 percent of the individuals wishing to fly actually being physically able to do so, this 93 percent success rate was fantastic news! While the training and related learning sessions were essential, however, it was still too early to determine their success until some actual flights had taken place.[69]

C. KNOWING HOW TO WOW YOUR CUSTOMERS

As of early 2013, Virgin Galactic had registered over 550 paying customers from fifty countries, by far the largest number among the companies that announced their intention to offer suborbital flights.[70] The question now was how do you keep these clients motivated? It had been a number of years since most of the Founders had signed up—between 2005 and 2006. How do you keep them interested, especially when the actual luxury experience will be delivered so far in the future? That's where Virgin Galactic had another advantage. While some of

its competitors might have the expertise to take passengers into space, Virgin Galactic was able to capitalize on another one of its skills in reaching out to potential customers: its know-how in luxury travel through Virgin Limited Edition. As the Virgin Web site explains, "Virgin Limited Edition is Sir Richard Branson's collection of stunning retreats and the luxury portfolio of Virgin Hotels Group Limited." So what is Virgin Limited Edition? When you refer to something as a limited edition, it normally implies an extraordinary, rare quality, usually offering something better, more exclusive, or more desirable. Well, that's exactly what they do. Virgin Limited Edition boasts a special collection of retreats embodying all of these values, providing unsurpassed service, a high-quality product, value for money, and, of course, fun![71]

Sir Richard's first step in the creation of Virgin Limited Edition was to purchase Necker Island in the Caribbean in 1979 for the modest sum of £180,000. It took another few years and approximately $10 million to turn the isolated island into a private paradise that can be rented for $54,000 a day and accommodate up to twenty-eight guests. A number of other breathtaking properties were added over the years: There is the Kasbah Tamadot, not far from Marrakech, Morocco, that Sir Richard purchased in 1998 during one of his famous ballooning expeditions; the Ulusaba Private Game Reserve in the Sabi Sand reserve on the border of Kruger National Park in South Africa; or the less exotic but absolutely stunning mountain retreat, The Lodge in Verbier, in the Swiss Alps. By managing all of these exclusive retreats, Virgin Limited Edition has learned how to handle the most discerning customers, ensuring their every whim and desire is attended to with a friendly smile and perfect professionalism.

The Luxury Alchemist

This is another art that the Virgin Group has perfected. While attending to demanding clients, it has maintained its hospitality and commitment to community. In many of these exotic locations, the Virgin Group has provided job opportunities to the local populations and gives back through charitable projects, such as their Pride 'n Purpose organization in South Africa. Virgin Limited Edition hopes to "guarantee the experience of a lifetime" and "delights in going the extra mile for all our guests!"[72] This is precisely how Virgin Galactic possesses the savoir faire to create an experience that surpasses the actual two-hour ride for which their future astronauts applied. These customers had no idea what Virgin Galactic would have to offer besides the flight when they first signed up, but the company marveled its Founder clients with one surprise after another.

In December 2005, there were only a handful of registered Virgin Galactic astronauts when Stephen Attenborough hosted a small private dinner at the Soho House in New York. It didn't matter how many participants there were; what mattered was showing them how Virgin Galactic did things. Astronauts were able to spend one-on-one time with the legendary Buzz Aldrin, who enchanted them not as much with his famous moon-landing story, but with his vision of space travel over the next decade. He believed it would really take off with all the new entrepreneurs entering the arena. This dinner was just the first of a series of impressive gatherings that Virgin Galactic has been planning from the very beginning. In doing so, it not only kept its customers informed and part of the dream, but also created a devoted community of clients who are, and will continue to be, the brand's best ambassadors. That is worth more than any advertising campaign anyone

could pay for. (Incidentally, to this day Virgin Galactic has not spent a dollar on advertising, and I would doubt it will do so in the foreseeable future.)

As another part in this series of events, Virgin Galactic invited its Founders, Pioneers, and Voyagers to Los Angeles in May 2006 to attend a full-day event in the Mojave Desert, at Burt Rutan's Scaled Composites, the company that had built the craft that won the 2004 X-Prize. Over one hundred future astronauts met for the first time for the unveiling of SpaceShipOne. As there are not many high-end accommodations in the desert near Scaled Composites, Virgin Galactic rented luxurious buses that took everyone to the Mojave for the event. The bus ride was the first time some of the future astronauts were able to meet their fellow space enthusiasts, and the two hours spent getting to know one another passed quickly for everyone on board. Once the group had arrived at Scaled, they had the privilege of meeting Burt Rutan, who gave them a personal presentation on the history of aviation and space travel and shared his excitement for his new partnership with Sir Richard Branson and Virgin Galactic. It was one of those once-in-a-lifetime episodes for space dreamers, who finally had the concrete feeling that something big was happening and that they were a part of it. Then Sir Richard arrived, and he and Will Whitehorn unveiled SpaceShipOne. After a light lunch and before getting back on the buses, the most intrepid of the group hopped on a very special ride aboard a Beechcraft Starship (a twin-turboprop eight-passenger aircraft designed by Burt Rutan) and experienced a little taste of the kinds of g-forces that a typical Virgin Galactic flight would have.

That was only the first of these bonding experiences. Astronauts later had the opportunity to travel in small groups

to Necker Island for a few days at a time and meet with Sir Richard and the other Virgin Galactic team members, including Brian Binnie, Peter Diamandis, Will Whitehorn, Stephen Attenborough, Susan Newsam, and Louella Faria-Jones. During these sessions the company not only created unforgettable memories for its future astronauts, but they also made their customers feel like part of the process; the sessions empowered them to share their thoughts and turned them into the best representatives any brand could dream of.

The future astronauts were asked what they expected during and even before their flight. Whom would they like to bring along? How many family members? Did they want them to share the same experiences on Earth, such as the training program, or did they think they would not care? Would they want special time alone before their big day, or did they prefer to share it with their families and friends, or with their fellow astronauts? What would they like to take from their trip, besides the movies and photos that Virgin Galactic would organize? Did they have any special concerns they felt were not addressed? What would they like Virgin Galactic to do between now and liftoff? Were they nervous about training? Once the trip took place, what would they do afterward?

While accumulating and analyzing this valuable feedback, Virgin Galactic continued reassessing the experience and learning from their clients. In today's world, in which customers want to be heard, Virgin Galactic is ahead of the curve (as the Virgin Group often is). They were really listening to their customers—something all luxury brands should do—except that in this case as, they were creating a whole new industry, they were identifying concerns that very few companies will ever face.

All future Virgin Galactic astronauts were invited to attend the unveiling of detailed models of SpaceShipTwo at the Museum of Natural History in New York in January of 2008. That milestone day was preceded by a gathering of over one hundred Founders, Pioneers, and Voyagers who had flown from all over the world—from Spain, Pakistan, Japan, Hong Kong, and Russia—to rekindle friendships and drum up excitement before the media got involved. That day was unique for all of the space aficionados who met Sir Richard, Burt Rutan, Buzz Aldrin, and other scientists and engineers they had been reading about. It was also the day when my students met Sir Richard, Burt Rutan, Will Whitehorn, Stephen Attenborough, and all of Virgin Galactic's key executives. What better way to kick off their project!

Remarkable an experience though it was, that was only in January of 2008. Virgin Galactic continues to dazzle its astronauts through the various events celebrating other milestones, such as the unveiling of SpaceShipTwo in the Mojave Desert in December 2009, an event that included over eight hundred guests; members of the international press, future astronauts, and their friends and family attended under a large tent one windy evening. Sir Richard, Burt Rutan, New Mexico Governor Bill Richardson, and California Governor Arnold Schwarzenegger kicked off the occasion with a special presentation. Then the true star of the evening arrived: SpaceShipTwo. The theatrics of the event coupled with the wind only enhanced the moment's magic.[73]

One of the last chapters of the Virgin Galactic adventure took place with the Spaceport America groundbreaking in New Mexico in October 2010, followed by its official opening on October 17, 2011. New Mexico Governor Susana Martinez

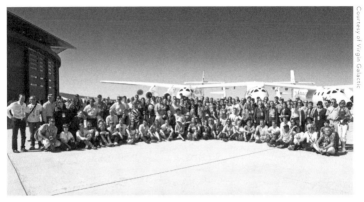

Official dedication of Spaceport America with VG future astronauts,
New Mexico, October 17, 2011.

(who had taken over for Governor Richardson, who had himself been instrumental in sealing the deal with Virgin Galactic) and Sir Richard officially dedicated the Spaceport before the crowd. The breathtaking, organically shaped, alien-looking structure, designed by Sir Norman Foster, was "dug" into its setting in order to be less intrusive in the barren landscape. When viewed from space the structure evokes Virgin Galactic's eye logo. Built using local materials, the facility is self-sustainable, uses geothermal heating and cooling, and meets LEED Gold standards for environmental quality.[74] More than eight hundred guests marveled as two aircraft, WhiteKnightTwo and SpaceShipTwo, flew above the Spaceport. After the flight, the actual dedication still managed to steal the show: Sir Richard, along with his two children, Sam and Holly, and performers from Project Bandaloop were lowered on ropes to perform a wall-walking dance along the Spaceport's glass panes. A bottle of champagne was then lowered to Sir Richard, who splashed the building and officially baptized it as the "Virgin Galactic Gateway to Space."

"Today is another history-making day for Virgin Galactic," said Sir Richard. "We are here with a group of incredible people who are helping us lead the way in creating one of the most important new industrial sectors of the twenty-first century. We've never wavered in our commitment to the monumental task of pioneering safe, affordable, and clean access to space, or to demonstrate that we mean business at each step along the way." Among the attendees, over 150 Virgin Galactic future astronauts had responded to the "Keys to a New Dawn" invitation, which included a kick-off evening of discussion about the company's progress on Galactic Unite, which we'll discuss later.

Virgin Galactic events continue to awe, such as one that took place in London in July 2012 in London, during the Summer Olympics. The next large gathering is planned for September 25, 2013, in the Mojave Desert with Sir Richard.

While you will not have to create the kind of event promotion before the launch of your luxury brand that Virgin Galactic has, you will still have to build a buzz in order to attract not only media coverage, but also excitement within your target customer's segment. Whether it's a viral social media campaign, unveiling events for a happy few, or press coverage, you'll need to create a sense of anticipation for your new brand, and then make sure you don't let your clients down.

8

READY TO LAUNCH

A. PRODUCT: THE SPACEPORT, SPACESHIPTWO, AND THE EXPERIENCE

The touch points for luxury brands are the environments in which the brand will be experienced, from stores to Web sites. An integral part of the purchasing experience, these environments will hopefully help garner repeat customers for your product. For your brick and mortar store, you not only need to create a luxurious experience that mirrors your product and values, but you also need to find the best location to attract clients. These locations are fairly easy to determine for luxury brands, even if it's not always easy to get the best spots: Madison Avenue, Rue Faubourg Saint-Honoré, Plaza 66—you know where you should go. Virgin Galactic's future home was not as obvious a decision, and they had to juggle a number of unusual considerations in order to make their choice.

Per the Futron/Zogby research, the company knew from the beginning that the Spaceport's location wouldn't really matter. The company was about addressing an international clientele who were willing and used to flying to faraway destinations. It was more a question of finding the *right* location and the *right* partner. For the first few years, Virgin Galactic only needs one location where all astronauts will take off. As more spacecraft are built, prices will go down and demand will grow, forcing the company to select other locations.

Seeing as Burt Rutan's company was based in California's Mojave Desert, the area seemed like a logical place to investigate. Most of the early Virgin Galactic project unveilings took place at the site, so it was decided early on that the first flights would also take off from that location. Executives considered building the Spaceport there, but also looked at other places that would be a good fit. New Mexico emerged as the ideal setting for a number of reasons.

New Mexico has incorporated the aerospace industry as a vital part of its economy since the 1940s, when the Air Force established two training bases there for World War II pilots. Since then the state has continued to be a destination of choice for testing space systems, and it houses more than one hundred aerospace companies. The climate, altitude, and open air space are major draws that play in the state's favor for the aeronautic sector.[75] The fact that New Mexico was willing to commit more than $200 million to the construction of the Spaceport certainly didn't hurt either.[76]

In 2005, Virgin Galactic and Governor Richardson announced that the structure would be built in Las Cruces, New Mexico. The fact that the Spaceport is located in an area of relatively low population is obviously an advantage, both from the point of view of real estate costs and concerns surrounding flight-testing. New Mexico offers another huge asset: It's a region rich in aviation engineers and the other kinds of talent needed for the project. Being in the middle of the desert poses a challenge for future clients, though. While infrastructure challenges can be easily addressed, even if they're extremely costly, the special environment required for a luxury experience is a bit more difficult to address. The UK–based Foster + Partners was selected to

build the Spaceport with a unique design that promised to wow even the most blasé clients.

Design and beauty must be a part of every luxury brand, especially in the actual experience that your client is purchasing. That is why Virgin Galactic knew that the spacecraft design in and of itself was paramount. A major milestone was achieved when Virgin Galactic announced that the future astronaut and world-renowned designer Philippe Starck would be an active participate in SpaceShipTwo's interior design.[77] Starck, a veteran luxury brand designer, knew the importance of delivering a consistently outstanding experience. His goal was to make sure that the future astronauts' trips be ideal in order to fully absorb every moment of the memorable occasion. His goal was for passengers to be able to take in the visual magnificence of space. The chairs would become almost

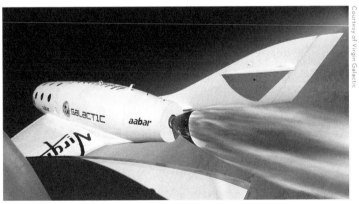

Above: Virgin Galactic visual identity created by Philippe Starck in conjunction with leading design agency GBH Design Ltd. *Below:* Virgin Galactic Spaceship Enterprise during its first rocket-powered supersonic flight, April 29, 2013.

flat when zero gravity kicked in and stay in that position to ease the intensity of the g-forces on the return flight. While the future astronauts' attention would be diverted toward the view outside, Philippe and Virgin Galactic knew that every detail of the design must evoke an unforgettable experience.

Starck also contributed ideas to Virgin Galactic's logo and brand identity. His first designs were much closer to the overall Virgin Group identity, but Virgin Galactic needed their own distinct visual identity that incorporated the fact that it was more than just another Virgin brand. It was a brand in a non-existent industry. In order to reflect the infinite possibilities that space has to offer, Starck looked to eyes and, more specifically, the iris. For him, "the curiosity and adventure of the human spirit exist in the vision of a human eye, from today, through millions of years of evolution, right back to the beginning of mankind." Every element of Virgin Galactic's brand identity is incorporated in the logo, which represents both the wonders of the cosmos and that of our planet and its inhabitants. It makes us all part of the adventure and captures this sense of the unknown and discovery.[78]

The Spaceport, which will become the Virgin Galactic brick and mortar location where clients will experience the brand, also incorporates these elements and ideas. While the venue was officially inaugurated in 2011, there is still a lot of work that needs to be done before Virgin Galactic can welcome customers. For example, to accompany the breathtaking beauty of its location, facilities, and design, Virgin Galactic will have to train everyone on the ground to make sure that their part of the experience reflects the brand's promises. As we know, it's a struggle that all luxury brands face: finding the right

talent, training it, and retaining it. It's a challenge that luxury brands are feeling more acutely in China, where the explosion in the demand for luxury products is such that companies have a very difficult time finding high quality salespeople and keeping them. While finding Virgin Galactic staff may seem more daunting because of its specific requirements, I don't think it's very different than any other brand expanding into either a new category or geography.

B. BUSINESS MODEL

With any new venture, including Virgin Galactic, you must answer some fundamental questions: What is my business model? How am I going to make money? How am I going to amortize my investments, which, in this case, are quite daunting?

The Futron/Zogby study had calculated that the potential market of the space tourism industry would reach $1 billion by 2021. Virgin Galactic is set to take a substantial share of that market using the power of their brand, but the company's executives felt from the beginning that this market would pale in comparison to the possibilities that launching small satellites into orbit could open. In September 2011, NASA awarded Virgin Galactic a contract to fly technology payloads along with some of its engineers and scientific researchers into space. This prestigious endorsement was just the first step in this part of Virgin Galactic's comprehensive business model.

On July 10, 2012, during the Farnborough International Air Show in London, Virgin Galactic announced the "LauncherOne" launch vehicle, which will make it affordable for researchers to send small satellites into orbit. With the

launcher's relatively reduced costs, Virgin Galactic is able to open up the market to start-ups, universities, and entrepreneurs, effectively transforming the small satellite market.[79]

The satellite business model was appealing enough that Virgin Galactic found a financial partner in Aabar Investments. In July of 2009, Aabar announced a $280 million commitment to Virgin Galactic for a 31.8 percent stake in Virgin Galactic's holding company, as well as an additional $100 million for the small satellite business. In October 2011, Aabar invested an additional $110 million and increased its stake to 37.8 percent. This is the kind of partnership that any luxury entrepreneur should seek, one that not only believes in your business model, but that is also able to continue its commitment for the long haul.

Virgin Galactic knew it had a sound business model and that the small satellite industry would make its business proposition even more attractive, but their space tourism remained their first priority, so the company still had to figure out how to connect with potential astronauts. Thanks to its marketing events strategy and the continued media coverage it was getting, Virgin Galactic knew that it would attract enough clients to cover the first two years of operations. Beyond that point, as is the case for any business, the selection of distribution channels is crucial to long-term success.

C. DISTRIBUTION VIA ACCREDITED SPACE AGENTS

For every luxury brand, one of the most important factors to success, one that needs to be selected and tightly controlled, is distribution: If the client doesn't have a good experience at the point of sale, if the environment, whether an actual store

or online, does not reflect the brand's values, the company's image (and business) will suffer. That is why luxury brands are so cautious when selecting their distribution partners, whether they are department stores, specialty stores, franchisors or even licensees in foreign countries. The moment you lose control, the moment the experience doesn't live up to your clients' expectations, you have a problem.

So how do you handle distribution for a luxury product such as Virgin Galactic? While Virgin has a number of brands that could be useful for this purpose, such as Virgin Limited Edition, Virgin Atlantic, or any of the aviation brands, this specific product requires careful screening and selection to ensure that the distribution will not only reflect the Galactic branch's values, but will be able to reach the target customer.

Given the specific profile of the Virgin Galactic customer, it seemed logical to bring in high-end travel agents who understood extraordinary, unique experiences. Both Virgin Atlantic and Virgin Limited Edition had worked with Virtuoso, a network of luxury travel agencies with global connections. In 2006, Virgin Galactic decided to select from among the Virtuoso network a handful of "Accredited Space Agents." Each candidate went through a lengthy application and interview process to make sure they possessed the necessary skills and interest in the endeavor. The individuals from the Virtuoso agents short list who made the final cut went through the same training required of future astronauts so that they could communicate first-hand the experience and technology behind the SpaceShipTwo experience. With their expertise, they helped gather over five hundred future astronauts by mid-2012, bringing upfront revenue of over $100 million.

Today, the network of Accredited Space Agents covers the globe, from Europe and Asia to Africa. Virgin Galactic has managed to line up all of its players, which isn't something that most luxury start-ups can do. As we saw with Savelli, retailers arrive slowly because they want proof of concept. The best way to address distribution when you are a "regular" luxury start-up is to confirm a few key partners who are willing to take a risk on your new brand. All retailers look for differentiation in the eyes of their customers, so that is an asset that will play in your favor, but it will only bring you so far, as retailing partners will rarely be willing to take on your full range of product offerings. For example, you might have to accept having your inventory on consignment. You should try to avoid that kind of position, but you may not have many other options when you start out. You also need to make sure that your cash flow will allow you to carry the financial burden of only being paid once your product is sold, instead of being paid up front by the retailer.[80]

D. INDUSTRY REGULATION

Once the legal documents relating to the creation and funding of your company are completed, you still have to comply with a number of rules and regulations in order to run your business. Those considerations could include your manufacturing country's labor laws, the multiple regulations and import taxes when structuring your product's shipping schedule and methodology, the various authorizations you must obtain if importing exotic materials, or the legal requirements for labels included in a garment. It's essential that you always familiarize yourself with the laws and regulations that will affect your company.

For Virgin Galactic the challenge was a bit more complicated because no regulations existed when it decided to enter the industry. Until then only a few countries had space programs and there was no need to look into regulations to protect the public. The few "commercial space travelers" that had gone with Space Adventures to the International Space Station were submitted to the same lengthy and rigorous training as professional astronauts.

In order to avoid the problems encountered by the aviation industry in its early years, the U.S. government decided to step in early on. As we know, aviation's early days didn't boast the best safety record. After the first two decades of aviation, technological advancements and increased levels of activity allowed for greater safety, but there were still significant issues that required regulator intervention. As is sadly often the case, it was only after a number of fatal, predominantly high-profile accidents in the 1930s that the U.S. government decided to become more involved. Even so, it wasn't until 1958 that President Eisenhower signed the Federal Aviation Act into law. The Act had only been written after two planes collided in the air over Arizona in 1956, killing everyone onboard.[81]

When the United States Congress passed the Commercial Space Launch Amendments Act of 2004, it gave the Federal Aviation Administration (FAA) the responsibility to start creating requirements for pilots, crew, and spaceship passengers. In December 2005, the FAA published proposed rules for the nascent industry, including screening procedures, training for emergency situations, verification of vehicle safety (including flight testing), and what kind of information must be disclosed to potential passengers on the risks of space flights. In order for a space tourism business to operate, it must receive a license

from the FAA. The FAA had to conduct numerous hearings in order to come to many of its conclusions. For example, the committee decided to require that pilots pass a performance requirement, but did not require that pilot to hold a certificate for a specific category of aircraft because existing aircrafts don't reflect the necessary skills needed to pilot a spacecraft.

The FAA also decided that the crew not only had to provide a certificate of good health, but also pass a performance qualification, and "demonstrate an ability to perform duties in the spaceflight environment in which they plan to operate." It will not require a physical exam for passengers, but certainly recommends it. The FAA mandates companies to provide adequate training for passengers to make sure they would know how to respond in case of an emergency situation. They did specify that passengers cannot bring any weapons on board and must sign a waiver of claims with the FAA. The overall goal of these regulations is to protect passenger well-being and help them make "informed decisions about their personal safety." The FAA also recognizes that the process requires a phased approach as it regulates commercial space travel, and that regulations will need to evolve as the industry matures.[82]

Obviously, safety has been and will continue to be the number one priority for Virgin Galactic. The rocket motor undergoes continuous ongoing hot-fire testing, as do all SpaceShipTwo flights. Virgin Galactic is committed to sending their future astronauts only once they are certain of their safety standards; after all, the first group to fly onboard one of their spacecrafts will be none other than Sir Richard and his children! As Will Whitehorn commented before the U.S Congress: "One of the biggest risks we face is if someone [. . .] decides to put somebody into space [. . .] and they

have an accident."[83] Virgin Galactic will not take any risks. While creating a new luxury brand involves a willingness to take risks, this kind of hazard is something you would want to safeguard your customers, and company, against.

E. GIVING BACK: GALACTIC UNITE

Today's luxury consumers want the brands they cherish to give back to society; they want these brands' values to be aligned with theirs because they care about their community and planet.

Concerning Virgin Galactic, it might seem like a controversial proposition. How can a company venturing into commercial space travel say they are taking care of the planet? Won't it use tons of rocket fuel to escape Earth's gravity? The company has addressed the issue head on, and Sir Richard explains that Virgin Galactic is committed to offsetting the environmental costs of their space program.[84]

The company goes even further to point out that compared to highly polluting space shuttle launches, its flights will have a minimal environmental impact. SpaceShipTwo is designed with lightweight, reusable materials, has shorter rocket burns, is debris-free, and its CO_2 emissions per passenger will be equivalent to approximately 60 percent of a per-passenger New York to London roundtrip flight.[85] The company is committed to working closely with environmental researchers and meeting its goal of reinvesting the profits of its Virgin Airline business into clean bio-fuels. They hope that its entire fleet will one day use "renewable aviation fuel or solar power."[86] Obviously, there are people who remain skeptical about the company's claims, which is fair given that they're in unchartered territory. Virgin Galactic isn't trying to avoid the issue,

and that's certainly an important point for all of the future astronauts who had expressed their desire to make a difference from the very beginning. In order to do so, Virgin Galactic capitalized on a previous venture. It launched Virgin Unite in 2005, an organization whose "aim is to help revolutionize the way that governments, businesses, and the social sector work together—driving business as a force for good."[87]

Now present in the UK, continental Europe, the United States, Canada, South Africa, and Australia, all of Virgin Unite's overhead costs are covered by Sir Richard and the Virgin Group, which means that any outside support will go entirely to its programs. Galactic Unite was officially launched in 2011. Operated by the Virgin Foundation in partnership with Virgin Unite and Virgin Galactic, they were built "from a desire by Virgin Galactic future astronauts to channel their energy and resources to achieve positive change in the world."[88] Like Virgin Unite, all of Galactic Unite's overhead costs are covered by Virgin and Sir Richard, so all donations will go directly to the programs. Galactic Unite's vision is to create a "global space community to re-imagine how we live in the world and beyond," to find practical ways to inspire and engage young people, to get them excited about space exploration, and to promote math and science education, which is lagging in the United States and Europe.

Given that the Spaceport is located in New Mexico, one of Galactic Unite's first initiatives was to partner with New Mexico State University and the New Mexico Space Grant Consortium Student Launch Program, which is part of NASA's Summer of Innovation Program. This organization holds a yearly competition that provides students with annual access to space experiments from Spaceport America in

New Mexico. It "inspires students to find answers to global challenges through space exploration" and encourages them to pursue scientific education.

Future Virgin Galactic astronaut Jann Bytheway has already donated $1 million to establish an endowment to fund a scholarship for young women pursuing science, technology, engineering, and mathematics degrees in U.S. colleges and universities. Sarah Brightman, another future astronaut, is following in Jann's footsteps. This is just the beginning. Galactic Unite intends to leverage future astronauts' experiences and use them as role models for kids by organizing classroom visits and working with teachers to come up with programs to help motivate students to study science and math. Undoubtedly, many more programs will be developed.

This is the kind of engagement customers desire from their favorite luxury brands. If you create your own luxury brand, it is not likely that you'll have either the means or the resources to create a not-for-profit organization from scratch, nor should you. Virgin Galactic is creating a new category, and with the power they have at their disposal, it seems fitting that they have such grand plans. All you need to do is ensure that your products are created, used, and will be disposable in an environmentally conscious way. Your suppliers should work in safe environments and workers should be paid at least fair market wages in their country (even though that's most likely not enough, so try to do better). You should aim to give back to society, so pick a cause that you are passionate about and make it a part of your journey!

F. LIFTOFF!

On April 29, 2013, exactly eighty-six years after Charles Lindbergh piloted his maiden flight on a small single-engine, single-seat aircraft, Sir Richard Burton witnessed "the spectacular first rocket powered supersonic flight of our wonderful Spaceship Enterprise." Writing to Virgin Galactic's future astronauts, he added that he left the Mojave Desert "with an even clearer sense that not only are we all part of history in the making, but we are also on the cusp of something more significant than any of us can yet fully understand." Thanks to this important milestone, it seems realistic that Virgin Galactic will fly to space within a year or so, and that the first astronauts will liftoff a year later! The dream will soon become a reality! [89]

As of May 2013, there are almost six hundred registered future astronauts, 17 percent of them women, with an average age range of forty-six to fifty-five years old. SpaceShipTwo completed its first glide in-powered flight in December 2012, and the first official flight with passengers is scheduled for 2014.

Virgin Galactic now has around 250 employees between its headquarters in London and its U.S. operations. Training actively continues as the company prepares to welcome its first astronauts for liftoff! All the years of hard work, preparation, putting together the right product (SpaceShipTwo), the right team, the right environment (Spaceport America), the right business model (both space tourism and payloads), the right distribution (Accredited Space Agents), the right marketing strategy (events that turned clients into brand ambassadors and the fans garnered through media). . . . All of this will come together to create long-term success for Virgin Galactic. I'll

be one of the multitudes of space devotees waiting to see this much anticipated moment and cheering for its triumph!

Sir Richard often comments on his dream to make space travel a real commercial reality through the use of environmentally friendly reusable vehicles to take more people into space. I too look forward to that day and hope that many will share this opportunity. I also hope that the Virgin Galactic saga has enlightened you as future luxury entrepreneurs and given you even more drive to pursue your dream and passion. I hope that the genesis of Virgin Galactic made you fully realize the importance of a vision, and that every step you take makes it even more of a reality. It's a challenging path, but the journey is as important as the end result!

CONCLUSION

In June 2005, Steve Jobs delivered a commencement address at Stanford's graduation ceremony that continues to inspire the millions of people who have read it—myself included. Using three stories from his life, he shared his values and highlighted the importance of following your curiosity and passion. "Have the courage to follow your heart and intuition." Try not to be too scared to lose, because you might stop making the kinds of right but risky decisions that enabled you to succeed to begin with. Embrace learning for the sake of learning, because one day the knowledge accumulated by pursuing esoteric topics that seem unrelated will come together. "You can't connect the dots looking forward; you can only connect them looking backwards."[90]

I hope you have enjoyed the short stories I have shared with you. I hope that they have made you smile and think, but most importantly, that they've also demonstrated the importance of following your passion, the secret ingredient in becoming a true Luxury Alchemist. I hope that they have shown you that while having a sound bottom line is essential, it's not the only ingredient necessary to succeed. Like every start-up out there, you will have cash flow issues at some point, but these problems will be fleeting if you follow your vision.

As a luxury entrepreneur, you will work harder than you ever imagined possible. There's no shortcut that will immediately transform you into a successful Luxury Alchemist, so you'd better have fun and love what you do.

Never forget your dreams and how all the various individual aspects we discussed—from hard work to surrounding yourself with talent and listening to others—are the necessary ingredients that will turn your passion, the Luxury Alchemist's Philosopher's Stone, into a success.

As Steve Jobs said, "Stay Hungry. Stay Foolish."[91]

ACKNOWLEDGMENTS

I would like to thank everyone who has helped me make *The Luxury Alchemist* a reality: Maria Eugenia Giron, whose book inspired me to have the courage to embark on this two year journey; Francis Cholle and Laura Neely who showed me the path to publishing a book; and especially Martine and Prosper Assouline who are willing to take a chance on a novice. To everyone at Assouline for their professionalism and support: Victorine Lamothe, Camille Dubois, Nadia Bennet, Jihyun Kim, Esther Kremer, and Chuck Hendricks. To Jon Freedman, Blake Perkins, and Kim Shefler, who each gave me a piece of the legal puzzle. To Maximilien, who took the time to read the first unfinished draft and managed to do a tough critique in a wonderful positive twist so I had the courage to reshape it into its current form. To Stuart, François, and Gustave who did the first full editing so the text could be presentable to professionals.

I am deeply grateful to all the luxury industry leaders who kindly took the time to review the various parts relevant to them or their company: Hervé Aaron, Claire Abeille, Reem Acra, Patrick Alès, Peter Ashall, Stephen Attenborough, Clotilde Bacri, Henri Barguirdjian, Pamela Baxter, Guy Bedarida, Michel Bernardaud, Daniel Boulud, Marina Bulgari, Milena Cavicchioli, Valérie Chapoulaud, Bob Chavez, Barbara Cirkva, François Curiel, Guillaume Cuvelier, Pamela Danziger, Roberto de Bonis, Patrick Demarchelier, Peter Diamandis, Pierre-Alexis Dumas, Joel Espelien, Jack Ezon, Audrey Francis, Claudio Guiliano, John and Cynthia Hardy, Cyrus Jilla, Kenny Kemp, Arie Kopelman, Leonard Lauder, Fabio Leoncini, Elio Leoni-Sceti, Enrico Mambelli, Safwan Masri, Gilles Mendel, Fernando Napolitano, Sam O'Donahue, Clare Pelly, Emmanuel Perrin, François Pogodalla, Geneviève Prillaman, Julia Restoin Roitfeld, Joel Rosenthal and Pierre Jeannet, Robert de Rothschild, Joshua Ruch, Claudio Rummazza, Burt Rutan, Christophe Salin,

Alessandro Savelli, Ronaldo Stern, Tim Stock, Dana Thomas, Marc Trahand, Marie-Lena Tupot, Vera Wang, Andrew Wu, and Maz Zouhairi.

I am indebted to all who shaped me into the professional I am today. From my early days in Paris to the leading "Commissaires-Priseurs" of Etude Ader Picard Tajan, and in New York to Marina Bulgari, Hervé Aaron, Gonzague Saint Bris, and François Curiel who saw something in me I did not know I could pull off. To Jean Bergeron, who listened to Hervé Aaron and hired me at the Comité Colbert. To Valérie Hermann, ma demi-soeur, Anne de Fayet, and Christian Blanckaert, for giving me the support and confidence to succeed during the first years of the American Colbert adventure. To Alain Teitelbaum, Liesbeth Moreaux, Frédérique Nicollet, and Alexandra Rendall, with whom I continued the Colbert journey. To all the US Reflection Committee members. To Alain Boucheron who was there for me when the time came to move on after the Colbert Foundation. And most importantly, to Jean-Louis Dumas and Arie L. Kopelman, my two mentors who were always there for me, pushing me, guiding me and believing in me.

To the formidable board of the Luxury Education Foundation, who have been my steadfast partners and dear friends since 2004: Barbara Cirkva, our amazing chair, Bob Chavez "My Jiminy," Henri Barguirdjian, François Kress, Marla Sabo, and Safwan Masri; and all the Advisory Board members: Daniel Barth, Pamela Baxter, Nicolas Bos, Laurent Claquin, Charles-Henri Cousin, Hermann Elger, Robert Ferguson, Jean-Marc Gallot, Fabio Leoncini, Guglielmo Malagari, Vincent Ottomanelli, Emmanuel Perrin, Farzad Rastegar, Thomas Serrano, Fred Wilson, and Maz Zouhairi.

I have a deep debt of gratitude to Professor Safwan Masri who, as Vice Dean of Columbia Business School, offered me the opportunity to come and teach as an Adjunct Professor in 2004: You gave me the opportunity to capitalize on my professional experience and allowed me to not only share it with so many talented young people, but also opened the path to my

new business endeavors. And to Maz Zouhairi, for being my companion in arms during my first semester, and ever since!

A humongous thanks to Caitlin O'Reilly, who spent months making sense of my footnotes, putting them in proper form, helping me get the numerous approvals, and assisting the editors with their questions and comments.

To my family: my mother, whose phenomenal accomplishments have been an inspiration; my father, whose integrity I hope I inherited; Zia Letizia, who has been an integral part of our lives; Zio Fabrizio and Zia Maria Chiara, Vera, Mario, Felice, Arturo, Enrica, Roberto, Gabriella, and Adriana—my other parents and the brothers and sisters I never had; Zio Mario, Zia Rosellina, Zio Gennaro, Mariella, Francesco, and Andrea, who all made my summers filled with joy and warmth. To Papa et Maman—Jacques and Françoise Maisonrouge, Christine and Xavier, Florence, Vin, Sylvie and Bob, Anne-Sophie and Sophie, and their children who welcomed me in the Red House clan like a daughter and sister. Thank you to all for making me a better person.

To François (now in Hong Kong), Judi, Alison and Douglas, Nazee and Roddy, Patrizia, Elliott, Geneviève and Jerry, Barbara and Keith, Olivia and Adam, Emmanuel and Mariana, Enrica and Fabrizio, François and Maritza, Gilles and Kylie, Bernadette, Olivier, Selima, Yolanda, Tarcila, Jacques and my NDI family, Ray and my ACF family, Jim and Dan and the Kips Bay family, and my two wonderful Mousquetaires: Thank you all for being our extended family. And especially to Stuart, who is always there for me.

Most importantly: to my husband, François, for his constant and unwavering support and belief in me. To our two sons, Maximilien and Gustave, who are my light, my strength, my whole life: We are immensely proud of the young men you have become.

ENDNOTES

INTRODUCTION, PROLOGUE, AND PART I

1. See the Web site of the Institut d'études politiques de Paris, http://www.sciencespo.fr/.

2. See the Web site of the Comité Colbert, http://www.comitecolbert.com/.

3. See the Web site of ESSEC, or the École supérieure des sciences économiques et commerciales, http://www.essec.fr/; and that of HEC Paris, or the École des hautes études commerciales de Paris, http://www.hec.edu/.

4. See the Web site of the Luxury Education Foundation, http://www.luxuryeducationfoundation.org/.

5. Evan Clark, "American Luxe Goods Market May Offer Untapped Potential," *Women's Wear Daily*, December 5, 2011, http://www.wwd.com/business-news/forecasts-analysis/luxurys-missed-us-opportunity-5411442.

6. *Collins Dictionary of Economics*, ed. C. L. Pass, Bryan Lowes, and Leslie Davies, (London: Collins, 2006), s.v. "luxury product."

7. "Cartier's Precious Moments," *Women's Wear Daily*, September 25, 2011, http://www.wwd.com/fashion-news/fashion-scoops/cartiers-precious-moments-5218171.

8. The Comité Colbert Festival des Artisans was held September 14–20, 1998, at the South Coast Plaza. Participating Comité Colbert members and artisans included Baccarat, Bernardaud, Céline, Chanel, Christian Dior, Christofle, Daum, Givenchy, Hermès, John Lobb, Krug, Lacoste, Lalique, Lancôme, Louis Roederer Champagne, Louis Vuitton, Saint Louis Crystal, and Van Cleef & Arpels.

9. Lynn Hirschberg, "In the Beginning, There Was Leather . . . ," *New York Times*, November 30, 2003, http://www.nytimes.com/2003/11/30/magazine/in-the-beginning-there-was-leather.html.

10. Stated by an Hermès executive.

11. Louis Vuitton, "Les Journées Particulières: LVMH Opens Its Heritage Sites to the Public on 15 and 16 October," press release, June 7, 2011, http://www.lvmh.com/press/595.

12. Sarah Karmali, "LVMH to Reprise Journées Particulières Event," *Vogue*, April 9, 2013, http://www.vogue.co.uk/news/2013/04/09/lvmh-journees-particularies-2013---visit-ateliers-workshops-of-dior-and-louis-vuitton.

13. Bibby Sowray, "Louis Vuitton: The World's Most Valuable Luxury Brand," *Telegraph*, May 24, 2012, http://fashion.telegraph.co.uk/news-features/TMG9287478/Louis-Vuitton-the-worlds-most-valuable-luxury-brand.htm.

14. Vivian Chen, "Even Babies, It Seems, Are Interested in Contemporary Artists," *South China Morning Post* (Hong Kong), January 20, 2011, http://www.scmp.com/article/736215/even-babies-it-seems-are-interested-contemporary-artists.

15. "The Portero Promise," accessed January 22, 2012, http://www.portero.com/about-portero.

16. Suzy Menkes, "Fashfile: A London Exhibition for 'Jar's,'" *New York Times*, June 12, 2001, http://www.nytimes.com/2001/06/12/news/12iht-jar_ed2_.html.

17. François Curiel, Chairman of Christie's Europe, "Presentation on JAR: October 31st Press Conference at Somerset House," presentation at press conference at Somerset House, London, October 31, 2002.

18. Helen Wigham, "Who's Who: Karl Lagerfeld," *Vogue*, accessed January 22, 2013, http://www.vogue.co.uk/spy/biographies/karl-lagerfeld.

19. Alice Cavanagh, "Alexander Wang's Balenciaga Debut," The Daily Beast, February 28, 2013, http://www.thedailybeast.com/articles/2013/02/28/alexander-wang-s-balenciaga-debut.html.

20. "How Engaged Are Your Customers?" (Cambridge, Forrester Consulting, 2008) http://www.adobe.com/engagement/pdfs/Forrester_TLP_How_Engaged_Are_Your_Customers.pdf.

21. "Executive Profile: Arie L. Kopelman," *Bloomberg Businessweek*, accessed January 22, 2012, http://investing.businessweek.com/research/stocks/private/person.asp?personId=7487793&privcapId=54907 82&previousCapId=4266252&previousTitle=Cha nel,%20Inc.

22. Cathy Horyn, "For a Chief, Gucci Reaches into Frozen Foods," *New York Times*, April 22, 2004, http://www.nytimes.com/2004/04/22/business/for-a-chief-gucci-reaches-into-frozen-foods.html.

23. Quote from Bruno Pavlovsky, President of Fashion, Chanel, in Ella Alexander, "Transcending Time," *Vogue*, October 3, 2011, http://www.vogue.co.uk/news/2011/10/03/chanels-bruno-pavlovsky-interview---karl-lagerfeld-and-couture.

24. Imran Amed, "CEO Talk: Bruno Pavlovsky, President of Fashion, Chanel," Business of Fashion, October 22, 2012, http://www.businessoffashion.com/2012/10/ceo-talk-bruno-pavlovsky-president-of-fashion-chanel.html.

25. Robert Frank, "Most Expensive Bottle of Wine Ever Sold at Auction," *The Wealth Report* (blog), *Wall Street Journal*, October 29, 2010, http://blogs.wsj.com/wealth/2010/10/29/most-expensive-bottle-of-wine-ever-sold-at-auction/.

26. Hugh Johnson and Jancis Robinson, *The World Atlas of Wine*. (London: Mitchell Beazley Publishing, 2005), 90.

27. Ch'ng Poh Tiong, "Will Lafite Remain Emperor of Wine Forever?," Chinesebordeauxguide.com, accessed May 20, 2013, http://www.chinesebordeauxguide.com/index.php?page=new_stories&id=49.

28. Cindy Blumenthal, "China to Become the Largest Cognac Market," Examiner.com, March 26, 2013, http://www.examiner.com/article/china-to-become-the-largest-cognac-market.

29. David Williams, "Six of the Best Affordable Bordeaux," *Observer*, September 18, 2010, http://www.guardian.co.uk/lifeandstyle/2010/sep/19/affordable-bordeaux-china.

30. Will Lyons, "The Lafite Phenomenon," *Wall Street Journal*, December 17, 2010, http://online.wsj.com/article/SB10001424052748704457604576011303280362530.html.

31. William Yau, "Red China," *South China Morning Post* (Hong Kong), November 23, 1997.

32. Tiong, "Will Lafite Remain Emperor of Wine Forever?"

33. Leo Lewis and Charles Bremner, "Vintage Obsession for the Beijing Elite," *Times* (London), December 11, 2010.

34. Andy Xie, "The Puzzle of Carruades de Lafite," Caixin Online, accessed January 23, 2012, http://english.caixin.com/2010-07-07/100158965.html.

35. Amy Ma, "Why the Chinese Love Lafite," *China Real Time Report* (blog), *Wall Street Journal*, September 17, 2010, http://blogs.wsj.com/chinarealtime/2010/09/17/why-the-chinese-love-lafite/.

36. Will Lyons, "Lafite's Asian Connection," *On Wine* (blog), *Wall Street Journal*, October 27, 2010, http://blogs.wsj.com/wine/2010/10/27/lafites-asian-connection/.

37. "CFDA Members: Gilles Mendel," Council of Fashion Designers of America, accessed May 20, 2013, http://cfda.com/members#!gilles-mendel.

38. "Fashion Brings Fur Back," MSN video, 1:44, February 17, 2011, http://video.th.msn.com/watch/video/fashion-brings-fur-back/yuoob1ri.

39. "Gilles Mendel Fiaf," YouTube video, 1:38, posted by "So5thavenue," March 14, 2010, http://www.youtube.com/watch?v=j83E1wlFIKc&feature=related.

40. "Luxury Leaders: J. Mendel's Gilles Mendel,"

BusinessWeek (podcast), July 29, 2008, http://www.podbean.com/home/podcast-directory-play.php?eid=2582540.

41. "Gilles Mendel Fiaf," YouTube video.

42. "Gilles Mendel's Fashion-Forward Home," Elledecor.com slide show, accessed May 20, 2013, http://www.elledecor.com/celebrity-style/gilles-mendels-fashion-forward-home-a-54784.

43. Reem Acra, "TEDxDoha: Reem Acra: The East, the West, the Past and the Future," YouTube video, 16:54, posted by "TEDxTalks," November 4, 2010, http://www.youtube.com/watch?v=UpKdckt1Hos.

44. Ibid.

45. "Al Hurra: December 2009," YouTube video, 4:19, posted by "reemacra," August 9, 2010, http://www.youtube.com/watch?v=6dRSW3gOl2E.

46. "Al Hurra: December 2009," YouTube video.

47. *Une Étrangeté Sous un Mur*, 1988, made of glass and crystal, designed by Starck and manufactured by Daum, accessed March, 15, 2013, http://www.starck.com/en/design/editors/daum.html#four_curiosities_against_a_wall.

48. See the Web site of Riedel, http://www.riedel.com/.

49. David Segal, "Apple's Retail Army, Long on Loyalty but Short on Pay," *New York Times*, June 23, 2012, http://www.nytimes.com/2012/06/24/business/apple-store-workers-loyal-but-short-on-pay.html?pagewanted=all&_r=0.

50. Yukari Iwatani Kane and Ian Sherr, "Secrets from Apple's Genius Bar: Full Loyalty, No Negativity," *Wall Street Journal*, June 15, 2011, http://online.wsj.com/article/SB10001424052702304563104576364071955678908.html?user=welcome&mg=id-wsj.

51. "Why Americans Once Loved France," an interview with David McCullough, by Fareed Zakaria, *Fareed Zakaria GPS*, CNN, July 28, 2011, http://globalpublicsquare.blogs.cnn.com/2011/07/28/david-mccullough-on-why-americans-were-once-fascinated-by-france/?iref=allsearch.

52. "Vera Wang Wed to Arthur Becker," *New York Times*, June 23, 1989, http://www.nytimes.com/1989/06/23/style/vera-wang-wed-to-arthur-becker.html.

53. "A Conversation with Vera Wang & Pamela Fiori at Guild Hall," YouTube video, 30:01, posted by "VVH-TV," October 7, 2009, http://www.youtube.com/watch?v=K7fZMdRTUMk&feature=related.

54. Anne M. Todd, *Vera Wang*, Asian Americans of Achievement. (New York: Chelsea House, 2007).

55. Ibid.

56. "A Conversation with Vera Wang & Pamela Fiori at Guild Hall," YouTube video.

57. Ibid.

58. "Vera Wang on Ice," YouTube video, 2:36, posted by "style," December 3, 2007, http://www.youtube.com/watch?v=_H1f-UAbsZo.

59. "Vera Wang Documentary (Designer)," YouTube video, 2:41, posted by "BroadbandTVFashion," August 6, 2008, http://www.youtube.com/watch?v=c0CGS5atFrU&feature=related.

60. Ibid.

61. "A Conversation with Vera Wang & Pamela Fiori at Guild Hall," YouTube video.

62. *Reference for Business*, accessed May 21, 2012, http://www.referenceforbusiness.com/businesses/M-Z/Vera-Wang-Bridal-House-Ltd.html, s.v. "Vera Wang Bridal House Ltd."

63. Robert A. Hamilton, "The View from: Stafford; Old Mill Town Revived by Foreign Investment," *New York Times*, December 13, 1992, http://www.nytimes.com/1992/12/13/nyregion/the-view-from-stafford-old-mill-town-revived-by-foreign-investment.html?pagewanted=all&src=pm.

64. Naomi West, "Golden Fleece," *Telegraph*, December 9, 2006, http://www.telegraph.co.uk/culture/3657017/Golden-fleece.html.

65. Lisa Lockwood, "Analysis: Sell or Go It Alone?," *Women's Wear Daily*, July 6, 2011, http://www.wwd.com/markets-news/ready-to-wear-sportswear/staying-independent-vs-selling-out-3701351.

66. Jean E. Palmieri, "What Does It All Mean? Shoppers Take a Stand," *Women's Wear Daily*, June 6, 2011, http://www.wwd.com/retail-news/trends-analysis/what-does-it-all-mean-shoppers-take-a-stand-3639934?navSection=issues.

67. "License Brands," accessed May 6, 2013, http://www.luxottica.com/en/brands/license_brands/index.html.

68. "History," Luxottica, last modified November 4, 2011, accessed May 21, 2013, http://www.luxottica.com/en/company/history/timeline/.

69. "Licensed Brands," Safilo Group, accessed May 21, 2013, http://www.safilo.com/en/2-licensed-brands.php.

70. Confirmed by Luxottica executives.

71. "License Brands," Luxottica.

72. "Licensed Brands," Safilo Group.

73. *Heilbrunn Timeline of Art History*, "Christian Dior (1905–1957)," accessed May 21, 2013, http://www.metmuseum.org/toah/hd/dior/hd_dior.htm.

74. Marie France Pochna, *Christian Dior: The Man Who Made the World Look New* (New York: Arcade Publishing, 1996).

75. "LVMH: The Empire of Desire," *Economist*, June 2, 2012, http://www.economist.com/node/21556270.

76. Suzy Menkes, "Fashion Houses Move to Tighten Brand Control: A License to Kill," *New York Times*, July 4, 2000, http://www.nytimes.com/2000/07/04/style/04iht-flicense.2.t.html.

77. "Izod vs. Lacoste," Style Guy, *GQ*, accessed May 21, 2013, http://www.gq.com/style/style-guy/shirts-and-ties/200508/izod-lacoste-alligator-crocodile.

78. Teri Agins, *The End of Fashion: How Marketing Changed the Clothing Business Forever* (New York: William Morrow Paperbacks, 2000).

79. Jack Trout, "Licensing: Trouble for Brands," Branding Strategy Insider, February 25, 2008, http://www.brandingstrategyinsider.com/2008/02/marketing-with.html#.UW2-a7Xvuh0.

80. Brenda Polan and Roger Tredre, *The Great Fashion Designers* (New York: Berg, 2009).

81. Jamie Huckbody, "Pierre Cardin, He's Everywhere," *Age*, August 1, 2003, http://www.theage.com.au/articles/2003/08/01/1059480531338.html.

82. Christina Passariello, "Pierre Cardin Ready to Sell His Overstretched Label," *Wall Street Journal*, May 2, 2011, http://online.wsj.com/article/SB10001424052748704547604576263541408680576.html.

83. Lisa Eisner and Román Alonso, "Bubbles in Paradise," *New York Times*, August 18, 2002, http://www.nytimes.com/2002/08/18/magazine/bubbles-in-paradise.html?ref=pierrecardin&gwh=EA45A0B4F229BC2CC43F58664702634D.

84. Jean-Pascal Hesse, *Pierre Cardin: 60 Years of Innovation* (New York: Assouline, 2010).

85. Uche Okonkwo, *Luxury Fashion Branding: Trends, Tactics, Techniques* (New York: Palgrave Macmillan, 2007).

86. Dominique Schroeder, "Fashion Legend Pierre Cardin 'to Sell Everything,'" AFP, June 29, 2009, http://www.google.com/hostednews/afp/article/ALeqM5gghuGVRoLOrRl3JqjNbPQEW5XJbQ.

87. Christina Passariello, "Pierre Cardin Ready to Sell His Overstretched Label."

88. "Pierre Cardin Fetes 30 Years at Maxim's," *Women's Wear Daily*, June 24, 2011, http://www.wwd.com/eye/parties/pierre-cardin-fetes-30-years-at-maxims-3682026.

89. "Burberry and Globalisation: A Checkered Story," *Economist*, January 20, 2011, http://www.economist.com/node/17963363.

90. As confirmed by Burberry executives.

91. See Burberry's Facebook and YouTube Web sites, accessed June 18, 2013, https://www.facebook.com/burberry and http://www.youtube.com/user/Burberry.

92. "Master and Muse: Reneé Lalique and Sarah Bernhardt," Christie's Features Archive, September 14, 2009, http://www.christies.com/features/2009-October-New-York-Master-and-Muse-218-1.aspx.

93. Fiona McCarthy, "The Sweet Smell of Success: Patrick Alès Magnificent Garden Is Still Going Strong," *Independent*, August 4, 2012, http://www.independent.co.uk/property/gardening/the-sweet-smell-of-success-patrick-als-magnificent-garden-is-still-going-strong-7999526.html?origin=internalSearch.

94. "Hermès' Themes Year by Year," Hermesology, accessed May 22, 2013, http://hermes.digitalurbana.com/2013/01/yearly-themes/.

95. Nick Carbone, "Evelyn Lauder, Pink Ribbon Pioneer and Breast Cancer Advocate, Dies at 75," *Time NewsFeed*, November 13, 2011, http://newsfeed.time.com/2011/11/13/evelyn-lauder-pink-ribbon-pioneer-and-breast-cancer-advocate-dies-at-75/.

96. Sandy M. Fernandez, "Pretty in Pink," *MAMM*, June/July 1998, http://web.archive.org/web/20071218231238/http://thinkbeforeyoupink.org/Pages/PrettyInPink.html.

97. As of December 31, 2012, the Breast Cancer Research Foundation (BCRF), a 501(c)(3) that Evelyn H. Lauder founded in 1993, had raised more than $400 million. See the BCRF Web site, http://www.bcrfcure.org/about.html.

98. "The Company," Merci, accessed June 19, 2013, http://www.merci-merci.com/en/the-company.html.

99. Patricia Marx, "Treasure & Bond," On and off the Avenue, *New Yorker*, January 23, 2012.

100. Sharon Edelson, "Nordstrom Opening Store for Charity in SoHo," *Women's Wear Daily*, August 16, 2011, http://www.wwd.com/retail-news/department-stores/nordstrom-to-open-charity-store-5066961.

101. Jem Bendell and Anthony Kleanthous, *Deeper Luxury: Quality and Style When the World Matters* (Godalming, Surrey: WWF UK, 2007), accessed May 22, 2013, http://www.wwf.org.uk/deeperluxury/report_download.html.

102. See the Web site of Artisans Angkor: Caring for the Past and Crafting for the Future, http://www.artisansangkor.com/.

103. "Evironmental Profit & Loss Account," Kering, accessed May 22, 2013, http://www.kering.com/en/sustainability/environmental-pl.

104. Dana Thomas, *Deluxe: How Luxury Lost Its Luster*, (London: Penguin Books, 2008).

105. "Hermès Hosts 'Family Reunion' for U.S. Employees," *Women's Wear Daily*, October 7, 2011, http://www.wwd.com/fashion-news/fashion-scoops/one-big-happy-luxury-family-5273529.

106. "The Great British Trench Coat: Made in England," Aquascutum, accessed May 22, 2013, http://www.aquascutum.com/history.aspx (page discontinued).

107. "What Went Wrong at Aquascutum?," Op-Ed, Business of Fashion, August 28, 2012, http://www.businessoffashion.com/2012/08/op-ed-what-went-wrong-at-aquascutum.html.

108. Nina Jones, "Aquascutum Goes into Administration," *Women's Wear Daily*, April 17, 2012, http://www.wwd.com/business-news/financial/aquascutum-enters-administration-5862122?src=nl/mornReport/20120418.

PART II AND CONCLUSION

1. "Vertu Chooses Android over Windows for Luxury Handset," BBC News, February 11, 2013, http://www.bbc.co.uk/news/technology-21387371.

2. Gartner, "Gartner Says Worldwide Mobile Phone Sales Declined 1.7 Percent in 2012," press release, February 13, 2013, http://www.gartner.com/newsroom/id/2335616.

3. "Luxury Goods Retailing, U.S., January 2008," (Mintel Reports, 2008). Supplied to Columbia University, New York.

4. ABI Research, "Luxury Brands Aim for Multi-Billion Dollar Revenues from the Mobile Handset Market," press release, Reuters, August 5, 2008, http://www.reuters.com/article/2008/08/05/idUS158896+05-Aug-2008+BW20080805.

5. Apple Press Info, "Apple Reinvents the Phone with iPhone," press release, January 9, 2007, http://www.apple.com/pr/library/2007/01/09Apple-Reinvents-the-Phone-with-iPhone.html.

6. "Goldvish Le million $1,000,000 (£540,540) Guinness Books of Records Most Expensive Phone," Phones Review, May 21, 2007, http://www.phonesreview.co.uk/2007/05/21/goldvish-le-million-1000000-dollars-540540-pounds-guinness-books-of-records-most-expensive-phone/.

7. Brian DeChesare, "Private Equity vs. Venture Capital," Mergers & Inquisitions, accessed June 5, 2013, http://www.mergersandinquisitions.com/private-equity-vs-venture-capital/.

8. Stephanie Bodoni, "Boris Becker's Former Wife Wins EU Court Ruling in Harman Trademark Case," Bloomberg, June 24, 2010, http://www.bloomberg.

com/news/2010-06-24/boris-becker-s-former-wife-wins-eu-court-ruling-in-harman-trademark-case.html.

9. Hogan Lovells and Andreas Renck, "Barbara Becker Scores before the Court of Justice," Lexology, July 22, 2010, http://www.lexology.com/library/detail.aspx?g=bf19eefb-6b3e-466f-953d-b4725334b1b6.

10. Norah T. Hunter, *The Art of Floral Design*, 2nd ed. (Clifton Park: Delmar, 2000), 200, http://books.google.co.uk/books?id=58WFNLW83jEC&pg=PA200&lpg=PA200&dq=%22Line+of+grace%22+design&source=bl&ots=zqoVbVcajo&sig=KdJENcfFXoG6PCr1Dvbs5DQIbNU&hl=en&ei=WV65ToXmAtHEtAb61PmjBg&sa=X&oi=book_result&ct=result&resnum=6&ved=0CFMQ6AEwBQ#v=onepage&q=line%20of%20grace&f=false.

11. Diana ben-Aaron and Matthew Campbell, "Diamond-Crusted Vertu Phone Defies Slump," Bloomberg, September 29, 2011, http://www.bloomberg.com/news/2011-09-28/nokia-s-6-800-diamond-crusted-vertu-phone-defies-slump-to-win-sales-tech.html.

12. "Hey, Big Spender, You Want Value?," *International Herald Tribune*, October 2009, https://www.ledburyresearch.com/news/archive/hey-big-spender-you-want-value-concierge-firms-thriving-in-downturn-as-rich-turn-finicky-in-luxury-c.

13. Allison Abell Schwartz and Oshrat Carmiel, "Apple May Be Highest Grossing Fifth Avenue Retailer," Bloomberg, August 24, 2009, http://www.bloomberg.com/apps/news?pid=newsarchive&sid=aK4TfewPa37M

14. EQT, Investments, http://www.eqt.se/Portfolio-Companies/Current-Portfolio/Vertu/.

15. Christofle and La Maison du Chocolat event held on Monday, April 2, 2012, accessed June 5, 2013, http://pulsd.com/new-york/eats/christofle-pop-up-shop/wine-and-chocolate-tasting-pop-up-shop.

16. "Target Pop Ups All Over the World, 2003: Isaac Mizrahi for Target Pop-Up in Rockefeller Center," A Bullseye View: Behind the Scenes at Target, August 31, 2011, accessed June 5, 2013, http://abullseyeview.com/target-pop-up-stores/2003-issacmizrahi_rockefellercenter_shop1/.

17. J.P. Morgan, *J.P. Morgan Minutes. 'The New Luxury Consumer' with Pam Danziger*, January 15, 2010, accessed June 5, 2013, http://www.unitymarketingonline.com/cms/uploads/white_papers/jpm_j.p._morgan_minutes_20100114_362244.pdf.

18. Pamela N. Danziger, *Putting the Luxe Back in Luxury: How New Consumer Values Are Redefining the Way We Market Luxury* (Ithaca, NY: Paramount Market Publishing, 2012).

19. ScenarioDNA, *The Culture of Luxury 2011* (Brand Packaging), SlideShare presentation, posted by Tim Stock, October 7, 2011, http://www.slideshare.net/scenariodna/the-culture-of-luxury-2011-brand-packaging.

20. Emanuel Rosen, *The Anatomy of Buzz: How to Create Word-of-Mouth Marketing* (New York: Crown Business, 2002), 45, accessed June 5, 2013, http://books.google.com/books?id=UD2OP-IJa3YC&pg=PA48&dpg=PA48&dq=Buzz+Marketing+Regular+hubs:+regular+people+who+serve+as+source+of+info+on+certain+products&source=bl&ots=FrEmdsvkhd&sig=XUZIwYkFja_GgPT6LmVPwAzCXV4&hl=en&sa=X&ei=Sj4VUbe1PJT60AGj8YGoDw&ved=0CFoQ6AEwAw#v=onepage&q=Buzz%20Marketing%20Regular%20hubs%3A%20regular%20people%20who%20serve%20as%20source%20of%20info%20on%20certain%20products&f=false.

21. Associated Press, "Judge Tosses Claims in Paris Hilton Hair Lawsuit," *Washington Times*, December 21, 2010, http://www.washingtontimes.com/news/2010/dec/21/judge-tosses-claims-in-paris-hilton-hair-lawsuit/.

22. See the Web site of the FACET Foundation, http://www.facet-foundation.org/.

23. *NASA Historical Data Book, Volume VI: NASA Space Applications, Aeronautics and Space Research and Technology, Tracking and Data Acquisition/Space Operations, Commercial Programs, and Resources, 1979–1988*, NASA SP-2000-4012, 2000, compiled by Judy A. Rumerman, accessed June 5, 2013, http://history.nasa.gov/SP-4409_4.pdf.

24. Dan Grossman, "DELAG: The World's First Airline," *Airships: The Hindenburg and Other Zeppelins* (blog), accessed June 5, 2013, http://www.airships.net/delag-passenger-zeppelins.

25. "Brief History of the Airplane," History of Airplanes, Saperecom, accessed June 5, 2013, http://www.historyofairplanes.net/.

26. "A Brief History of the FAA," Federal Aviation Administration, last modified February 1, 2010, accessed June 5, 2013, http://www.faa.gov/about/history/brief_history/.

27. "Airlines and Airliners: The Beginning of Transatlantic Services," Century of Flight, accessed June 5, 2013, http://www.century-of-flight.net/new%20site/commercial/Transatlantic%20Services.htm.

28. Georgina Cruz, "Flights of Fancy," *Sun Sentinel*, June 18, 1989, http://articles.sun-sentinel.com/1989-06-18/features/8901310283_1_flight-atlantic-meals.

29. "Liner Transatlantic Crossing Times, 1833–1952 (in Days)," The Geography of Transport Systems, accessed June 5, 2013, http://people.hofstra.edu/geotrans/eng/ch3en/conc3en/linertransatlantic.html.

30. "Airlines and Airliners," Century of Flight.

31. Ibid.

32. Tim Kirkwood, "82nd Anniversary of the First Female Flight Attendant, Ellen Church," Yahoo! Voices, January 26, 2011, http://voices.yahoo.com/82nd-anniversary-first-female-flight-attendant-7711386.html.

33. "Brief History of the Airplane," History of Airplanes.

34. James C. Kruggel, "Simplify, Simplify, Simplify," Airliners.net, June 16, 2002, http://www.airliners.net/articles/read.main?id=23.

35. Dr. Robert Alexander Goehlich, "Space Tourism: Spring Semester 2004," lecture series, accessed 5, 2013, http://www.robert-goehlich.de/downloads/lect_sptoI_04_Lecture%20R.A.%20Goehlich.pdf.

36. "Virgin Galactic: Milestones to Space," YouTube video, 3:23, uploaded by "virgingalactic," October 28, 2010, http://www.youtube.com/watch?v=IRr0GLSAzdw.

37. Kenny Kemp, *Destination Space: How Space Tourism Is Making Science Fiction a Reality*, London, Virgin Books, 2010).

38. Jim Grichar, "Hurray for Burt Rutan and Paul Allen: Now It's Time to Deep-Six NASA!!!," LewRockwell.com, October 5, 2004, http://www.lewrockwell.com/grichar/grichar49.html.

39. Kenny Kemp, *Destination Space*, 83.

40. "The SpaceShipOne: The First Private Manned Mission to Space," Gizmo Highway, accessed June 5, 2013, http://www.gizmohighway.com/space/space_ship_one.htm.

41. "Branson and Rutan Launch New Spaceship Manufacturing Company," Space Daily, July 28, 2005, http://www.spacedaily.com/news/spacetravel-05zzzg.html.

42. "Company Profile," on the Futron Corporation Web site, accessed June 5, 2013, http://www.futron.com/company_profile.xml.

43. *The Mendelsohn Affluent Survey*, (San Francisco, Ipsos MediaCT, 2008).

44. "Women in Space: Female Astronauts before and after Sally Ride," Huffpost Science, July, 24, 2012, http://www.huffingtonpost.com/2012/07/24/astronaut-women-sally-ride-space_n_1698274.html.

45. *Space Tourism Market Study*, (Bethesda, Futron Corporation, 2002), http://www.spaceportassociates.com/pdf/tourism.pdf.

46. Volvo, "Volvo and Virgin Galactic Team Up in Space," press release, February 5, 2005, https://www.media.volvocars.com/.../media/.../2610_2_1.aspx.

47. "About Virgin," on the Virgin Web site, accessed June 5, 2013, http://www.virgin.com/about-us.

48. Benson Space Company, "SpaceDev Founder Jim Benson Launches Civilian Spaceflight Venture, Benson Space Company," press release, SpaceRef, Sept 28, 2006, http://www.spaceref.com/news/viewpr.html?pid=20930.

49. NASA, "NASA Announces Next Steps in Effort to Launch Americans from U.S. Soil," press release, August 3, 2012, http://www.nasa.gov/home/hqnews/2012/aug/HQ_12-263_CCiCAP_Awards.html.

50. "Internet Pioneer Seeks engineers for Spaceflight Effort," *International Herald Tribune*, January 4, 2007, http://www.nytimes.com/2007/01/04/business/worldbusiness/04iht-bezos.4097265.html?_r=0.

51. "Commercial Crew Development: Space Act Agreement No. NNK11MS02S," March 29, 2011, accessed June 6, 2013, http://procurement.ksc.nasa.gov/documents/NNK11MS02S_SAA_BlueOrigin_04-18-2011.pdf.

52. "Company Overview," on the XCOR Aerospace Web site, accessed June 5, 2013, http://www.xcor.com/about_us/index.html.

53. Dan P. Lee, "Welcome to the Real Space Age," *New York*, May 19, 2013, http://nymag.com/news/features/space-travel-2013-5/index2.html/.

54. "About Lynx," on the XCOR Aerospace website, accessed [insert date or use date I checked, June 6, 2013], http://www.xcor.com/products/vehicles/lynx_suborbital.html.

55. Kenny Kemp, *Destination Space*, 49.

56. "Space Tourism Gets Cheaper and Cheaper," Jaunted, posted by "omri," May 4, 2010, http://www.jaunted.com/story/2010/5/4/154813/5376/travel/Space+Tourism+Gets+Cheaper+and+Cheaper.

57. Mark Whittington, "Space Adventures Plans Private Lunar Voyage for February 2017," Yahoo! News, February 2, 2012, http://news.yahoo.com/space-adventures-plans-private-lunar-voyage-february-2017-203300719.html.

58. Mark Odell, "BAE Agrees New Deal for Astrium," *Financial Times*, February 2, 2003.

59. Rob Coppinger, "EADS Astrium Puts Its 'Space Jet' on Hold Indefinitely," *Hyperbola* (blog), Flightglobal, March 24, 2009, http://www.flightglobal.com/blogs/hyperbola/2009/03/eads-astrium-puts-its-space-je.html.

60. "Introduction," on the Bigelow Aerospace Web site, accessed June 6, 2013, http://www.bigelowaerospace.com/introduction.php.

61. "Opportunities and Pricing," on the Bigelow Aerospace Web site, accessed June 6, 2013, http://www.bigelowaerospace.com/opportunity-pricing.php.

62. "Company Overview," on the SpaceX Web site, accessed June 6, 2013, http://www.spacex.com/company.php.

63. Kenny Kemp, *Destination Space*, 19.

64. "Abercrombie & Kent Acquisition Boosts Intrawest's Performance," *Pique Newsmagazine*, November 19, 2004, http://www.piquenewsmagazine.com/whistler/abercrombie-and-kent-acquisition-boosts-intrawests-performance/Content?oid=2148896.

65. Christina Heyniger, *North American Adventure Travelers: Trends and Attitudes about Adventure and Ecotourism in Brazil*, SlideShare presentation, ABETA Adventure Travel Summit, São Paulo, Brazil, September 20, 2011, http://www.slideshare.net/ChristinaHeyniger/adventure-traveler-statistics.

66. *ATDI 2011 Adventure Tourism Development Index Report*, accessed June 6, 2013, http://www.adventuretravel.biz/wp-content/uploads/2012/11/atdi_2011_report.pdf.

67. Jeff Foust, "Screening and Training for Commercial Human Spaceflight," The Space Review, February 18, 2008, http://www.thespacereview.com/article/1062/1.

68. Ibid.

69. Kenny Kemp, *Destination Space*, 234.

70. Virgin Galactic, "Virgin Galactic Reveals Privately Funded Satellite Launcher and Confirms SpaceShipTwo Poised for Powered Flight," news release, October 7, 2012, http://www.virgingalactic.com/news/item/xxx/.

71. Jeff Foust, "Screening and Training."

72. See the Ulusaba Web site, http://www.ulusaba.virgin.com/en/ulusaba/about_us.

73. Kenny Kemp, *Destination Space*, 190.

74. Virgin Galactic, "Sir Richard Branson and New Mexico Governor Susana Martinez Dedicate the 'Virgin Galactic Gateway to Space,'" news release, October 17, 2011, http://www.virgingalactic.com/news/item/sir-richard-branson-and-new-mexico-governor-susana-martinez-dedicate-the-virgin-galactic-gateway-/.

75. "New Regulations Govern Private Human Space Flight Requirements for Crew and Space Flight Participants," Federal Aviation Administration, last modified February 7, 2007, accessed June 6, 2013, http://www.faa.gov/about/office_org/headquarters_offices/ast/human_space_flight_reqs/.

76. Kiva Bottero, "Environmental Upside to Commercial Space Travel?," Cleantech Authority, November 12, 2011, http://cleantechauthority.com/environmental-upside-space-travel.

77. Kenny Kemp, *Destination Space*, 180.

78. See the Virgin Galactic Web site, http://www.virgingalactic.com.

79. Virgin Galactic, "Virgin Galactic Reveals Privately Funded Satellite Launcher."

80. Christopher Elliott, "Space Agent Upchurch: Virgin Galactic Flights Will Be 'Life Changing,'" Consumer Traveler, December 7, 2009, http://www.consumertraveler.com/today/space-agent-upchurch-virgin-galactic-flights-will-be-life-changing/.

81. "A Brief History of the FAA," Federal Aviation Administration.

82. "New Regulations," Federal Aviation Administration.

83. Kenny Kemp, *Destination Space*, 179.

84. Ariel Schwartz, "Branson on the Impact of Space Travel," Co.Exist, accessed June 6, 2013, http://www.fastcoexist.com/1678646/branson-on-the-impact-of-space-travel.

85. Kiva Bottero, "Environmental Upside."

86. Dave Demerjian, "Virgin Galactic's Green Cred Up for Debate," Wired, May 19, 2009, http://www.wired.com/autopia/2009/05/virgin-galactics-green-cred-up-for-debate/.

87. "Virgin Unite," Virgin, accessed June 6, 2013, http://www.virgin.com/company/virgin-unite.

88. "Galactic Unite," Virgin Unite, accessed June 6, 2013, http://www.virginunite.com/Templates/campaign.aspx?id=beff7532-4303-435f-a4e7-b3d4cea320de&nid=baa433fb-a751-4914-8258-0781487ed291.

89. Richard Branson, e-mail message to future astronauts, April 29, 2013.

90. Steve Jobs, commencement address delivered at Stanford University, California, June 12, 2005, posted in the Stanford Report, June 14, 2005, http://news.stanford.edu/news/2005/june15/jobs-061505.html.

91. Ibid; *Whole Earth Catalog*, October 1974, accessed June 6, 2013, http://htmlimg3.scribdassets.com/4988llwpkwmc54c/images/324-157e00fdae/000.jpg.

ABOUT THE AUTHOR

Ketty Pucci-Sisti Maisonrouge was born in Italy and grew up in Switzerland and France. Her broad background includes a degree from Sciences Po in Paris and a master's degree in law from the Sorbonne. In 1988 Maisonrouge founded KM & Co., which specializes in luxury innovation by assisting luxury firms and start-ups in branding, financing, and long-term strategies. She is also the cofounder and a board member of a few start-ups, including Savelli; a board member of J. Mendel; and a senior advisor to the Gores Luxury Group. In 2005 Maisonrouge joined the Columbia Business School faculty as an adjunct professor and teaches the master class "Marketing of Luxury Products." Maisonrouge has served as the U.S. Representative of the French auction house Tajan and the Comité Colbert, an association of over seventy French luxury companies, in addition to being the president of the Luxury Education Foundation since 2004. In 2001 she was awarded the title of Chevalier de l'Ordre National du Mérite by the French government and the title of Chevalier de la Légion d'Honneur in 2009.

66 The Luxury Alchemist *is a fascinating read! Ketty has great entrepreneurial spirit and offers a unique perspective on what it takes to create a true luxury brand. She shares this knowledge through lessons she's learned from numerous fashion and business icons whose talent, determination, tremendous drive, and, above all, genuine passion she greatly admires. This book is perfect for anyone wanting to know how to transform ideas into a successful and enduring brand.* 99

LEONARD A. LAUDER
chairman emeritus of the Estée Lauder Companies Inc.

66 *Talent might be the essential building block for success, but you need to learn your craft to transform fabric into a whimsical dress, and you need a vision to transform a collection into a brand.* The Luxury Alchemist *takes you behind the scenes of the glamorous world of luxury, and makes you discover what it really takes to get to the top.* 99

GILLES MENDEL
creative director and CEO of J. Mendel

66 The Luxury Alchemist *will help you discover how to attain true luxury's ultimate goal: bringing joy and beauty to your life.* 99

REEM ACRA
fashion designer

66 *From fashion to technology to space travel, luxury exists or can be created.* The Luxury Alchemist *brings us on a journey from the glorious past to the dynamic future, defining the essence of what it takes to be the very best.* 99

ROBERT CHAVEZ
president and CEO of Hermès of Paris